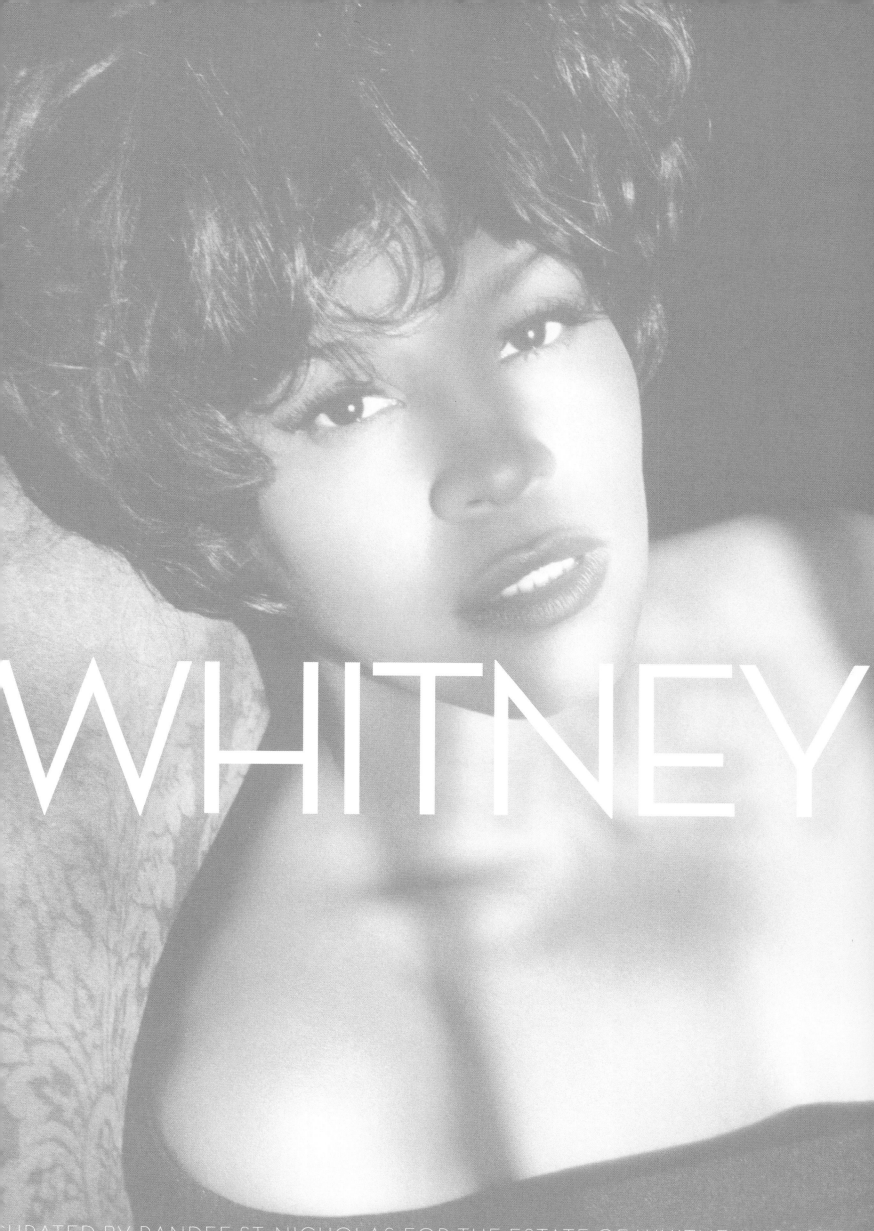

WHITNEY

CURATED BY RANDEE ST. NICHOLAS FOR THE ESTATE OF WHITNEY HOUSTON

The photos in this book powerfully capture all the wonderfully expressive personalities that were part of Whitney Houston and who she was.

I first saw Whitney in her mother's act at a club called Sweetwater's in Manhattan in 1983. Her beauty was immediately striking but it was her soulfulness that instantly and deeply affected me. She was singing the song "Home" from the show "The Wiz" and it was the naturally raw emotion with which she delivered it that took my breath away. The second and final song she sang was "The Greatest Love of All," a song I had personally commissioned years earlier to be the title song of the film "The Greatest," which was based on the life of Muhammad Ali. In 1983 Whitney was still a teenager and yet the purity of her voice, her innocence and her power all registered resoundingly true and literally made me gasp. You, the reader, will see and feel all these same emotions from the photos in this book.

Whitney's smile was absolutely infectious. When she was happy her face would light up with joy and her radiance would fill the room. Whitney could be vibrant, she could be intense and she could be seductive. She could also be the young ingénue experiencing certain feelings for the first time or she could be the wise teacher giving advice on life itself. In searching for material over the years for her to record, I never had to limit myself to only one type of material she could interpret. Ballads, of course, were her forte and she could rip your heart out, but she could own up-tempos as well and you could dance the whole night just to her rhythmic songs. In a snap of two fingers you can picture exactly what she looked like when she did "I Want To Dance With Somebody," "I'm Every Woman," "It's Not Right But It's Okay," "Step By Step"– I could go on and on. All of those looks, vivid visual images, and unforgettable memories are captured in this book.

Creating her visual image was as much a part of Whitney's legacy as those indelible vocals that are the benchmark of every singer who has begun a career in the years following Whitney's domination of the airwaves. All I have to say is "headdress" and you immediately conjure up her electrifying scene from "The Bodyguard" where she provokes chills with "I Have Nothing." Was anyone more beautiful than Whitney singing "Run To You" or more joyous, in that white track suit and wearing that white hair band, inspiring the world forever with "The Star-Spangled Banner"?

Whitney and I were special creative partners on all her songs that have become the soundtrack of the lives of millions all over the world but she was the sole arbiter of her fashion, her hair, her outfit, her look. She knew the camera well and the camera truly loved her. This book provides so many memorable pictures that trigger the deep emotional connection that we all had with Whitney. It's like a visual greatest hits and I know you will enjoy them, be affected by them and hopefully be touched by them always.

Clive Davis

For three decades she mesmerized the world with her voice, her music, and her uncompromised spirit. She was a magical girl with a voice from the heavens, an honesty that always let you know where you stood, and a heart that never wavered.
When she smiled…you smiled…and her **joy** was real.

Nippy did not really like to spend much time having her photograph taken…she loved to sing, she loved to dance but she did not like to hold still for **any** length of time.

Fortunately she was so beautiful and charismatic
that when she got in front of the camera the passionate way
she expressed herself transcended her camera shyness,
making her a fascinating subject, as you will see in this
collection of photographs gathered for this Tribute.

Here are 130 poignant photographs spanning her 30 years
as an Iconic artist as seen through the eyes of 22 photographers
who had the opportunity to capture the essence of this
amazing woman-child known as Whitney Houston.

Randee St. Nicholas

ANDREA BLANCH

LARRY BUSACCA

MICHELANGELO DI BATTISTA

DIRCK HALSTEAD

DAVID LACHAPELLE

KEVIN MAZUR

FRANK MICELOTTA

NEAL PRESTON

EBET ROBERTS

NORMAN SEEFF

MICHAEL ZAGARIS

MARC BRYAN-BROWN

PATRICK DEMARCHELIER

SANTE D'ORAZIO

BILL JONES

DANA LIXENBERG

STEVEN MEISEL

SHERYL NIELDS

STEVE PREZANT

WARWICK SAINT

RANDEE ST. NICHOLAS

FIROOZ ZAHEDI

For Nippy

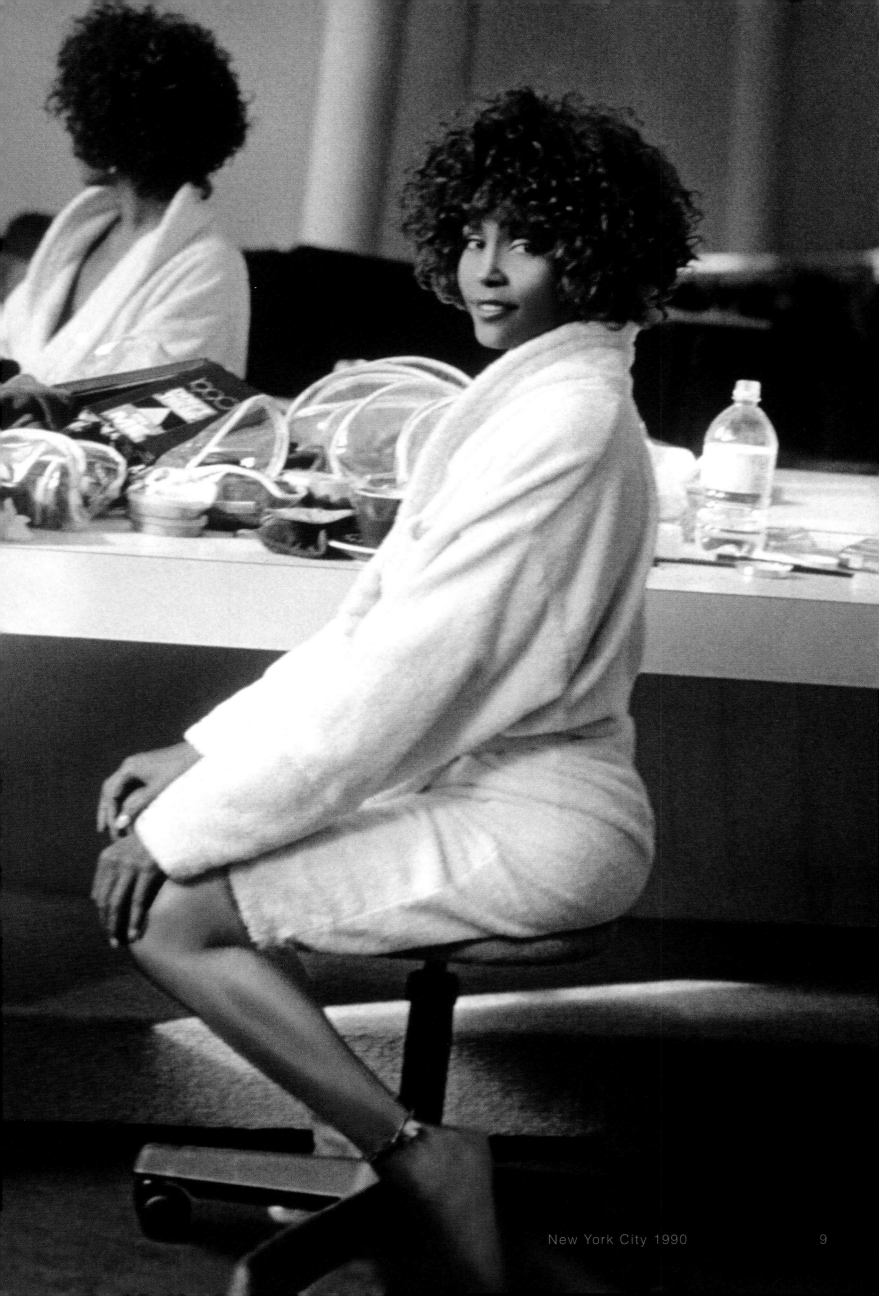

New York City 1990 9

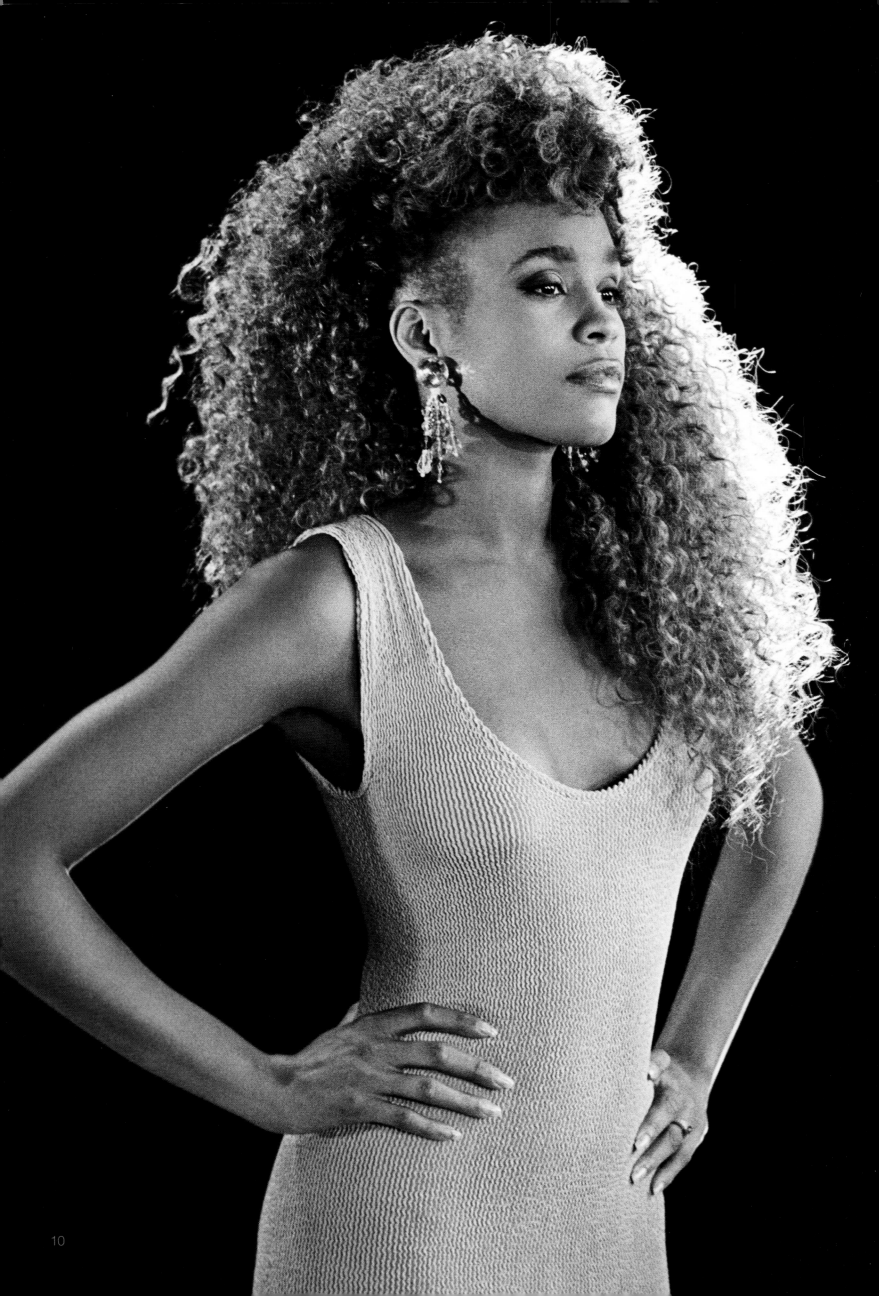

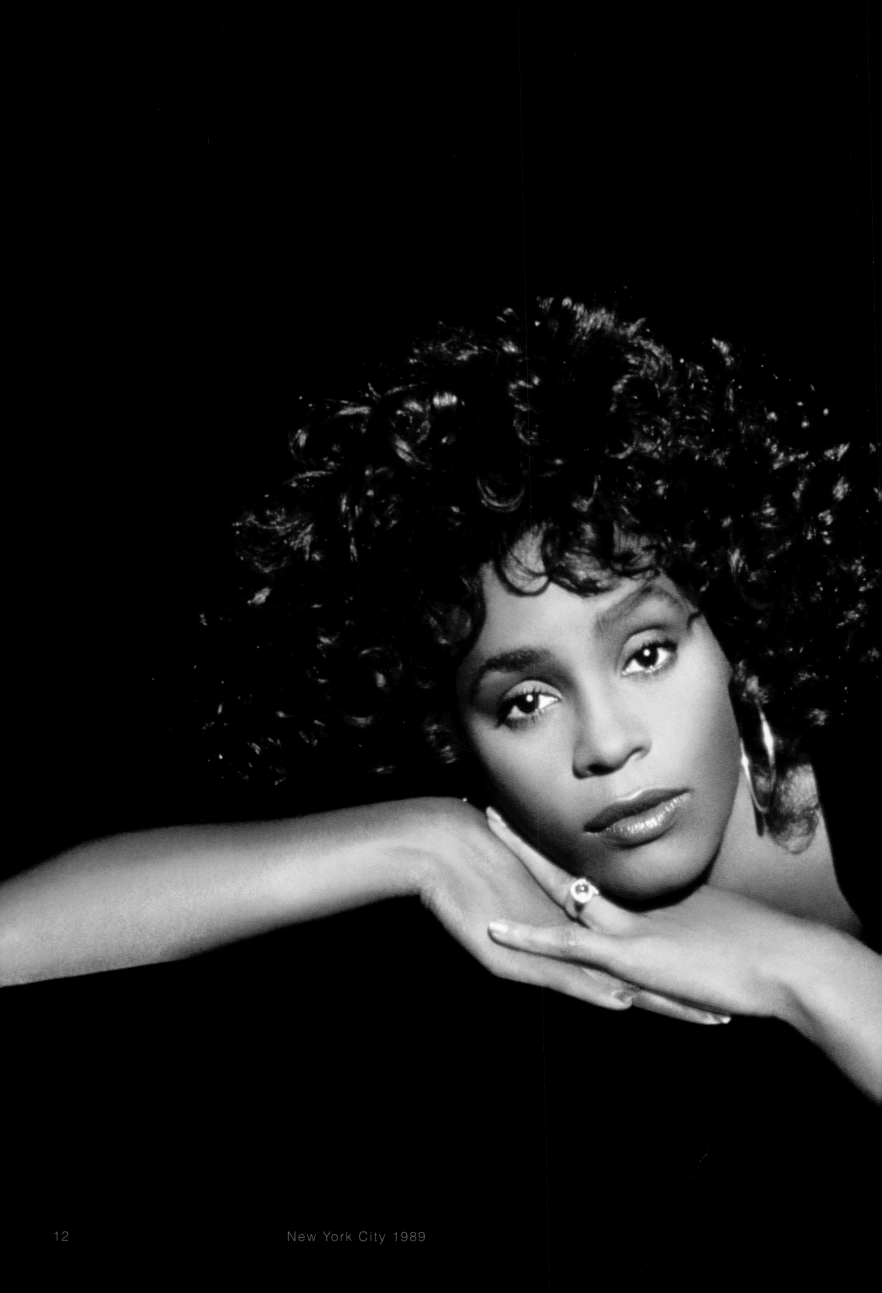

New York City 1989

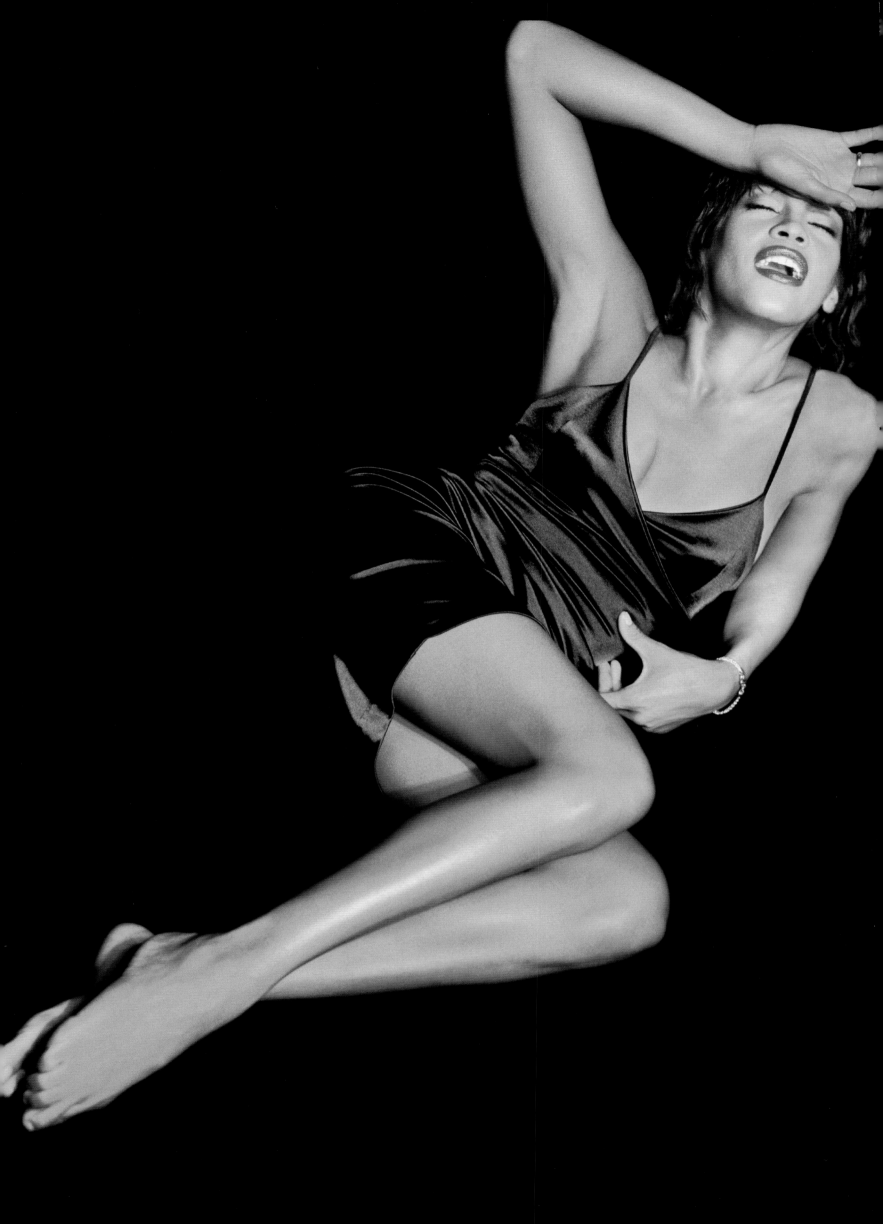

14　　　"Waiting To Exhale" video shoot New York City 1995

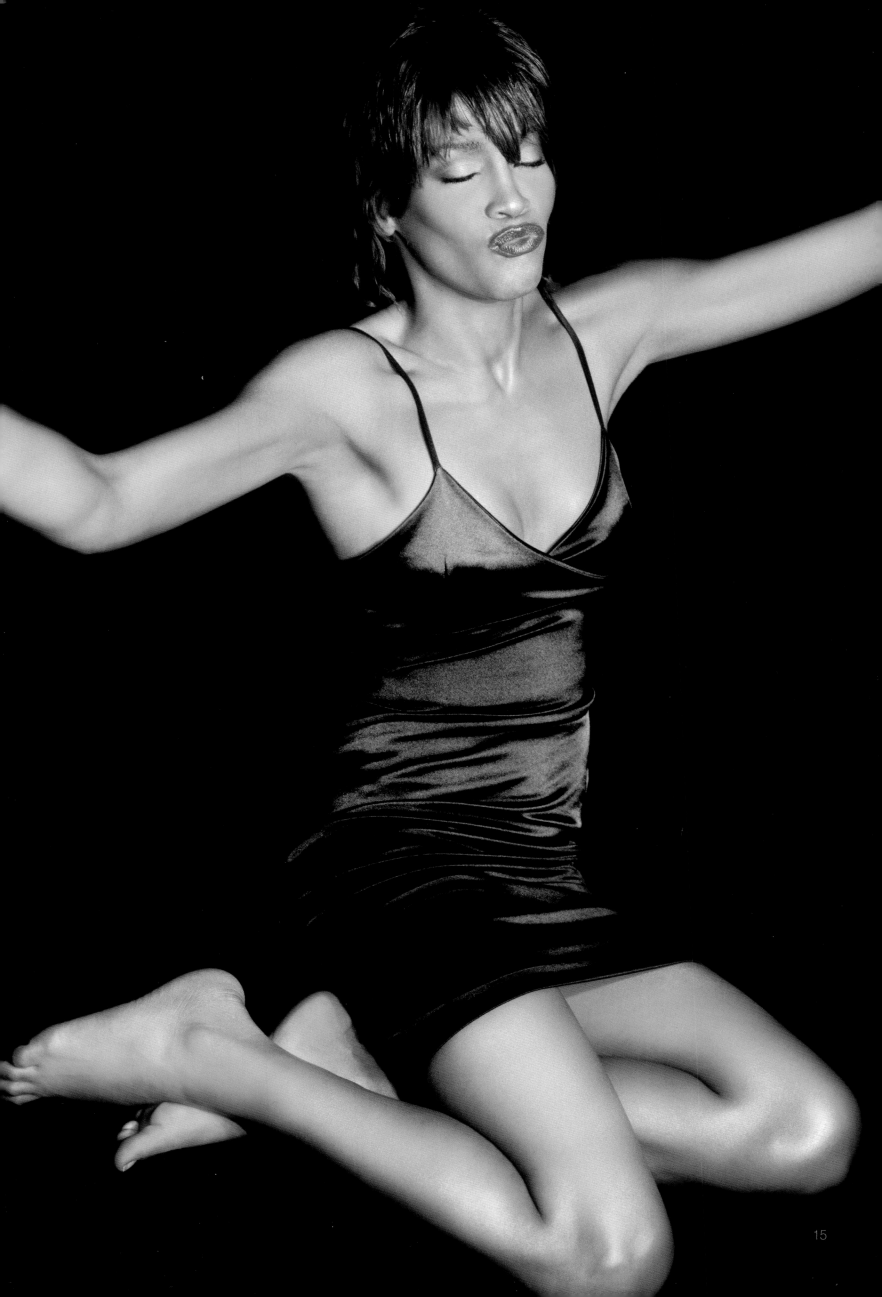

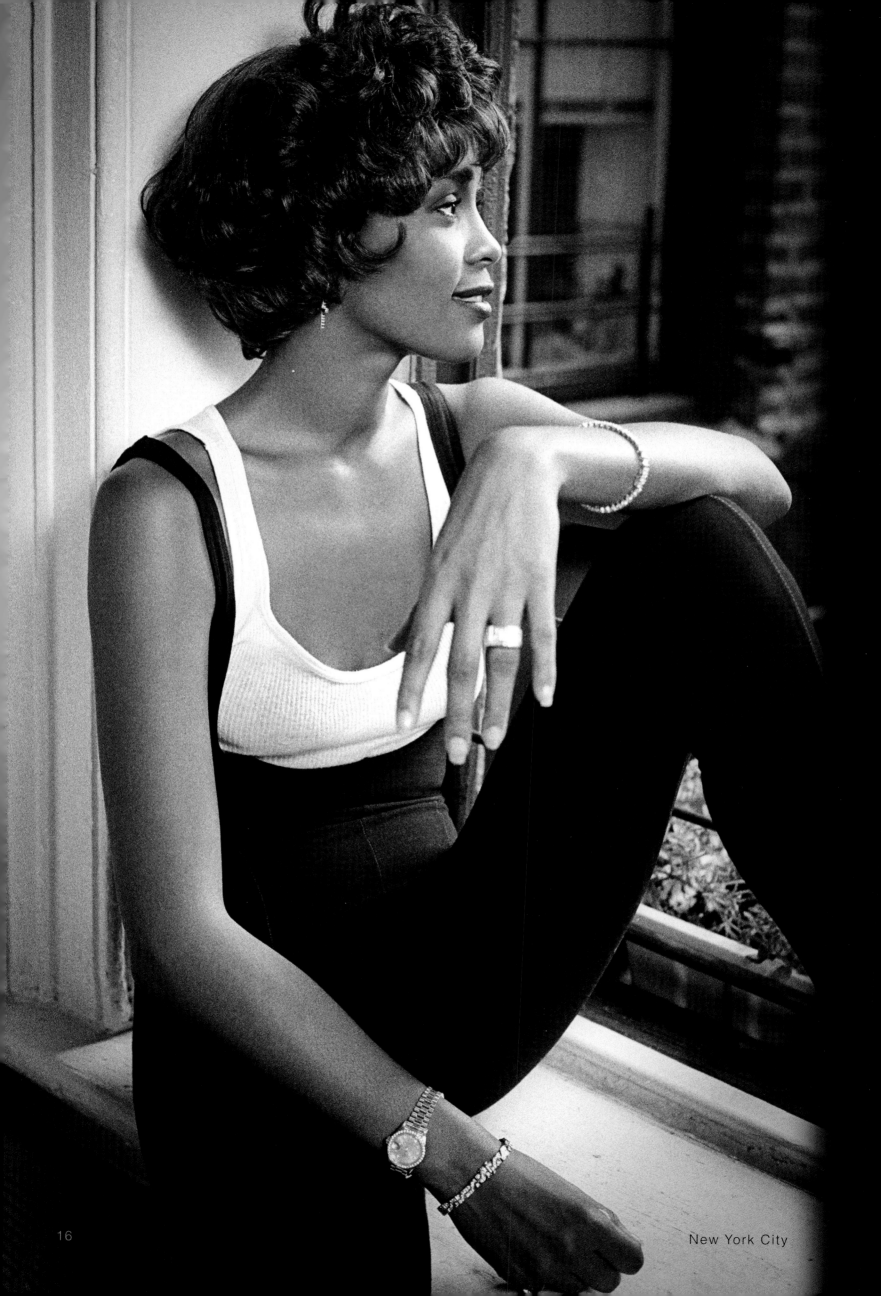

New York City

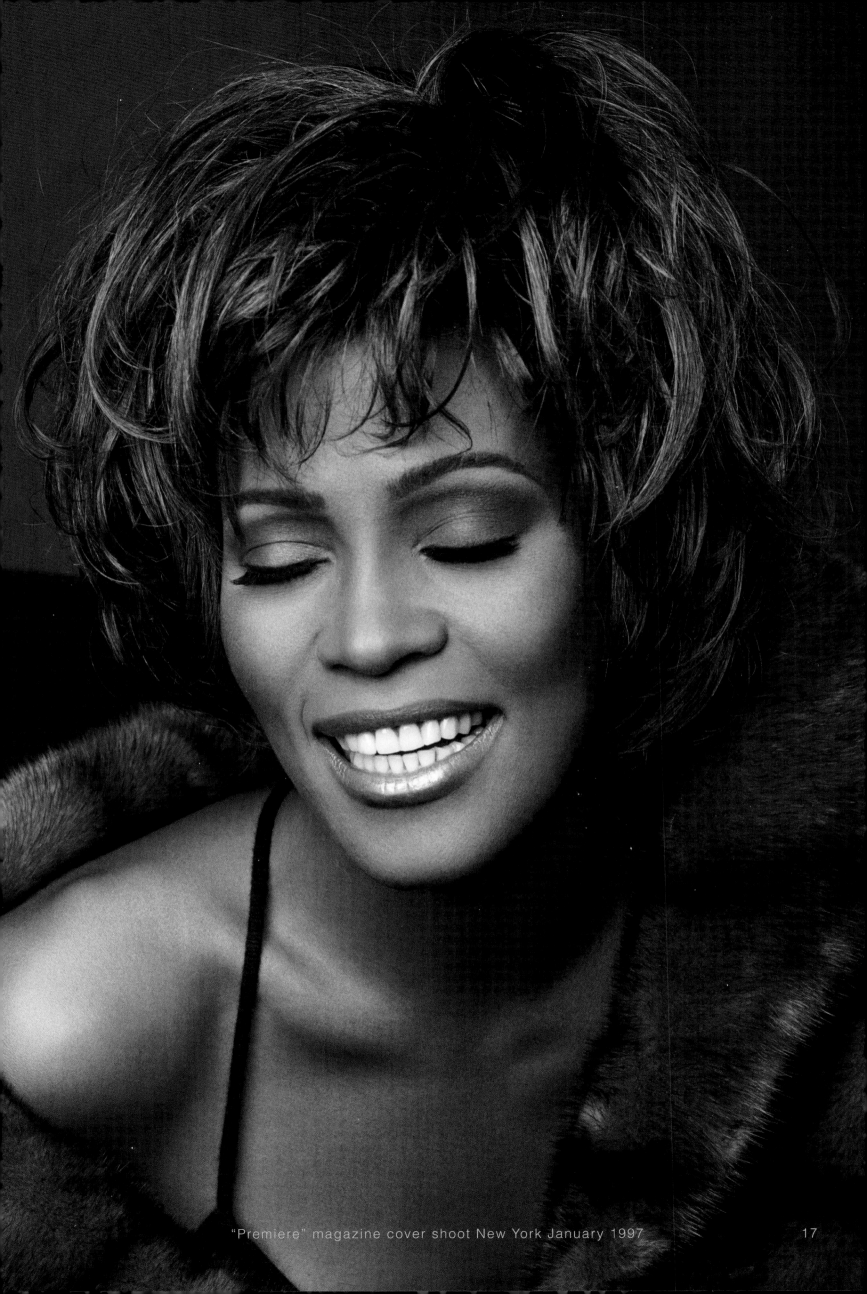

"Premiere" magazine cover shoot New York January 1997 17

in a recording studio in N[

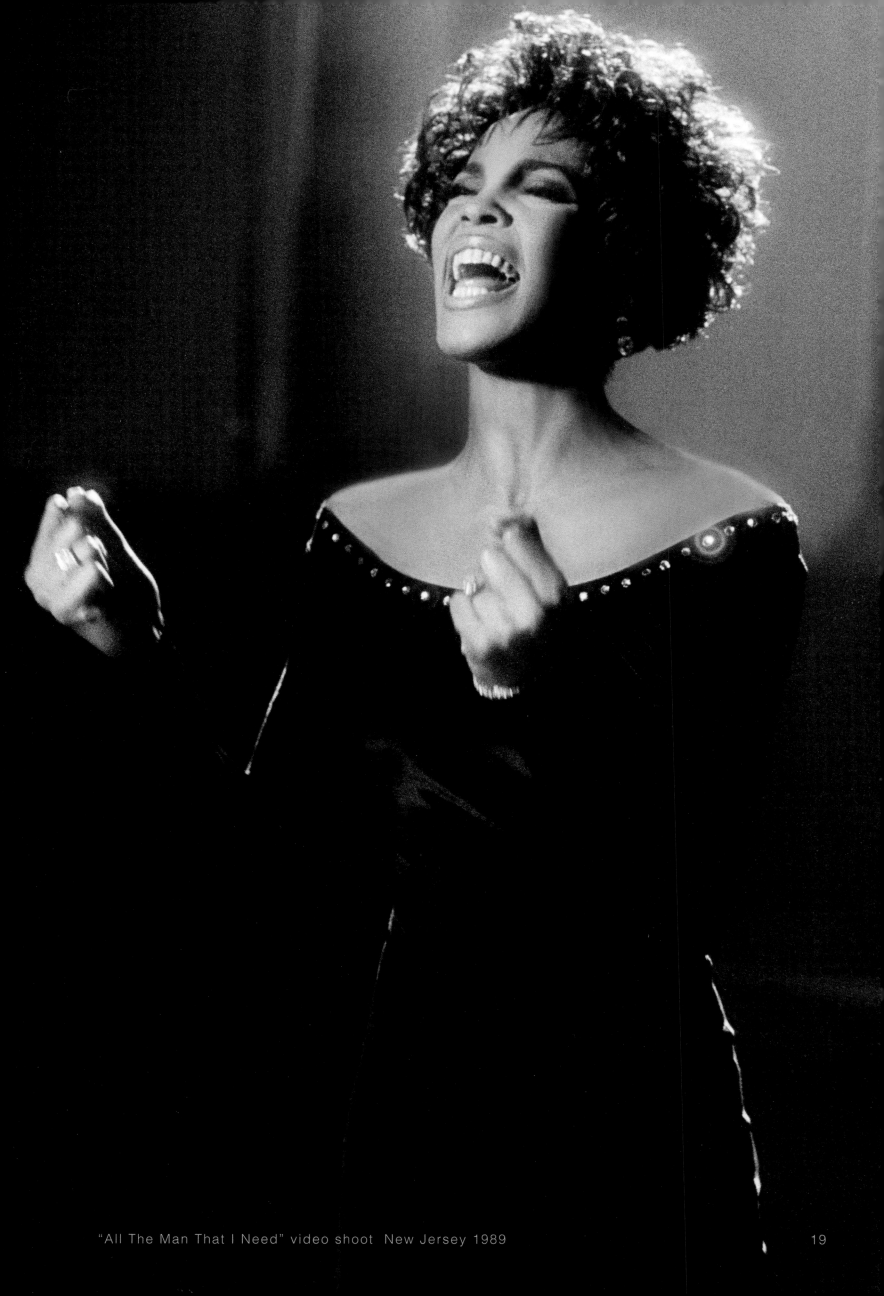

"All The Man That I Need" video shoot New Jersey 1989 19

1991 tour in Tampa, Florida

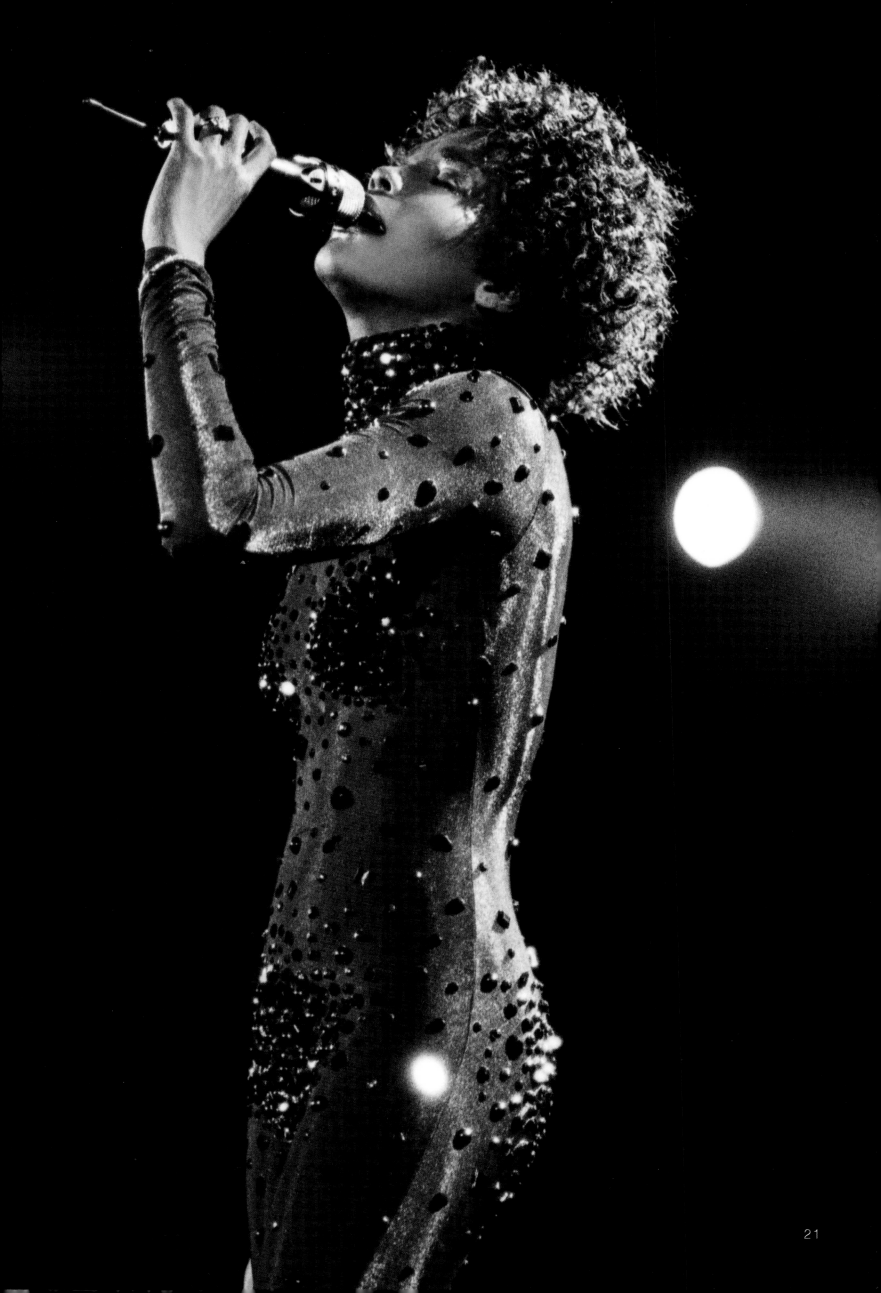

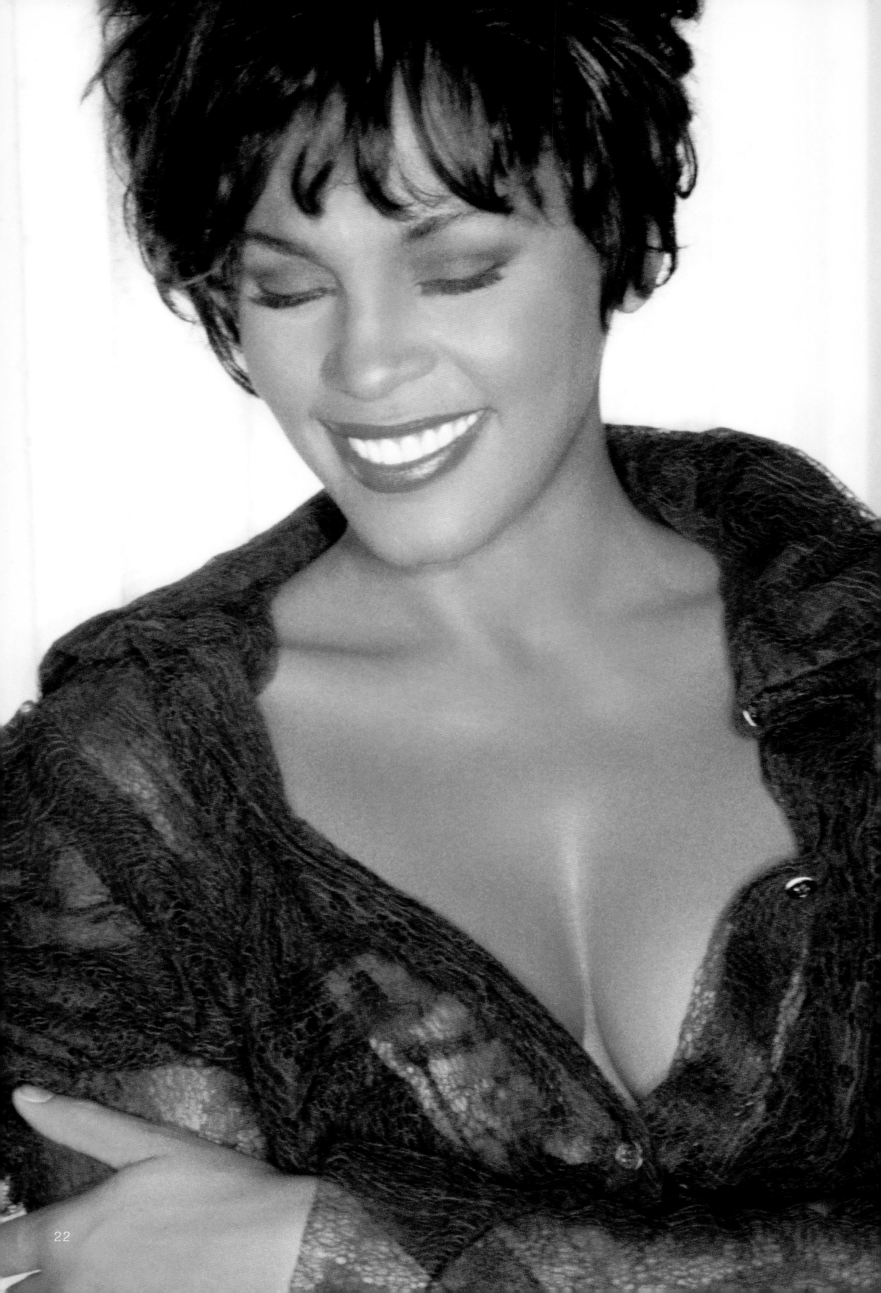

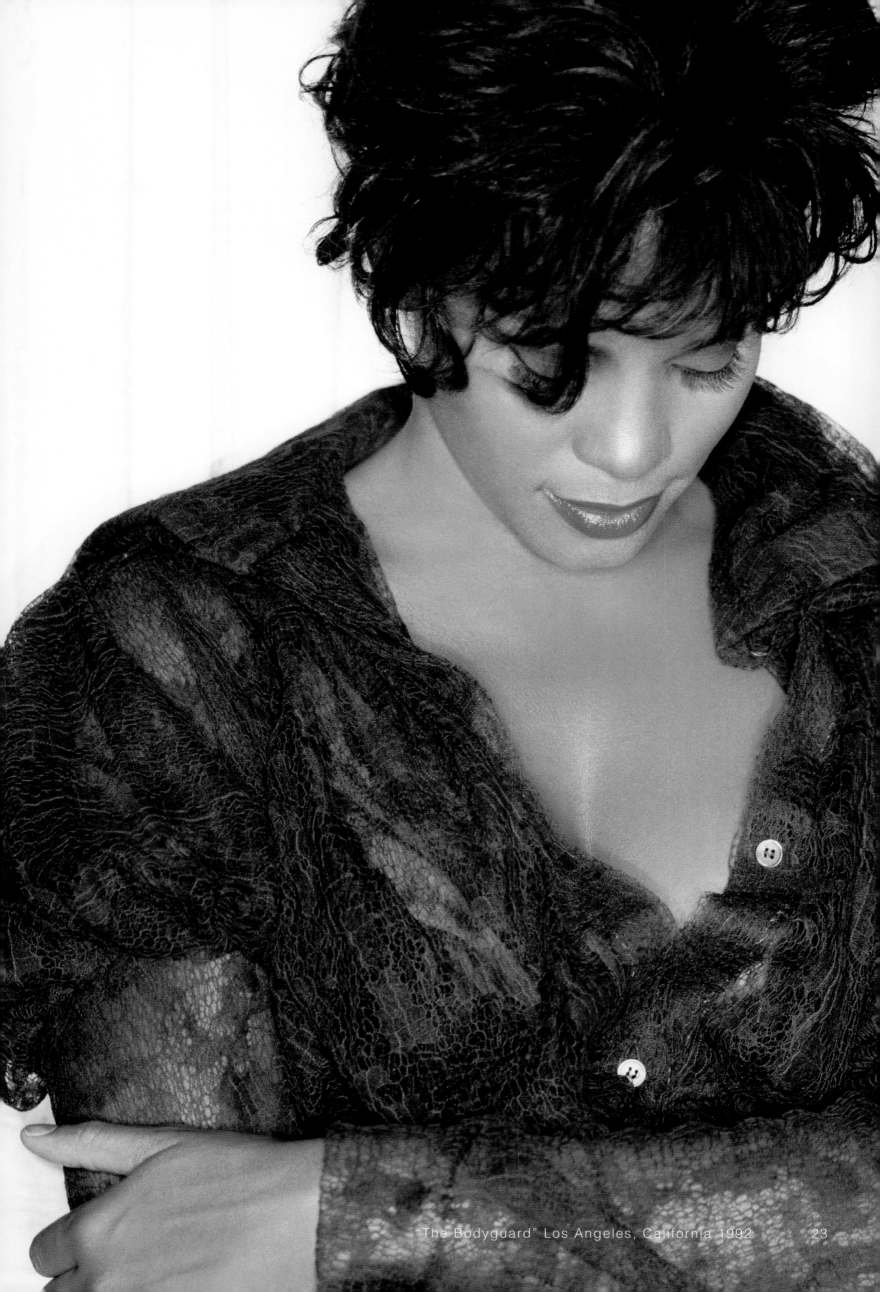

"The Bodyguard" Los Angeles, California 1992 23

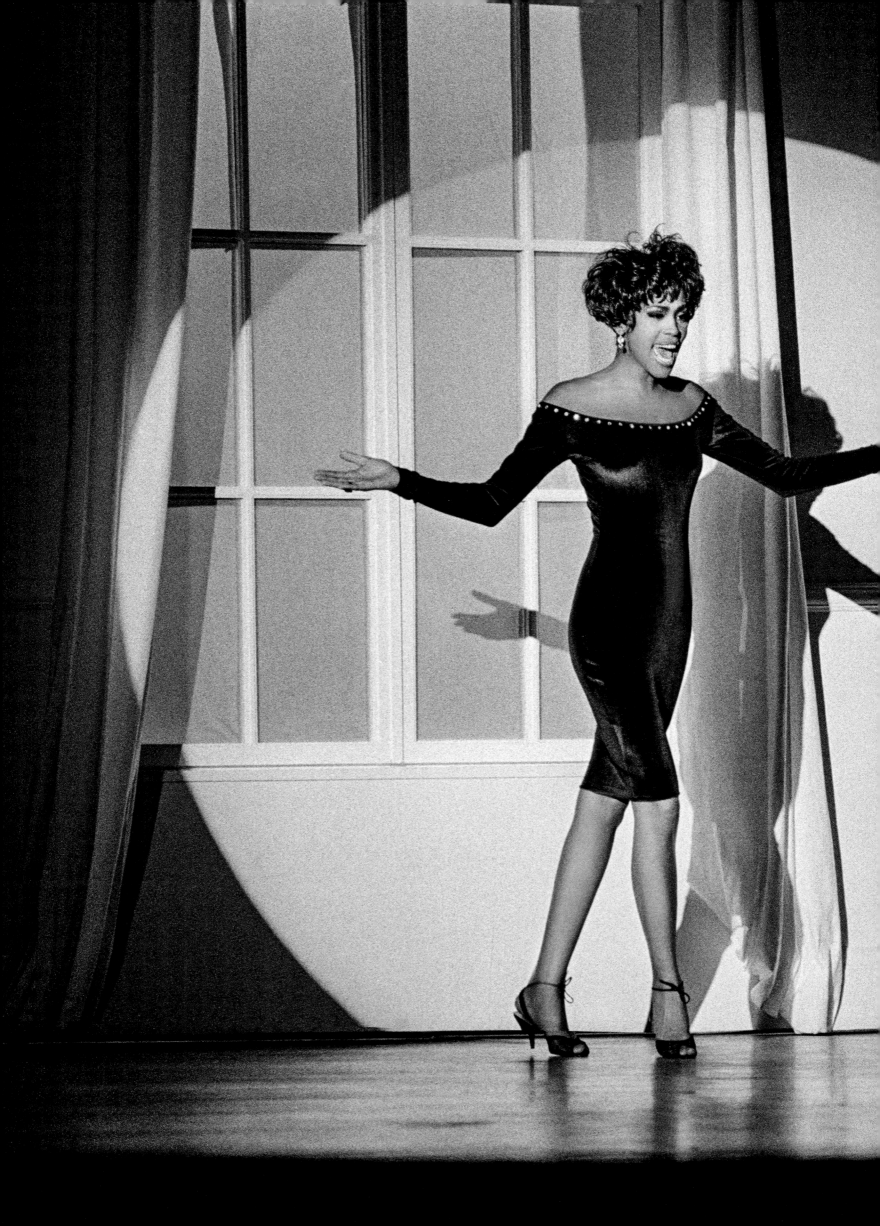

"All The Man That I Need" video shoot New Jersey 1989

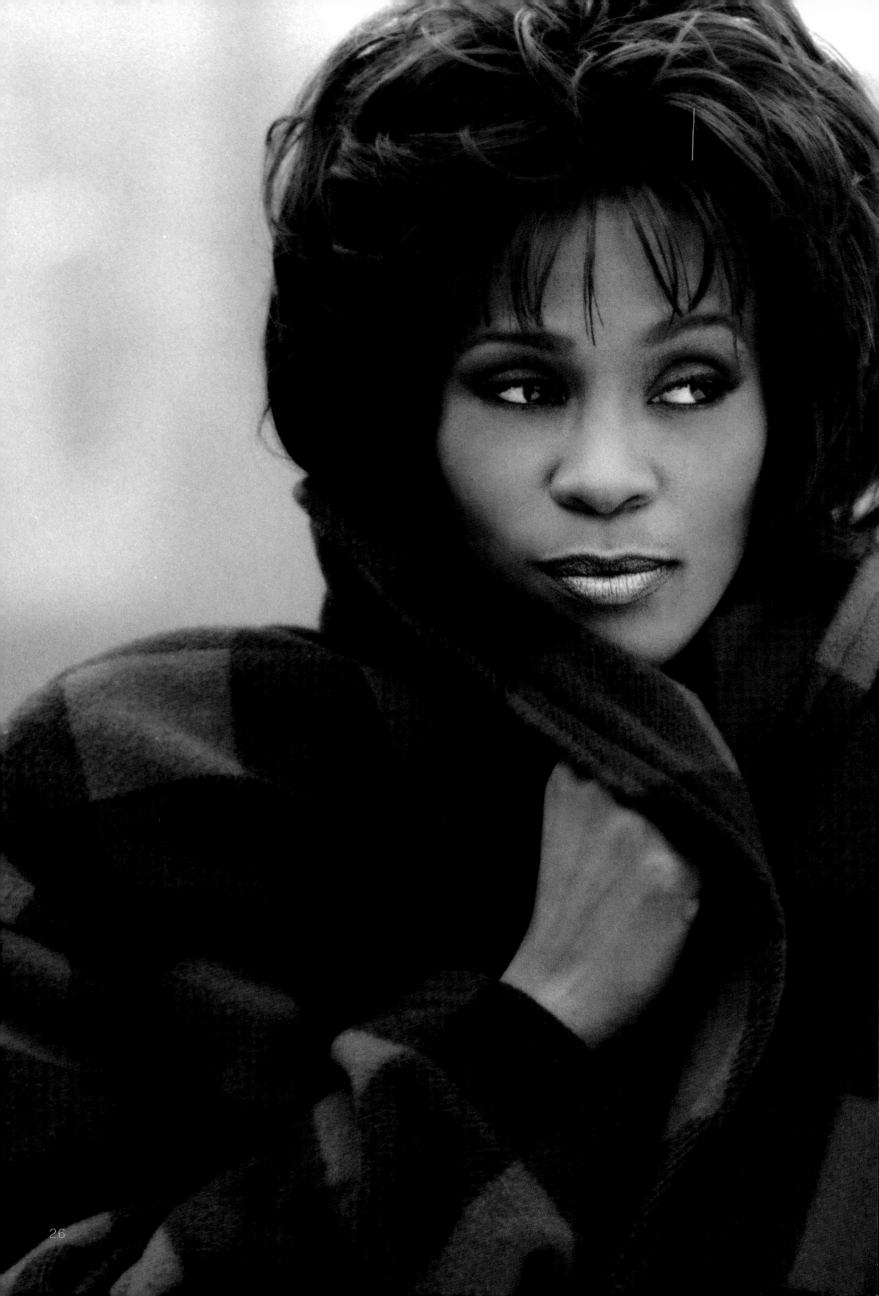

New York City 1995

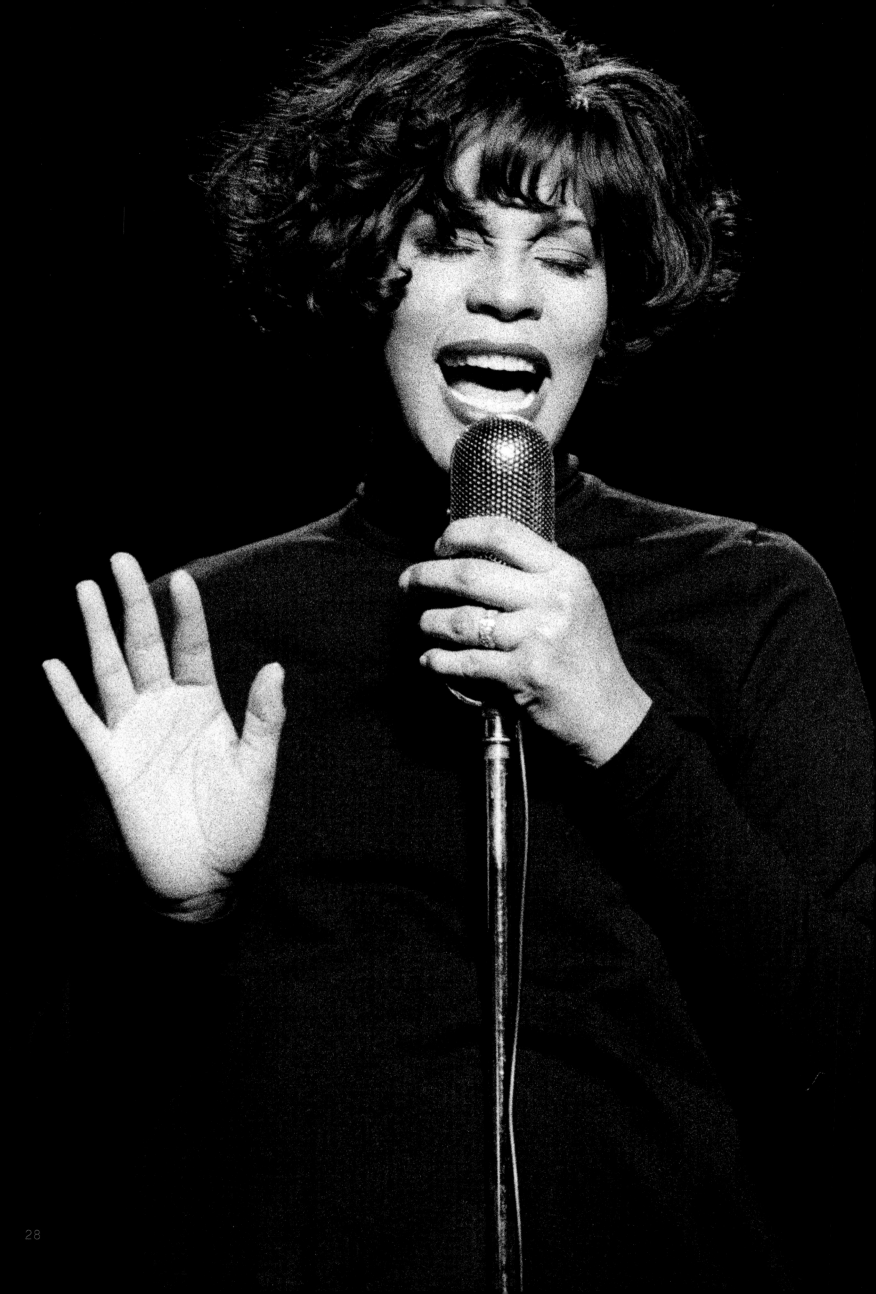

shot on the set of "I'm Every Woman" music video New York City 1993

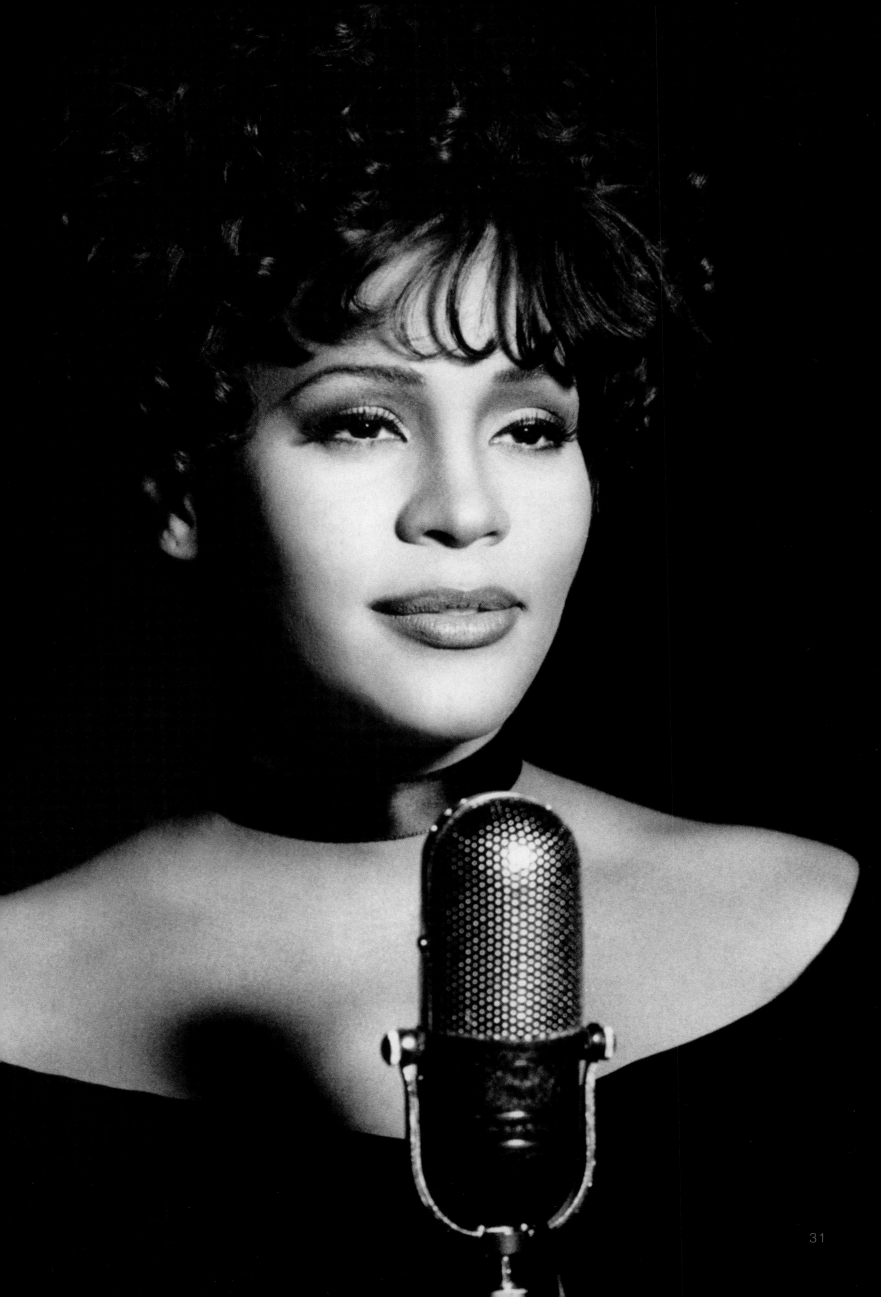

South Africa Tour Johannesburg 1994

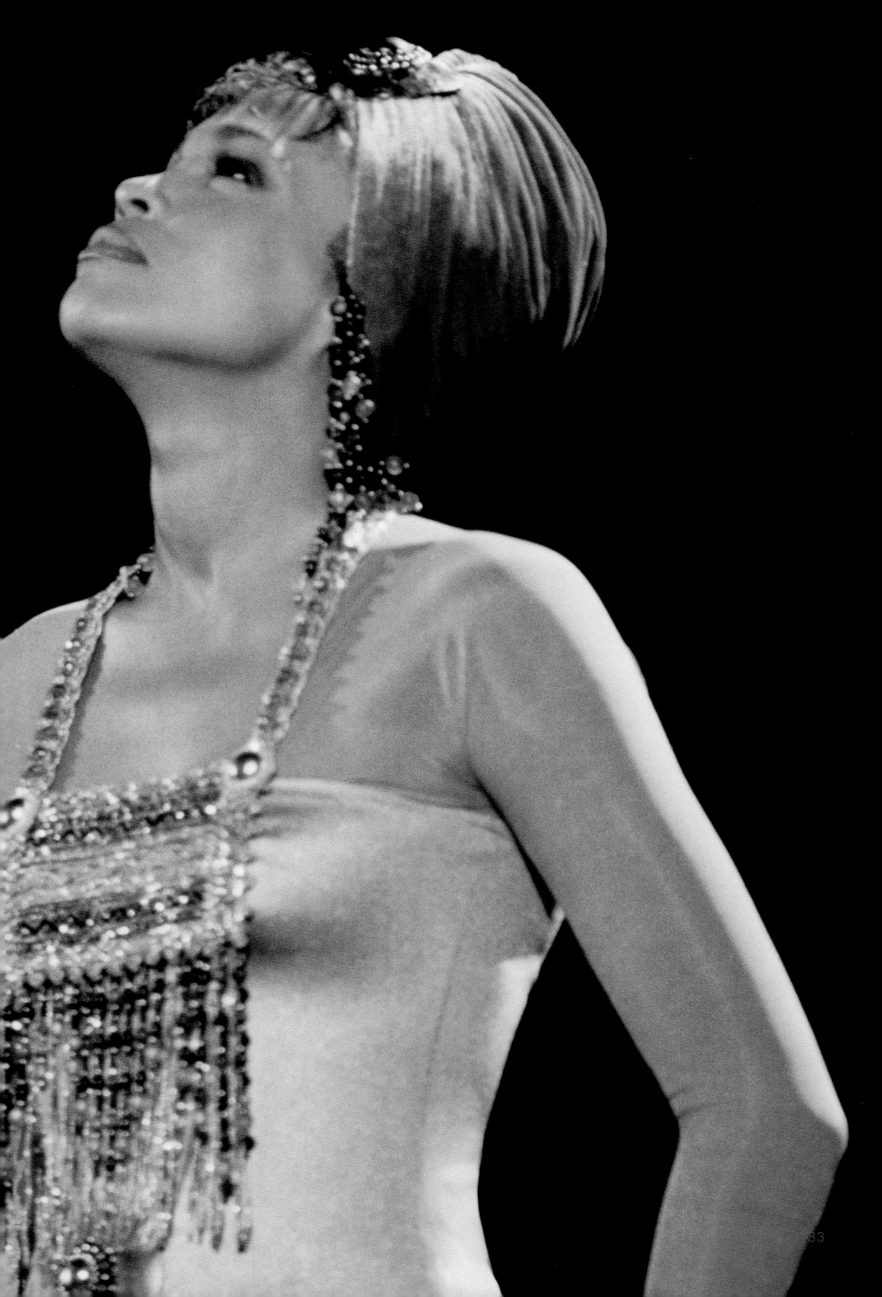

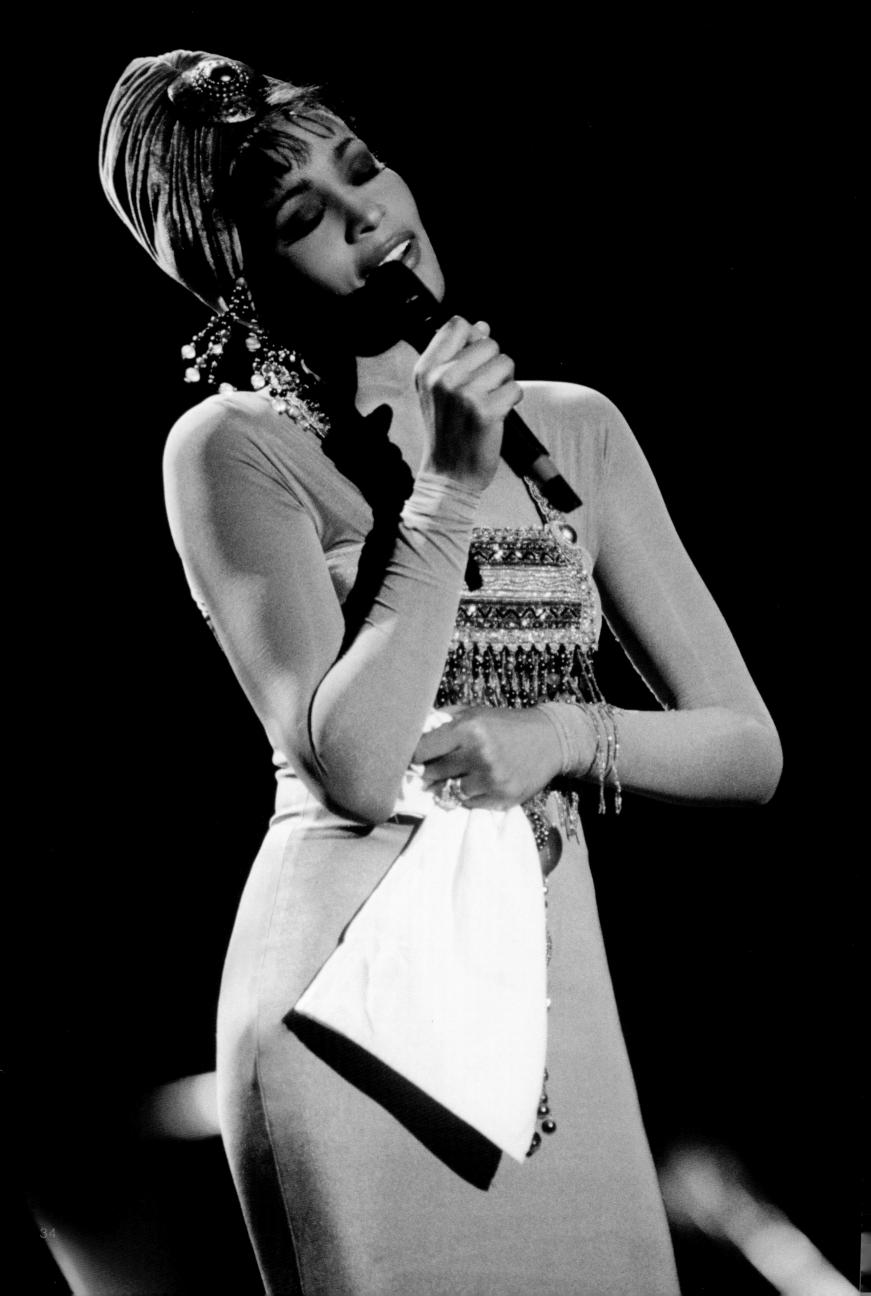

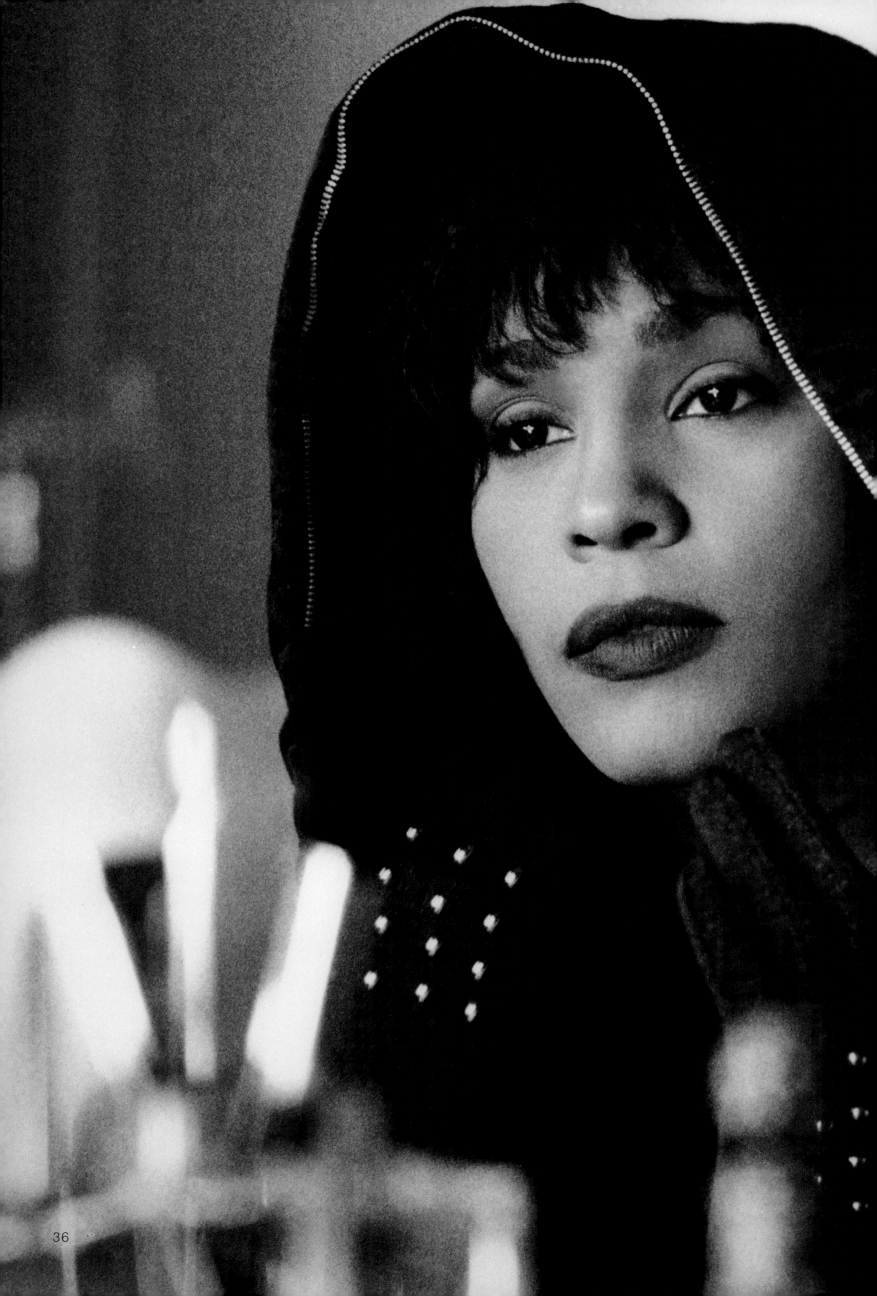

on the set of "The Bodyguard" Los Angeles, California 1992

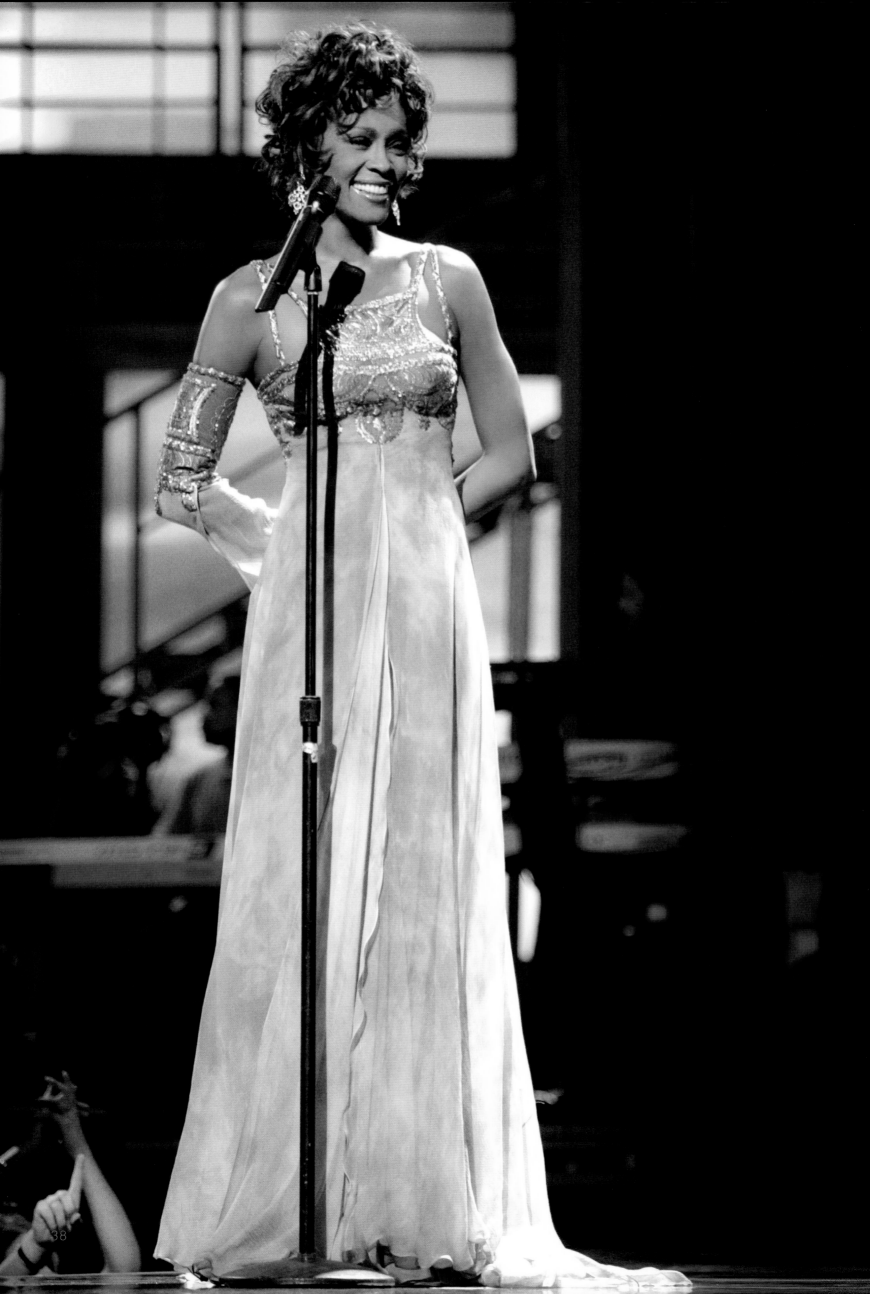

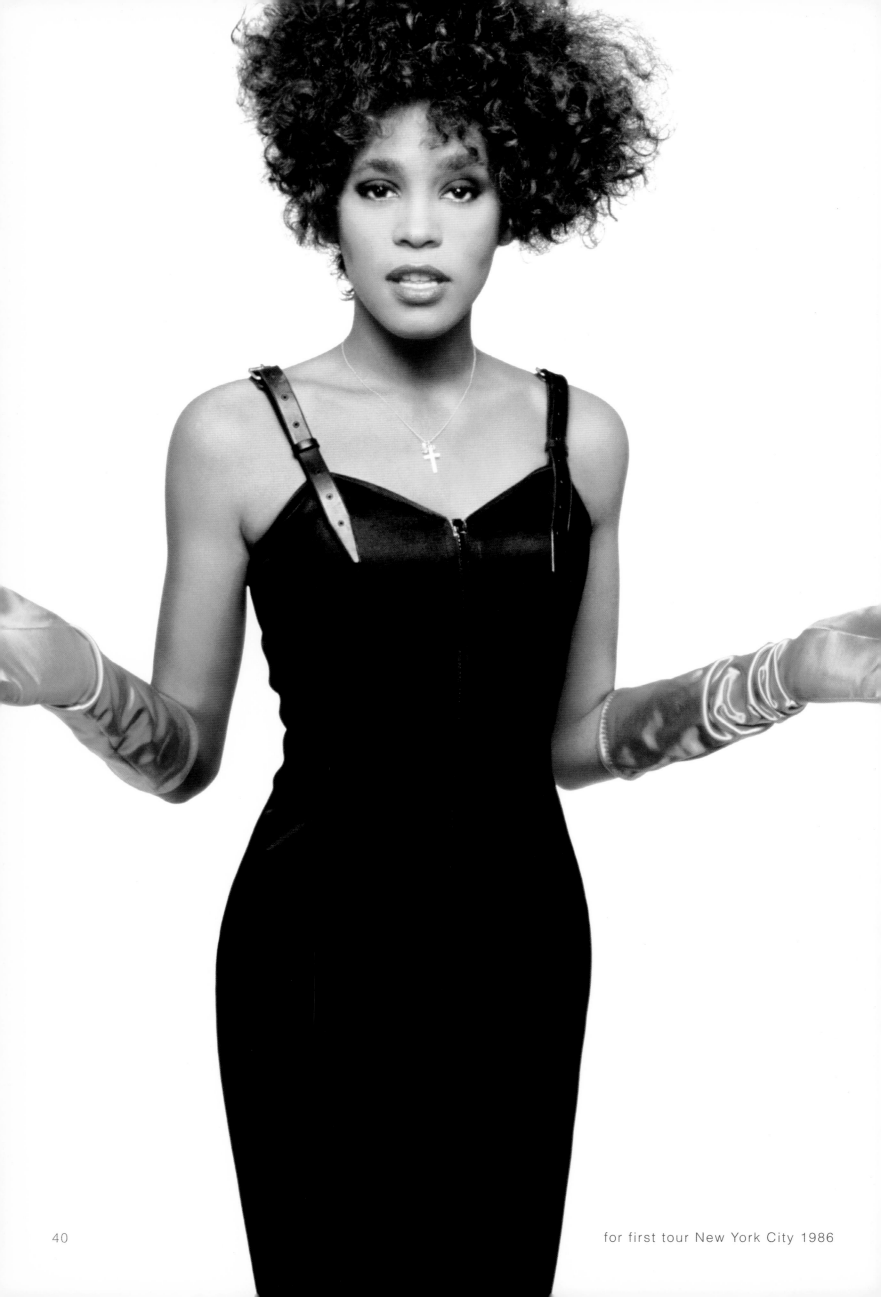

for first tour New York City 1986

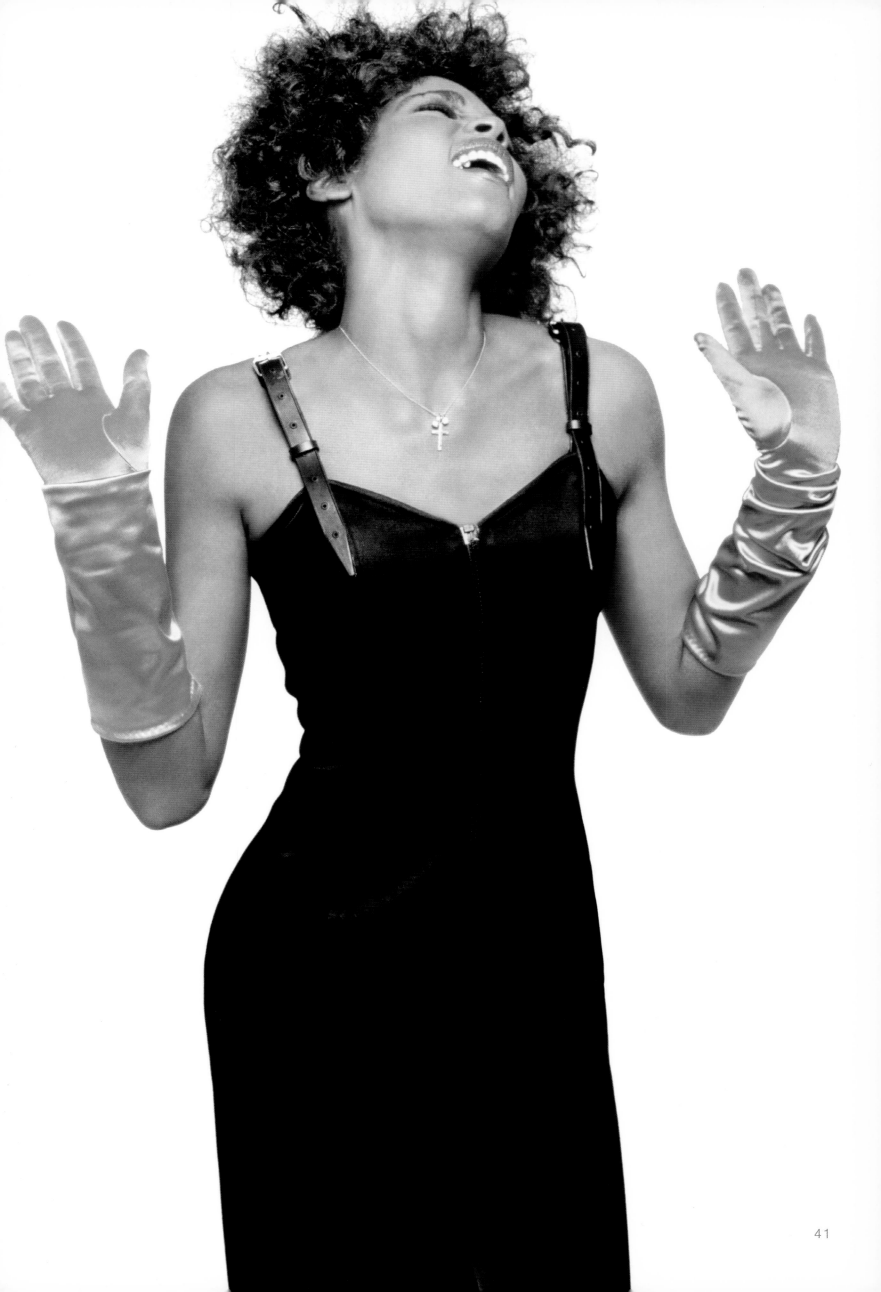

"My Name Is Not Susan" video shoot 1991

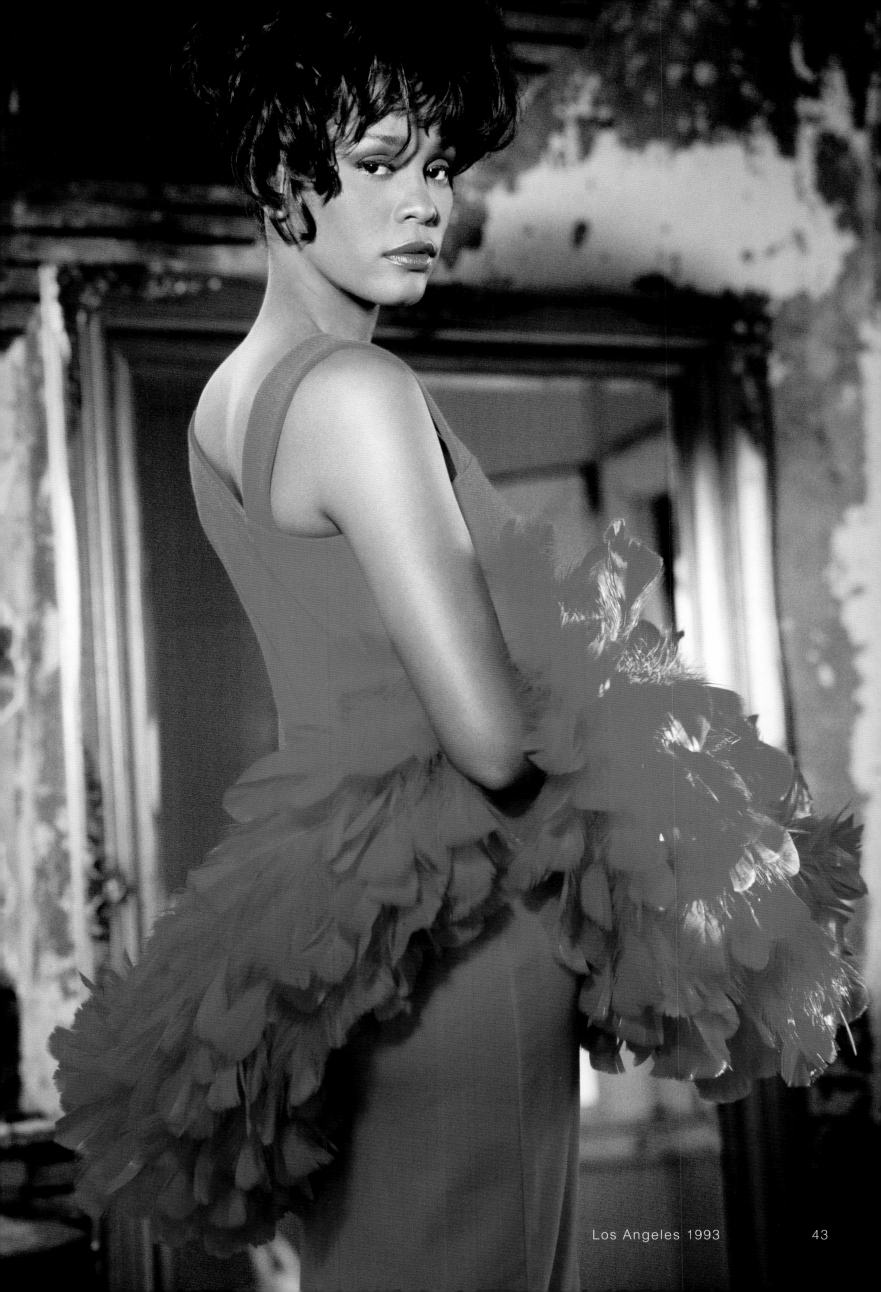

Los Angeles 1993 43

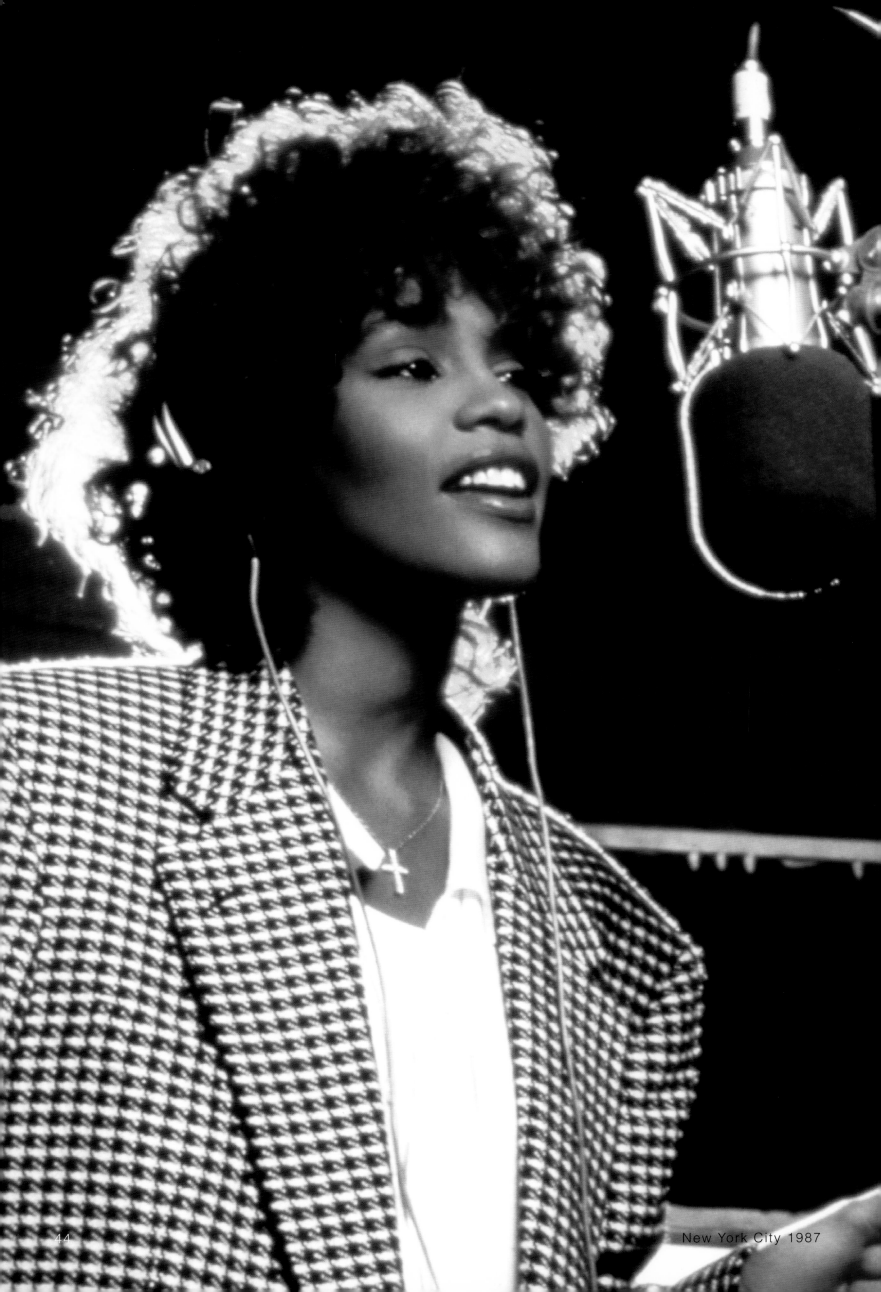

New York City 1987

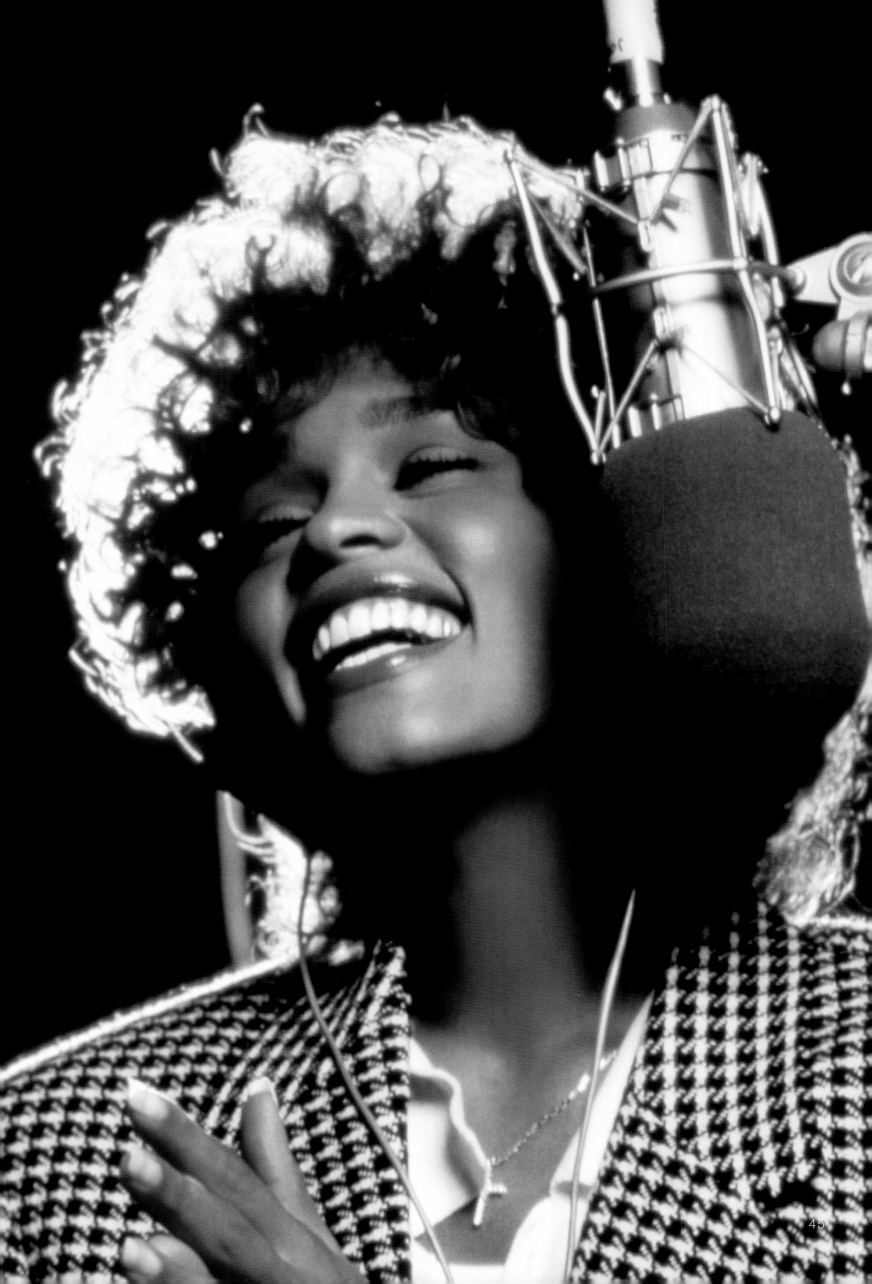

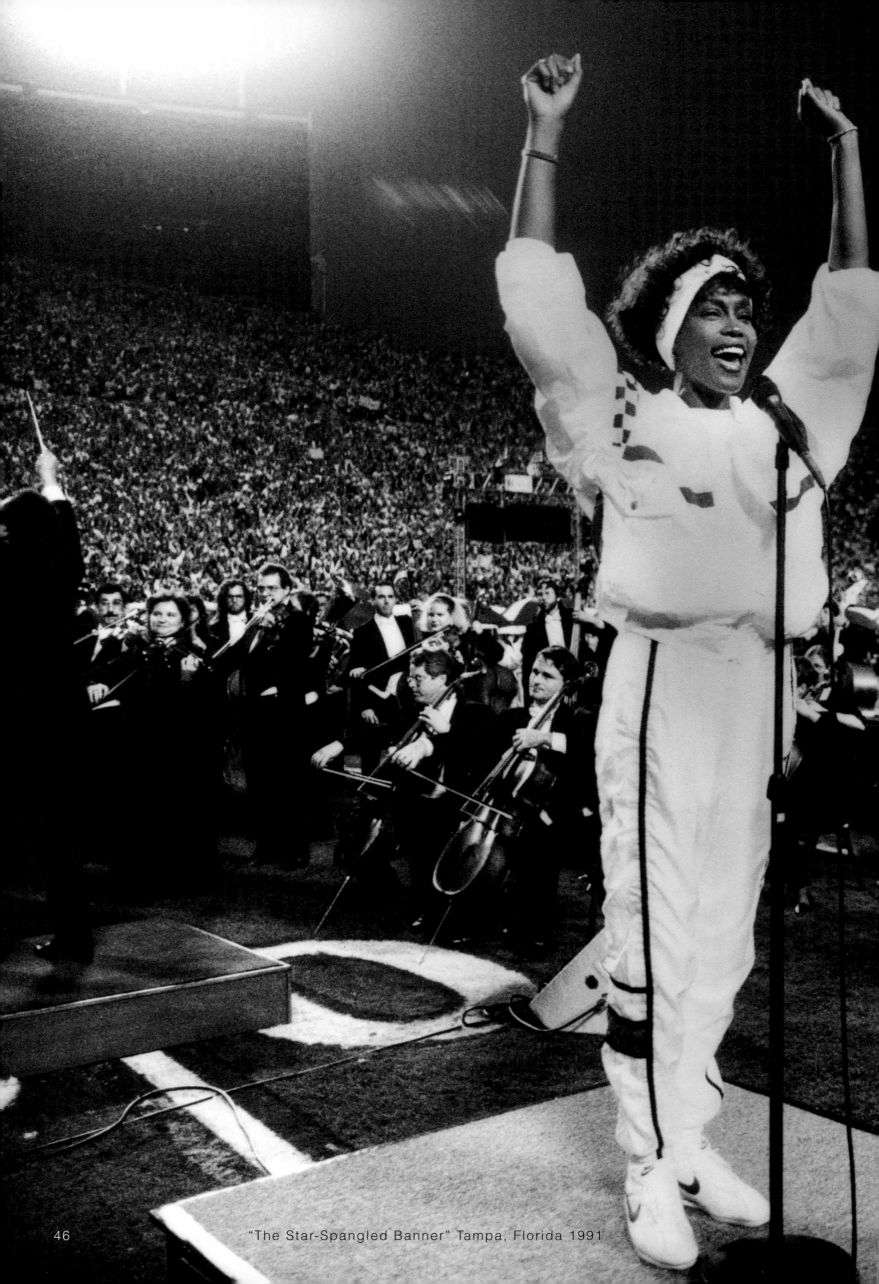

"The Star-Spangled Banner" Tampa, Florida 1991

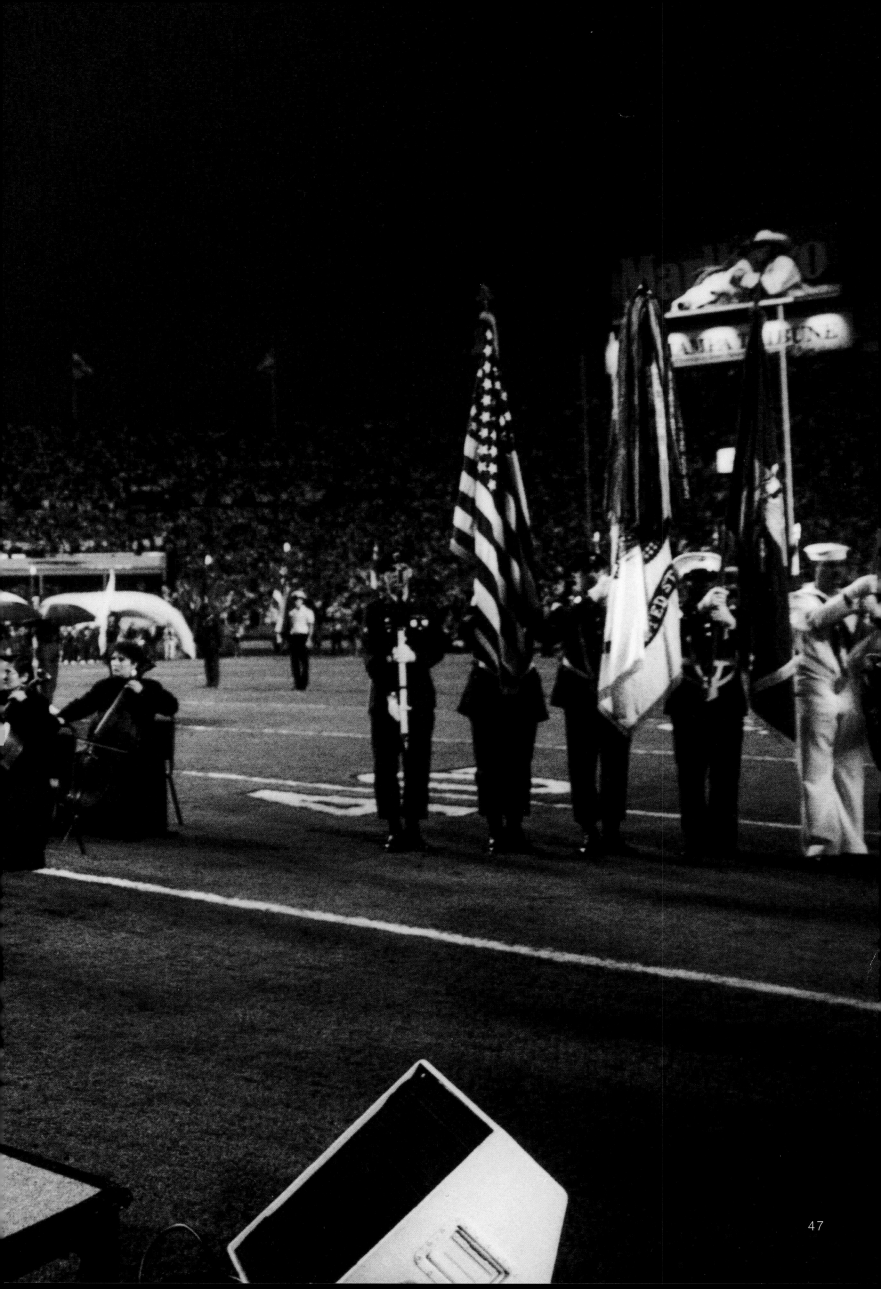

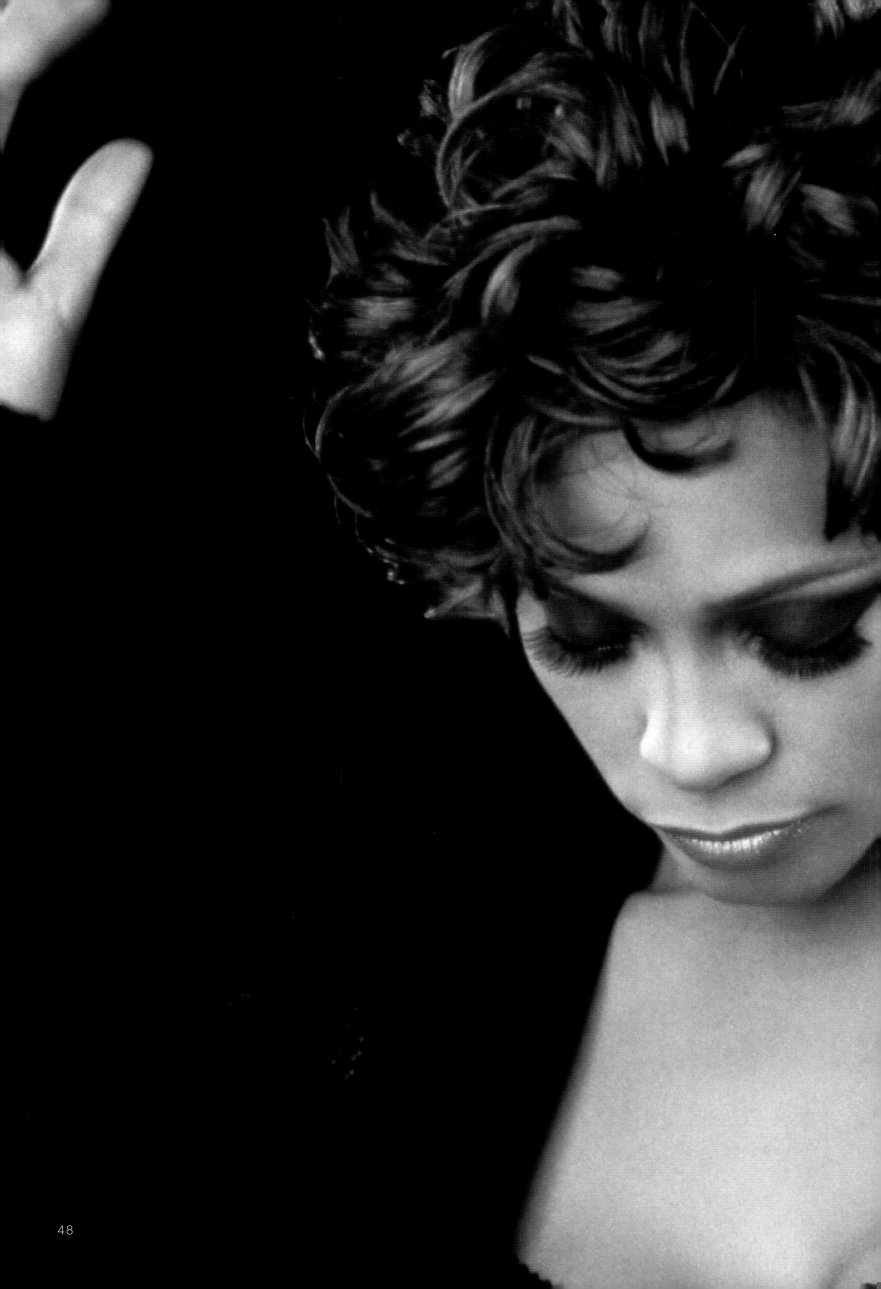

New York City 1996

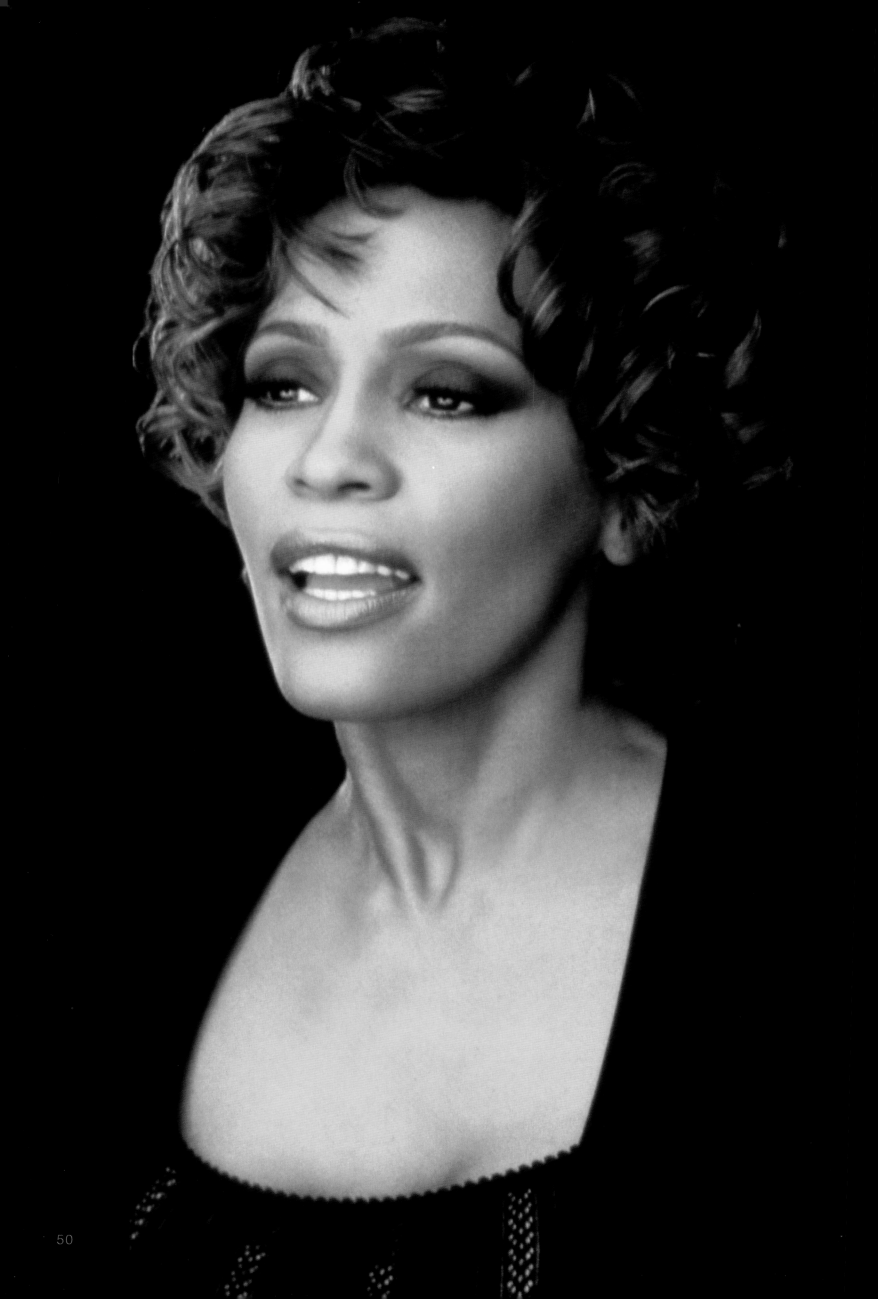

Los Angeles 1999

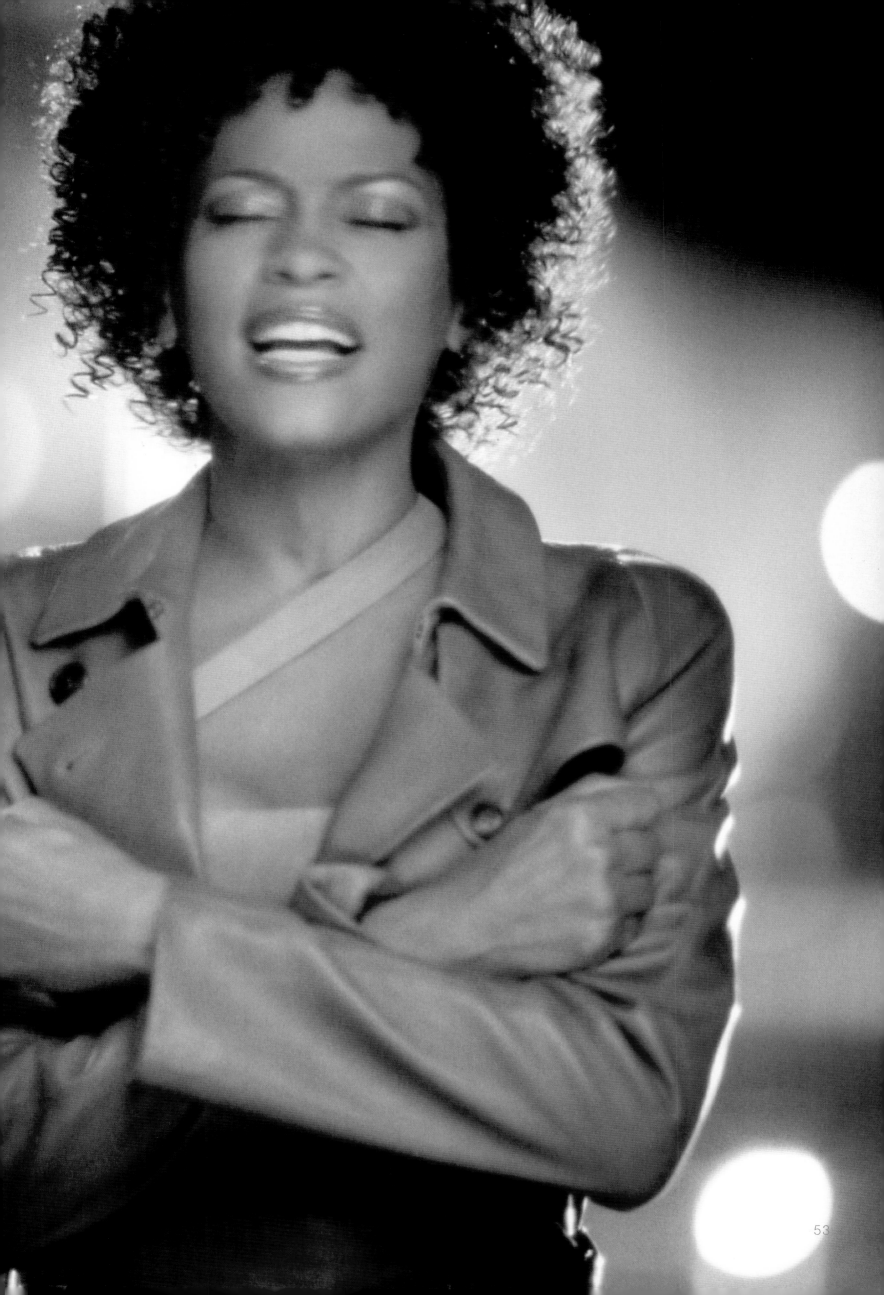

New York City 1996

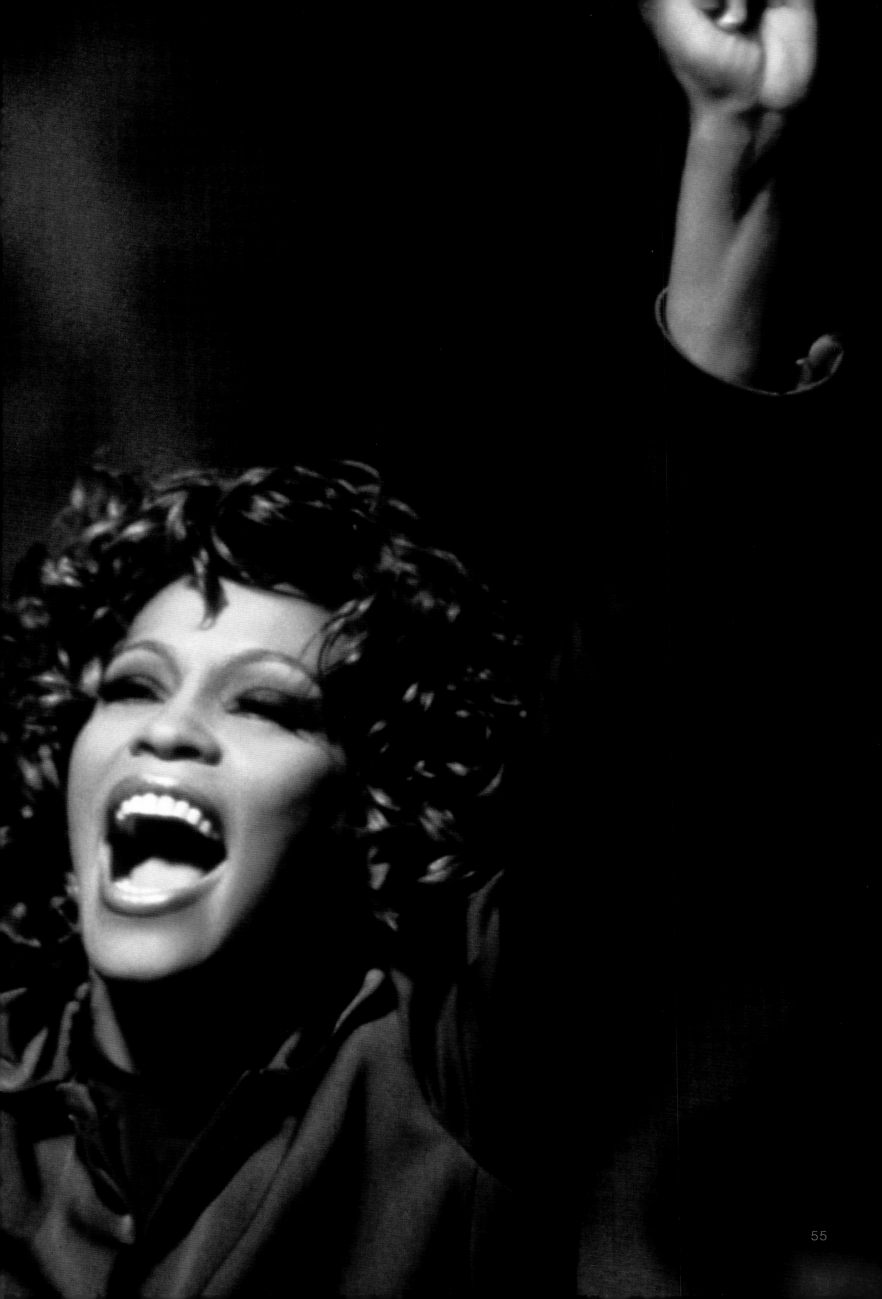

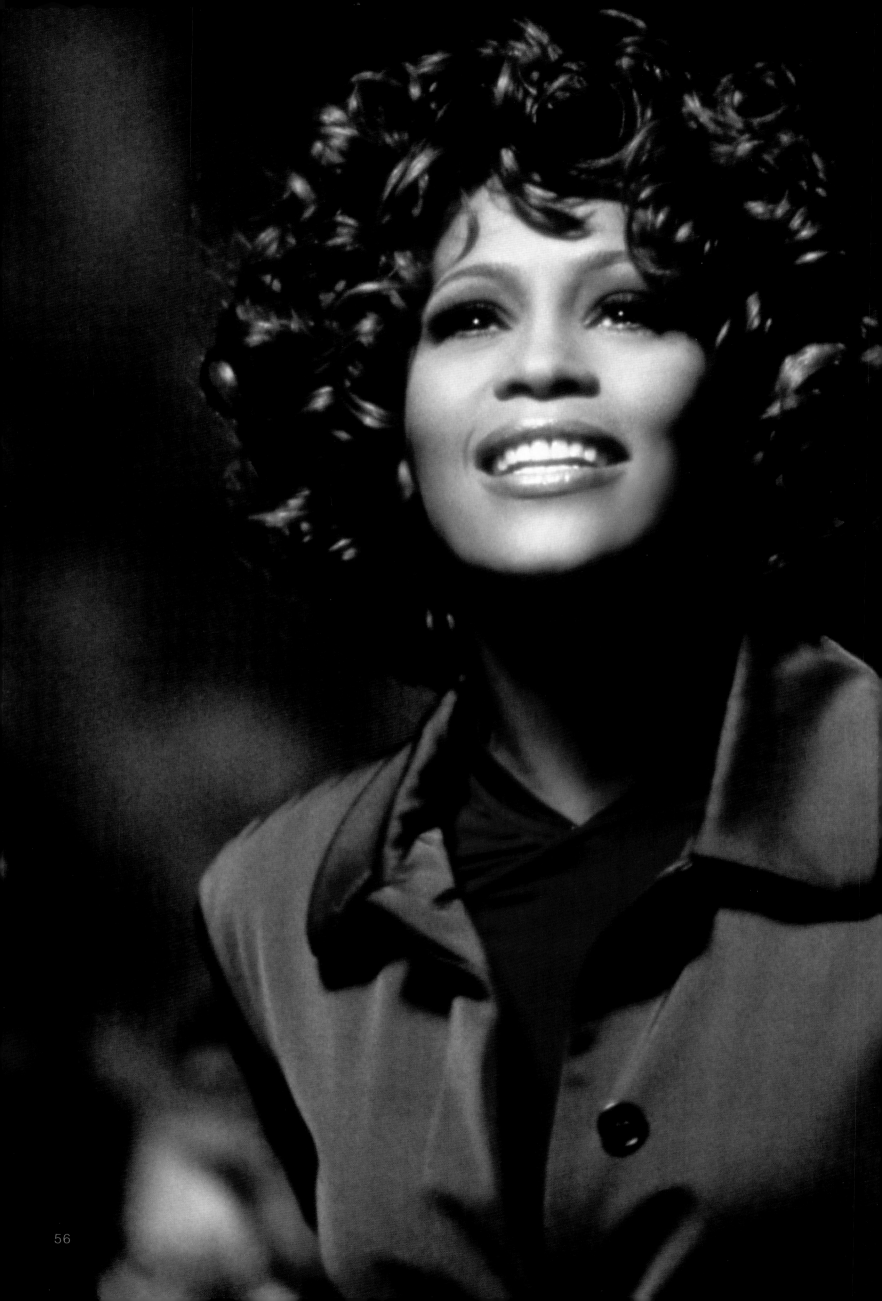

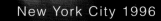

New York City 1996

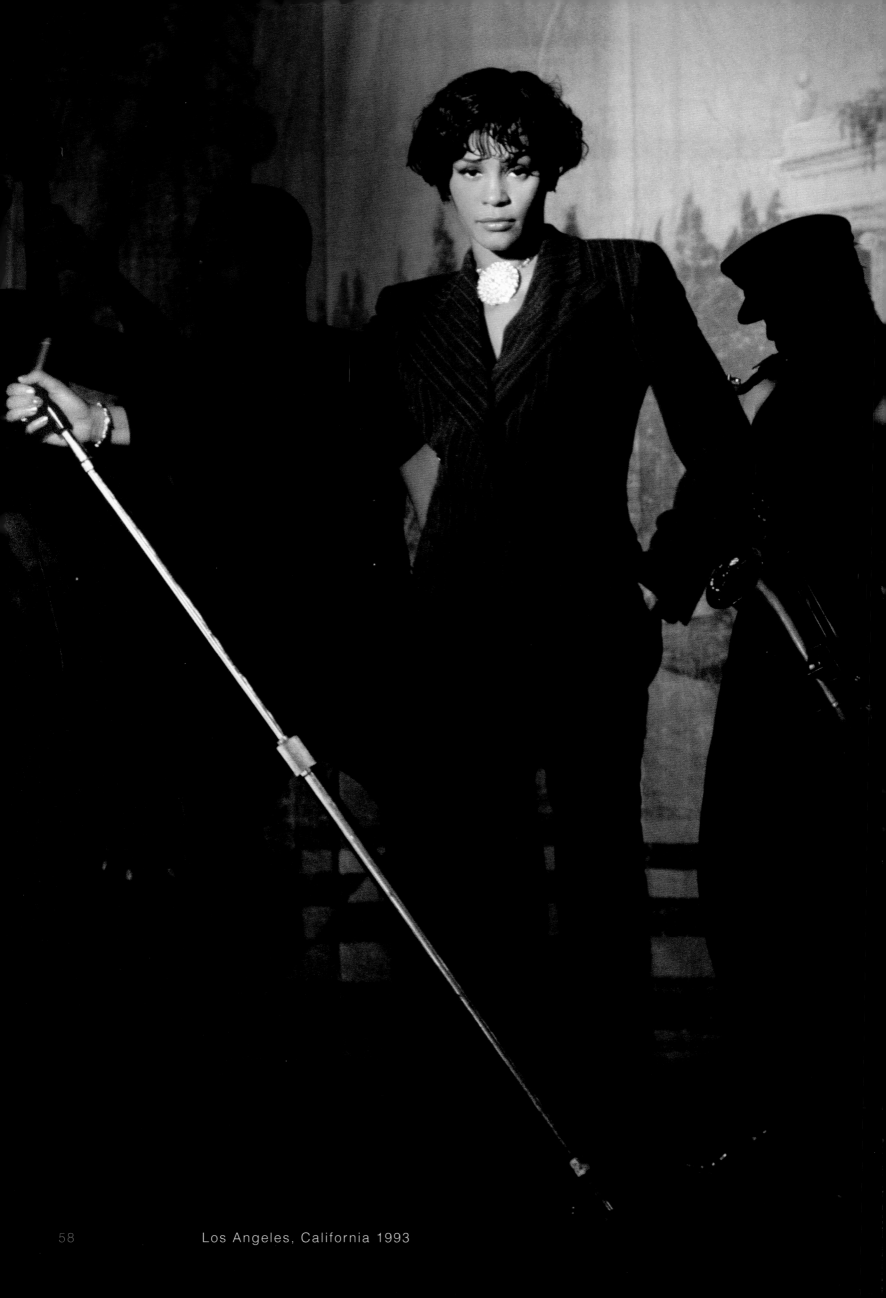

Los Angeles, California 1993

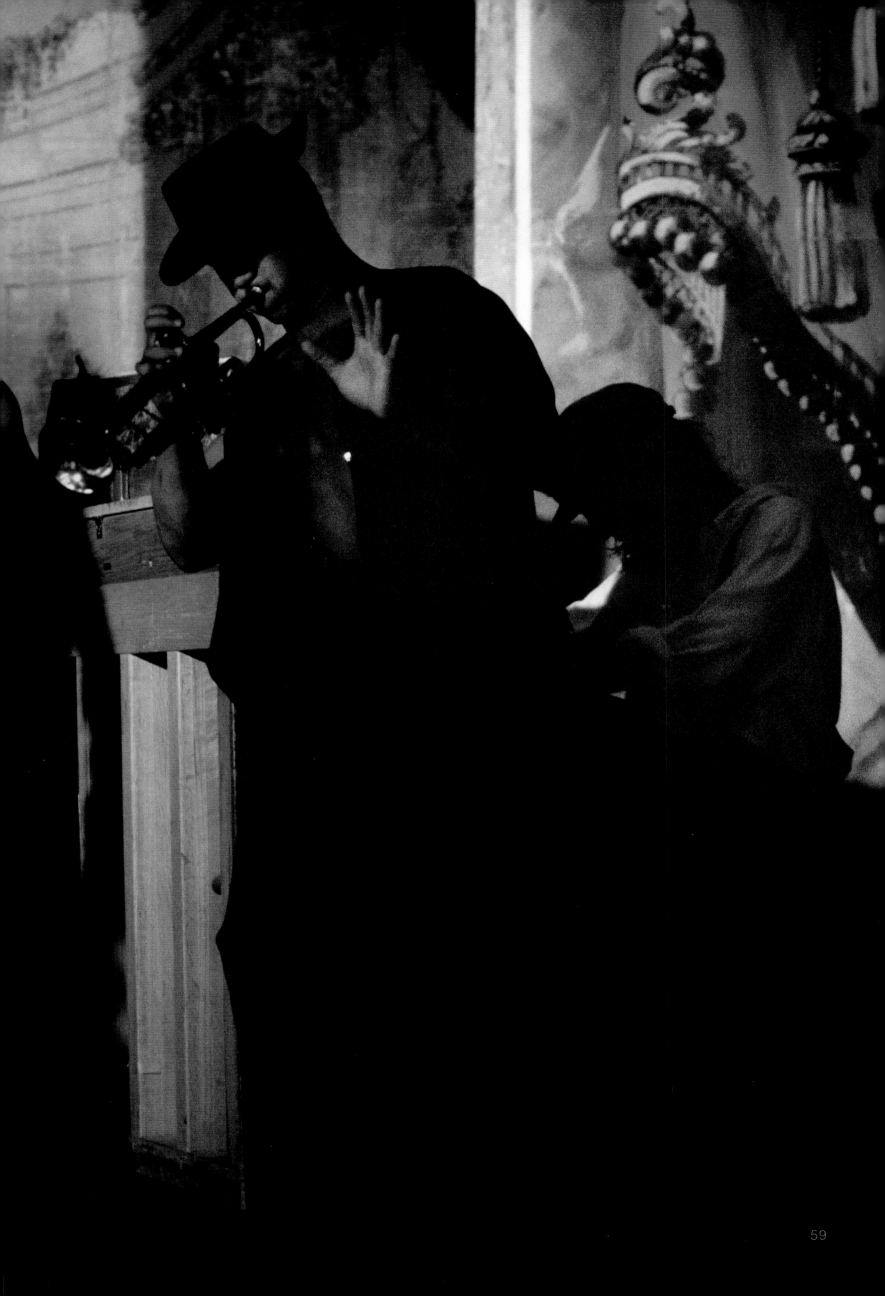

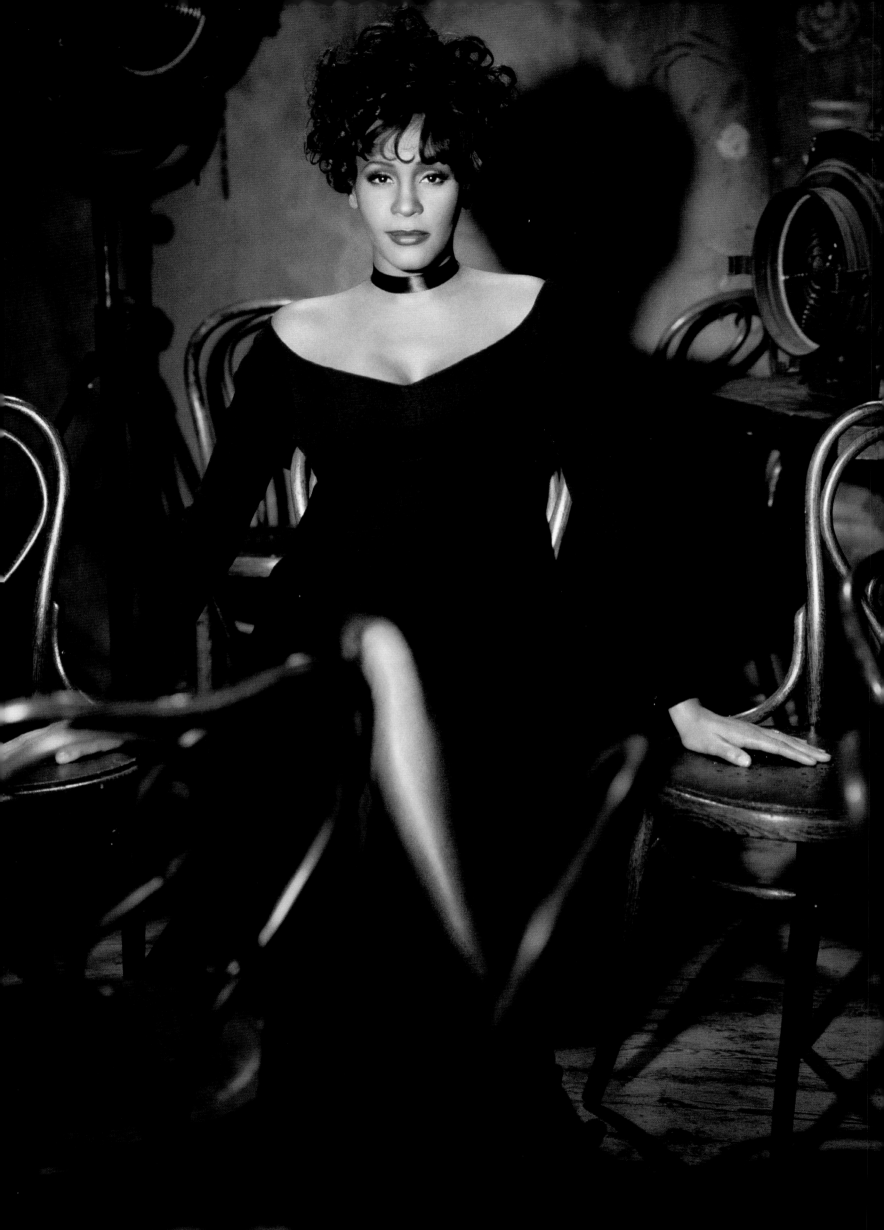

"The Bodyguard" New York City 1993

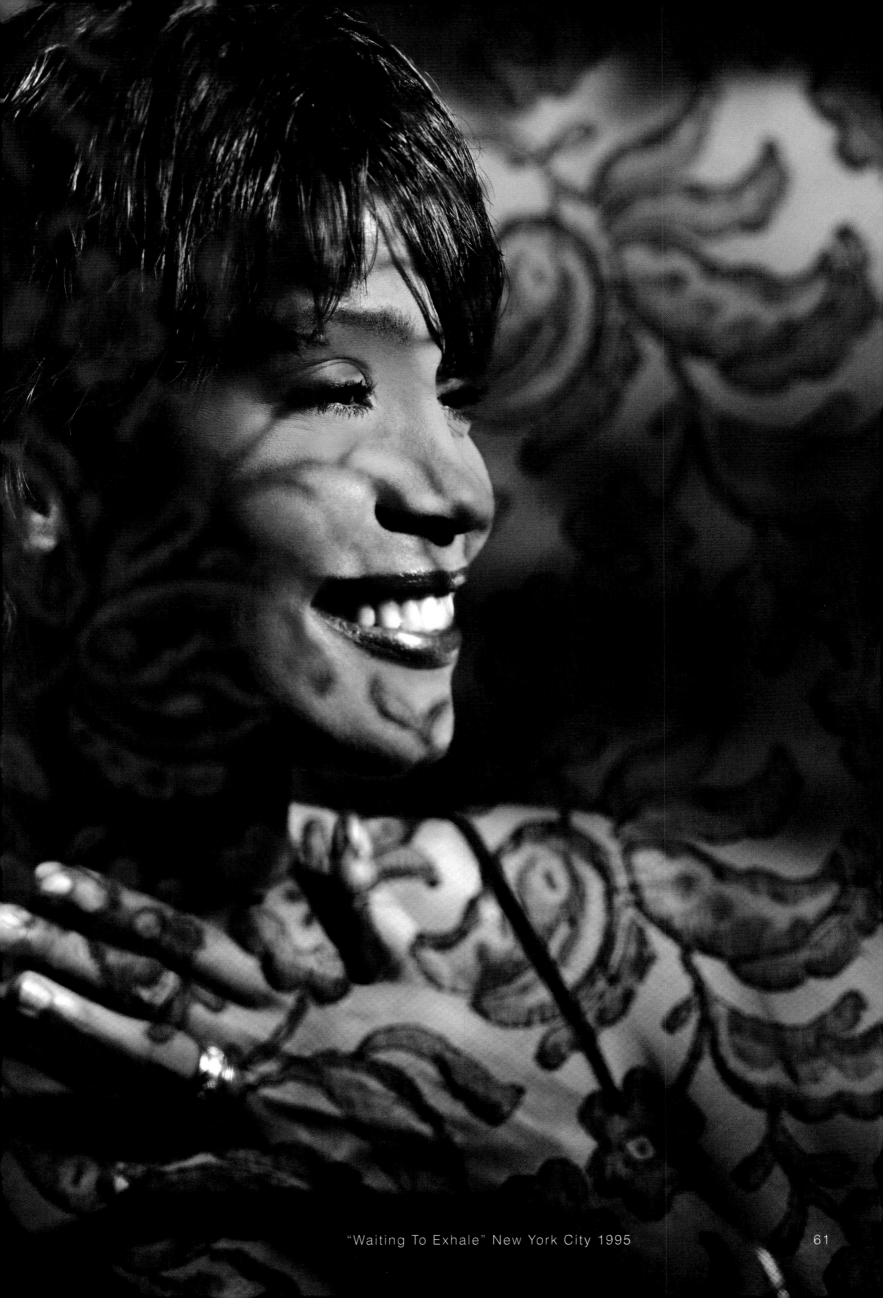

"Waiting To Exhale" New York City 1995

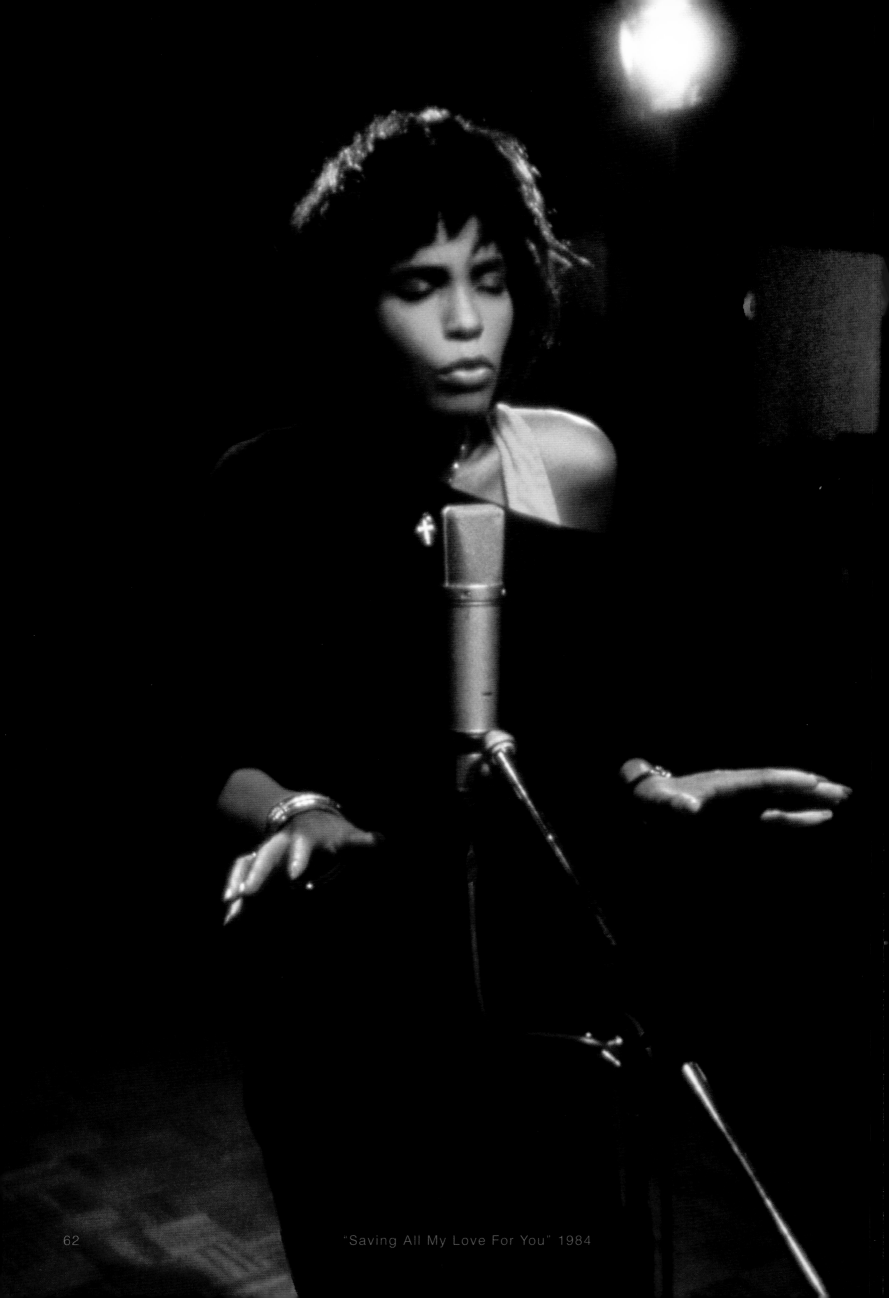

"Saving All My Love For You" 1984

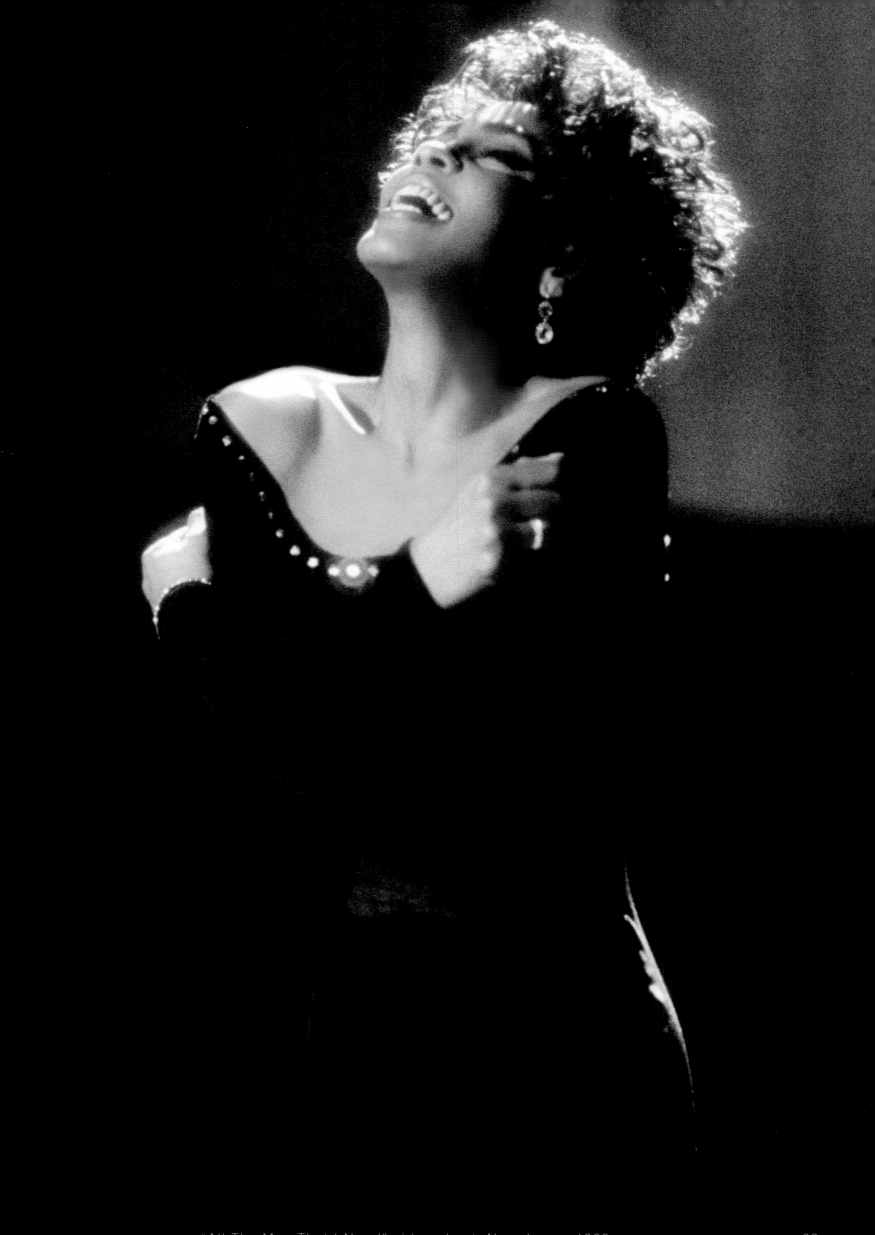

"All The Man That I Need" video shoot New Jersey 1989 63

"It's Not Right But It's Okay" video 1998

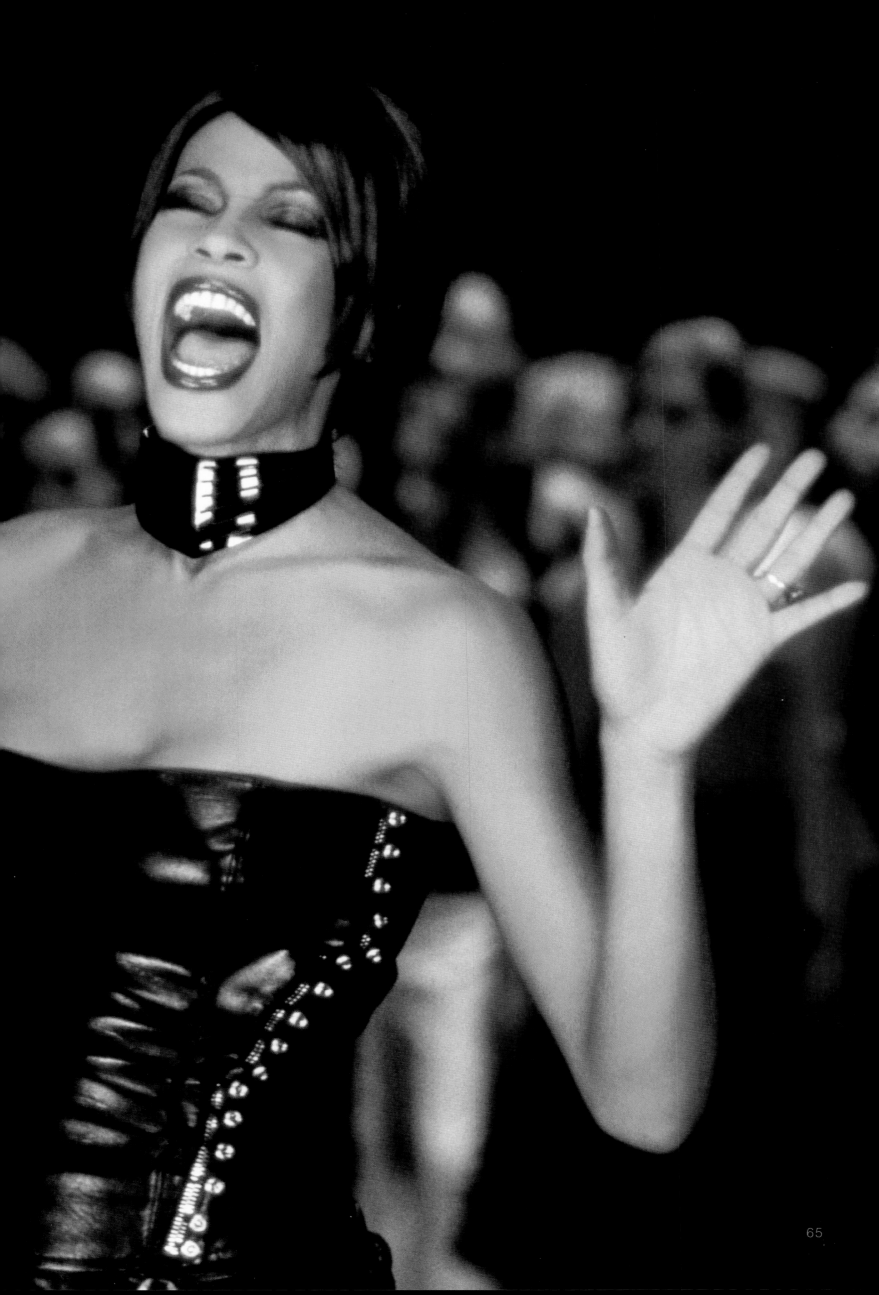

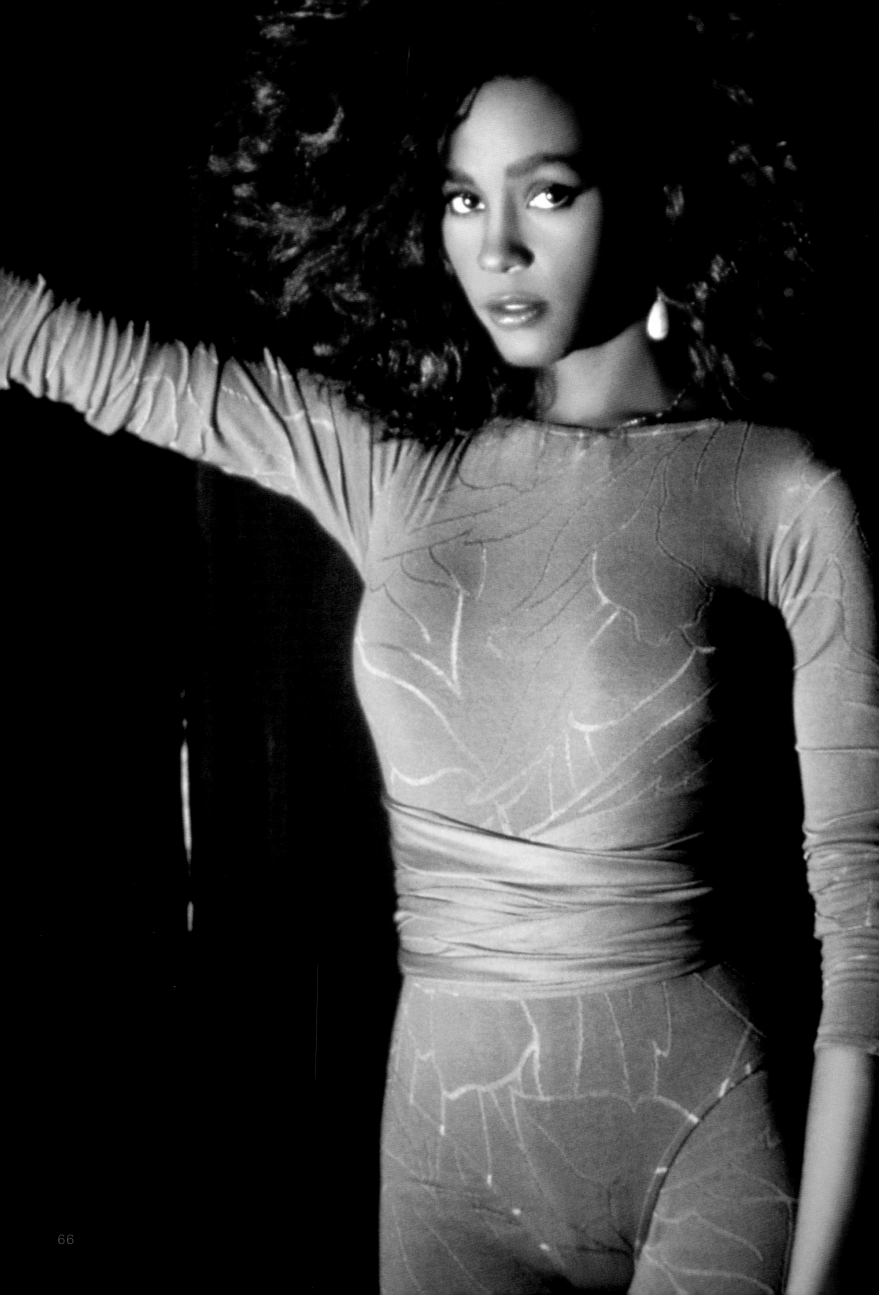

New York City 1986

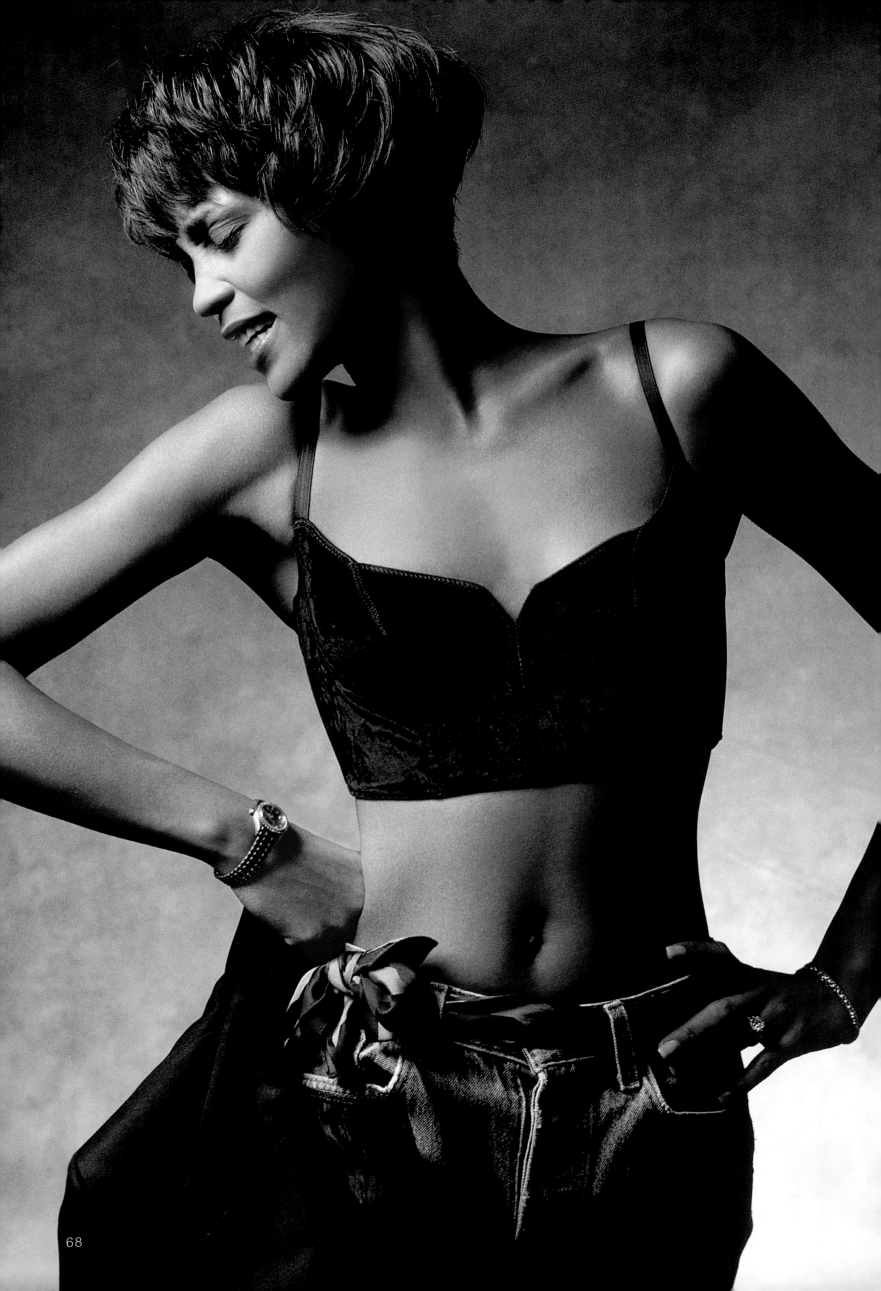

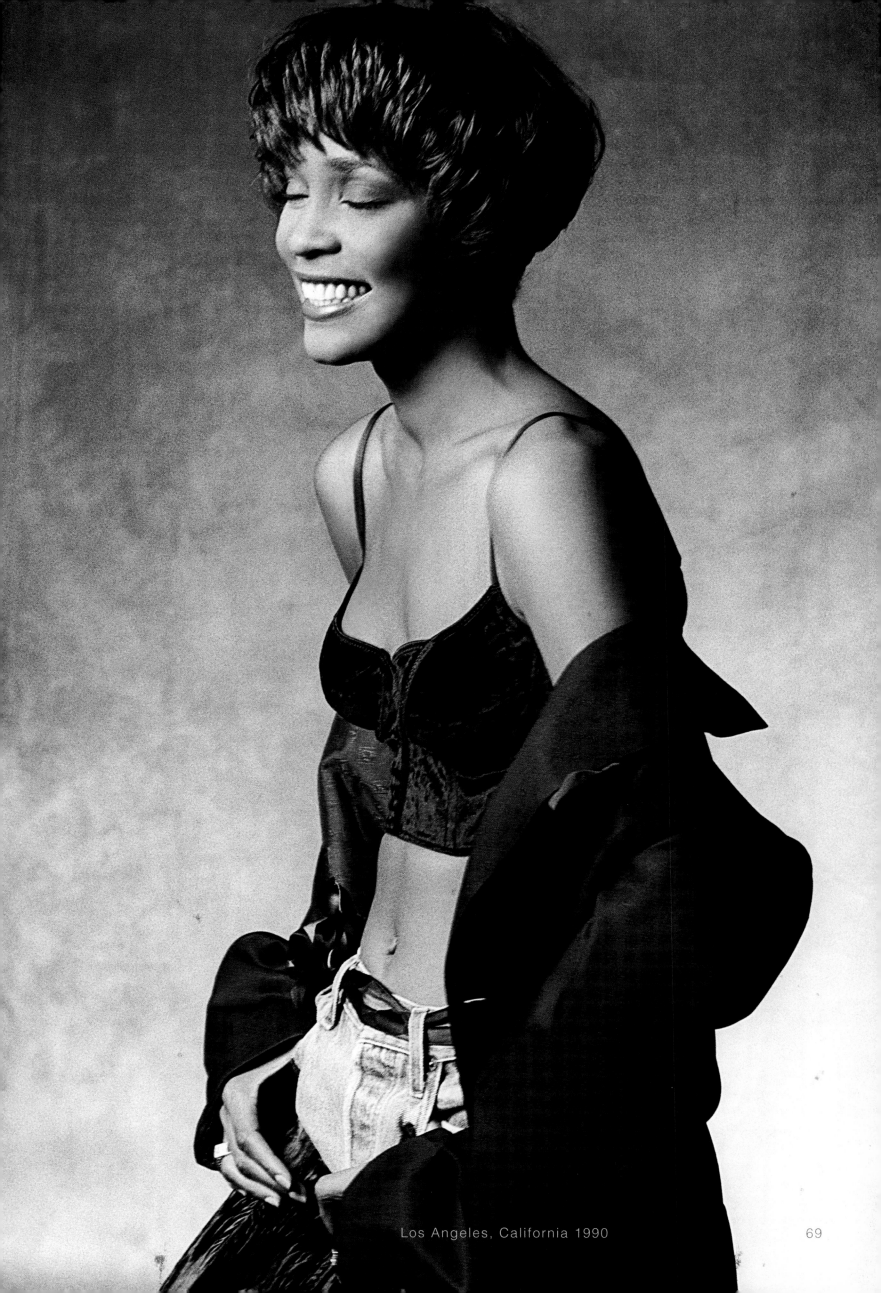

Los Angeles, California 1990

Chicago, Illinois 1999

New York City 1997

Biltmore Hotel Florida 1998

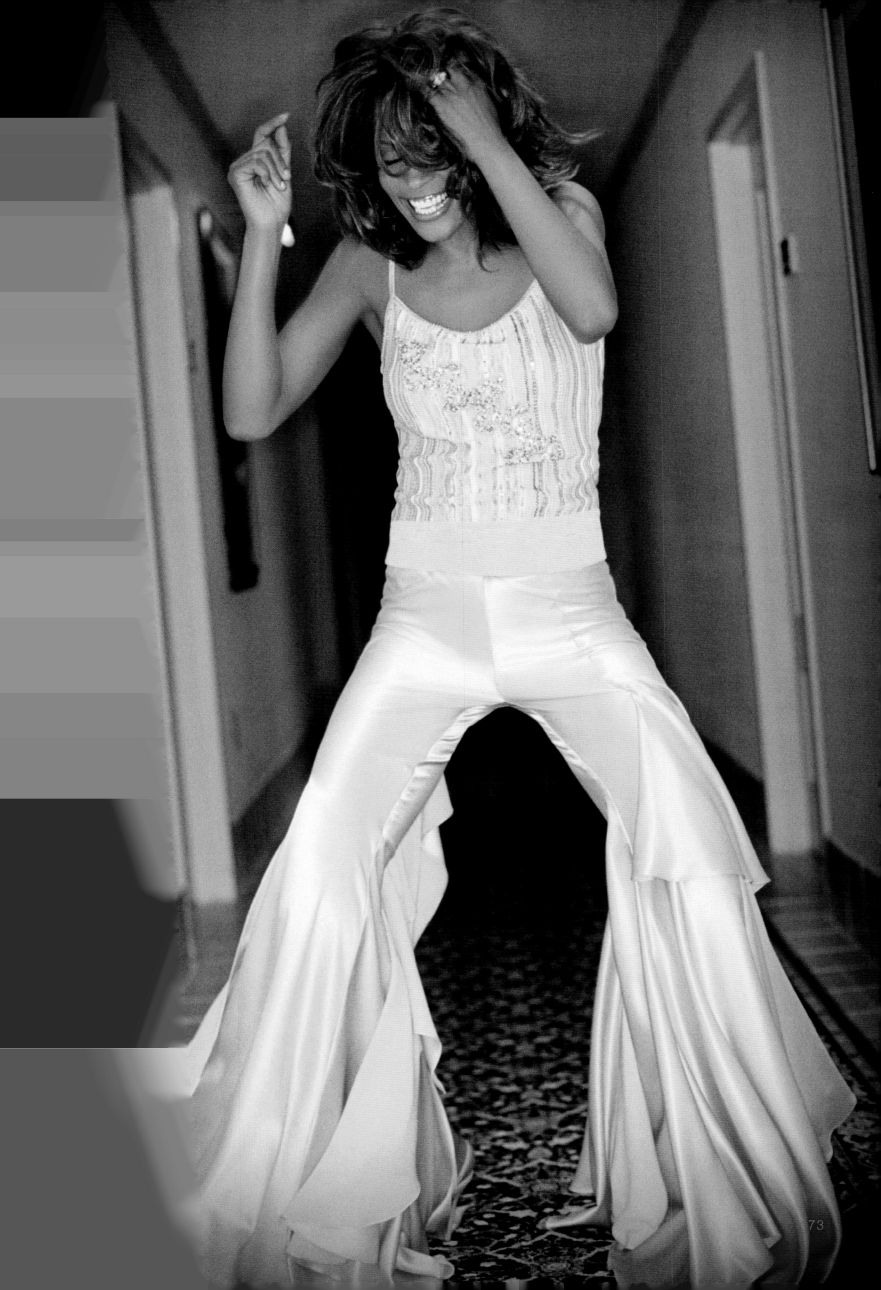
73

on set of "I Look To You" music video Los Angeles, California 2009

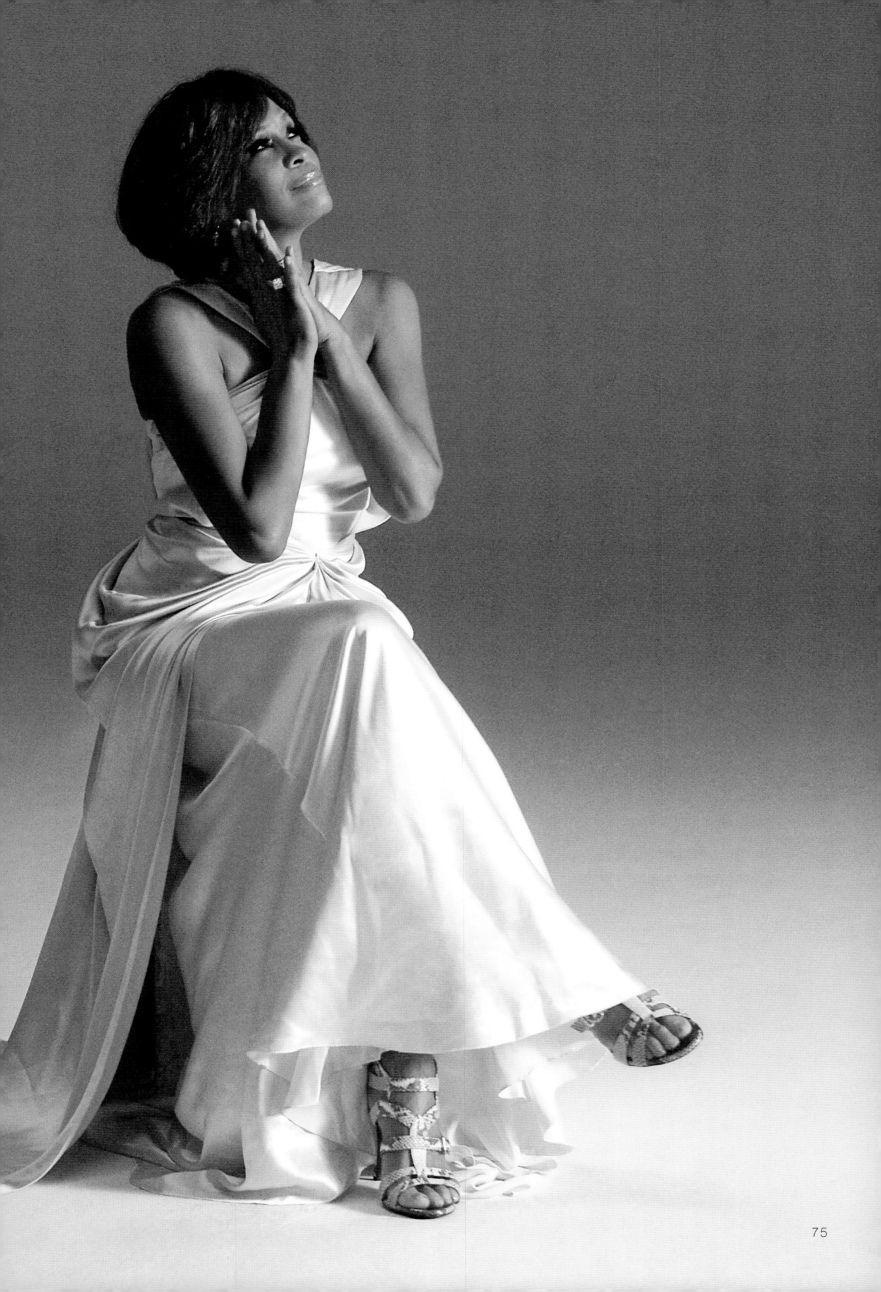

"The Preacher's Wife" 1996

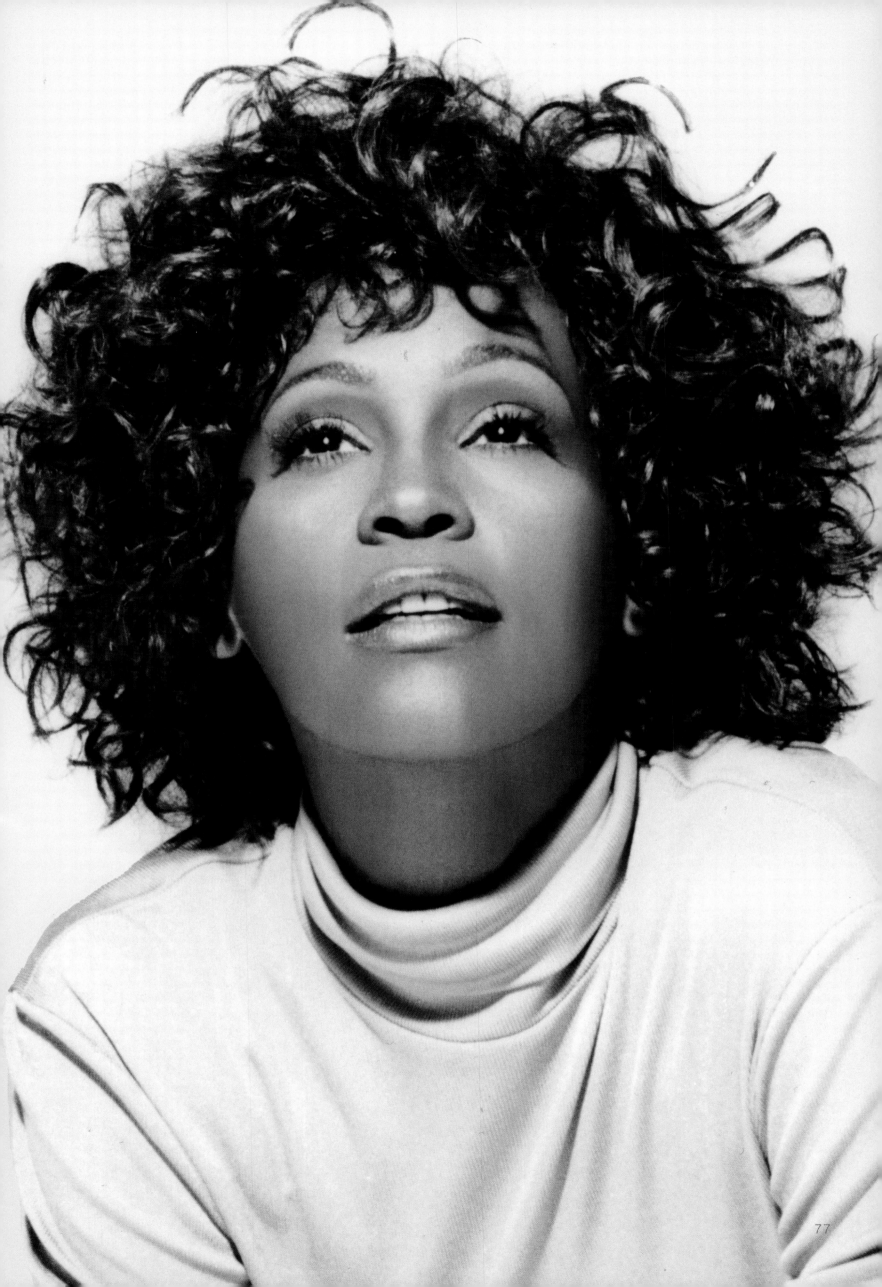

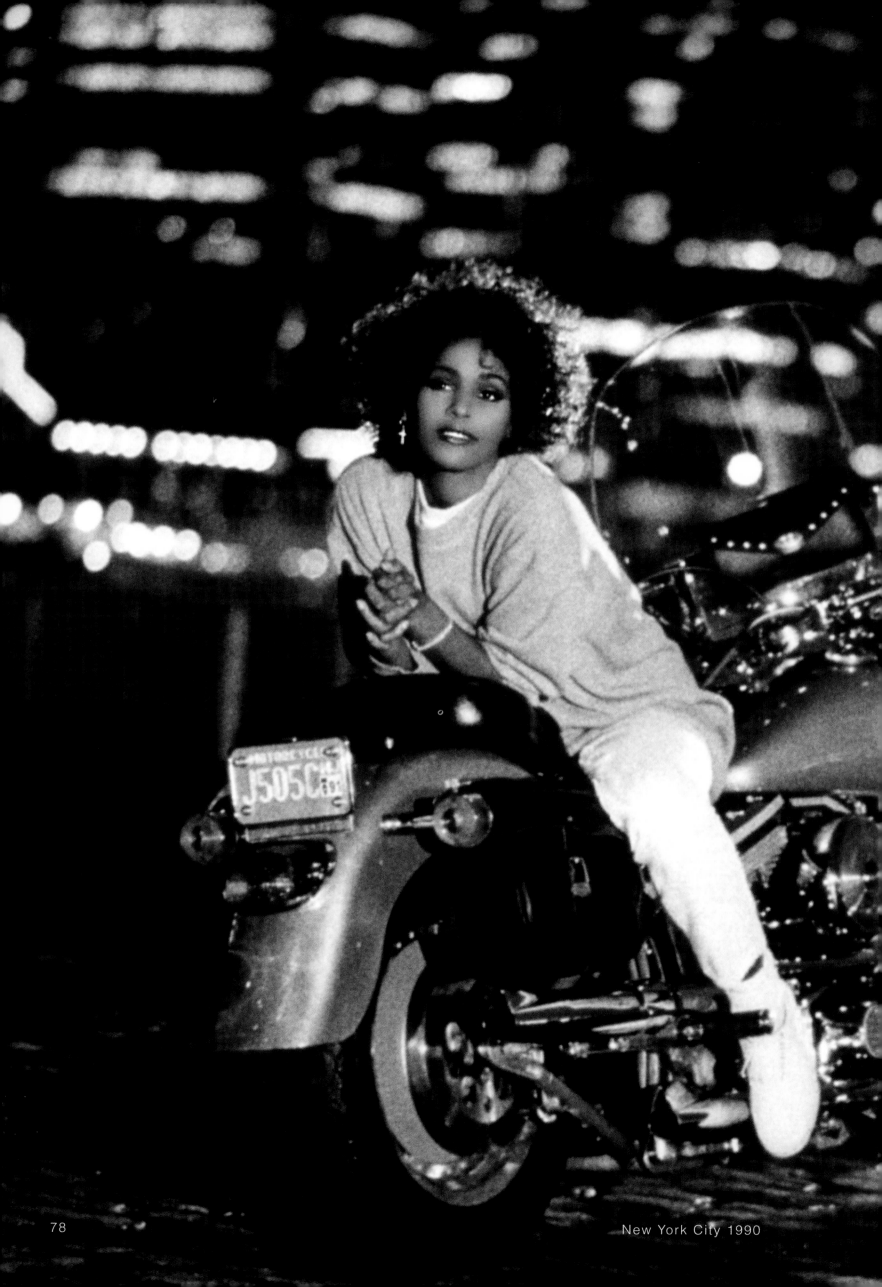

New York City 1990

performance for "Good Morning America" Lincoln Center Plaza, New York City 2002

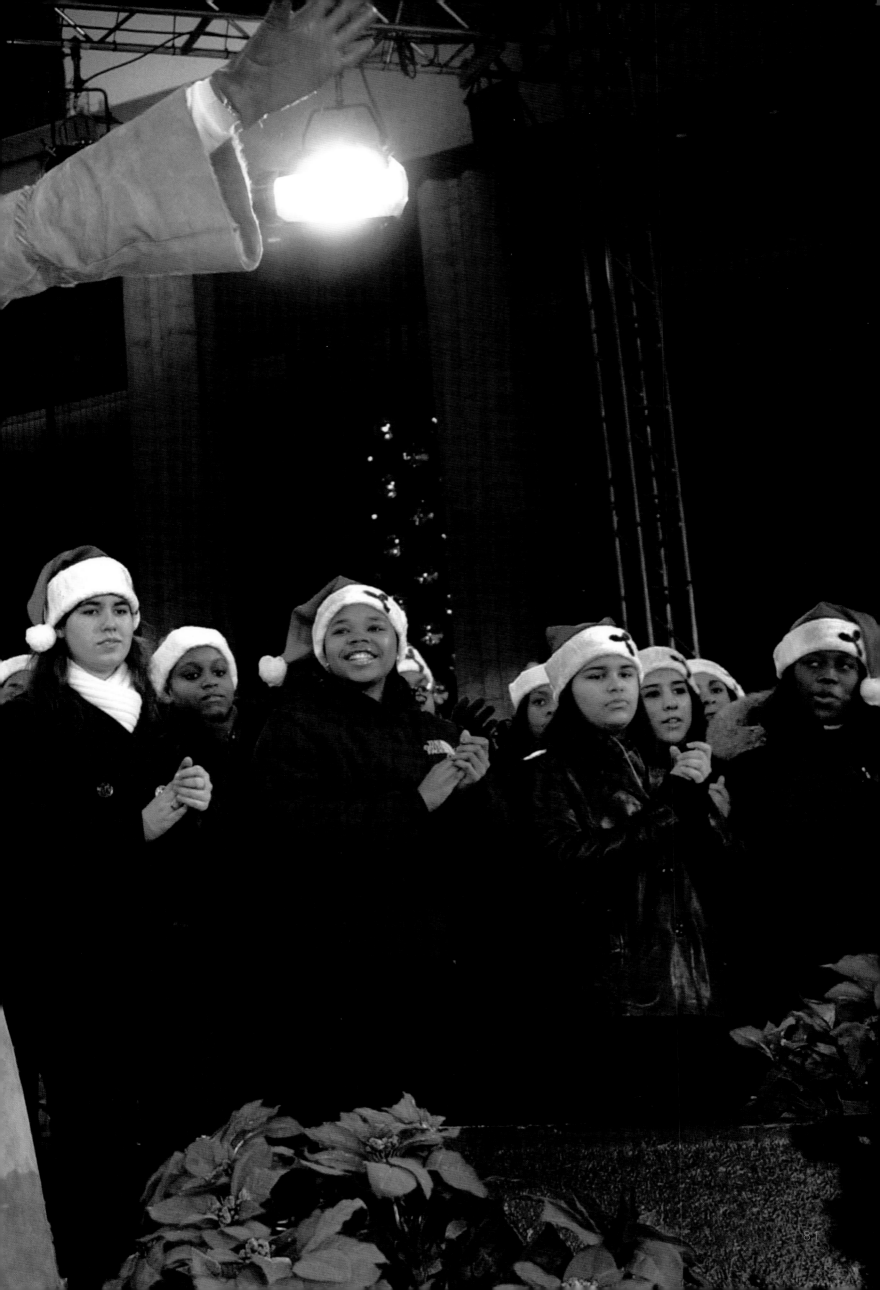

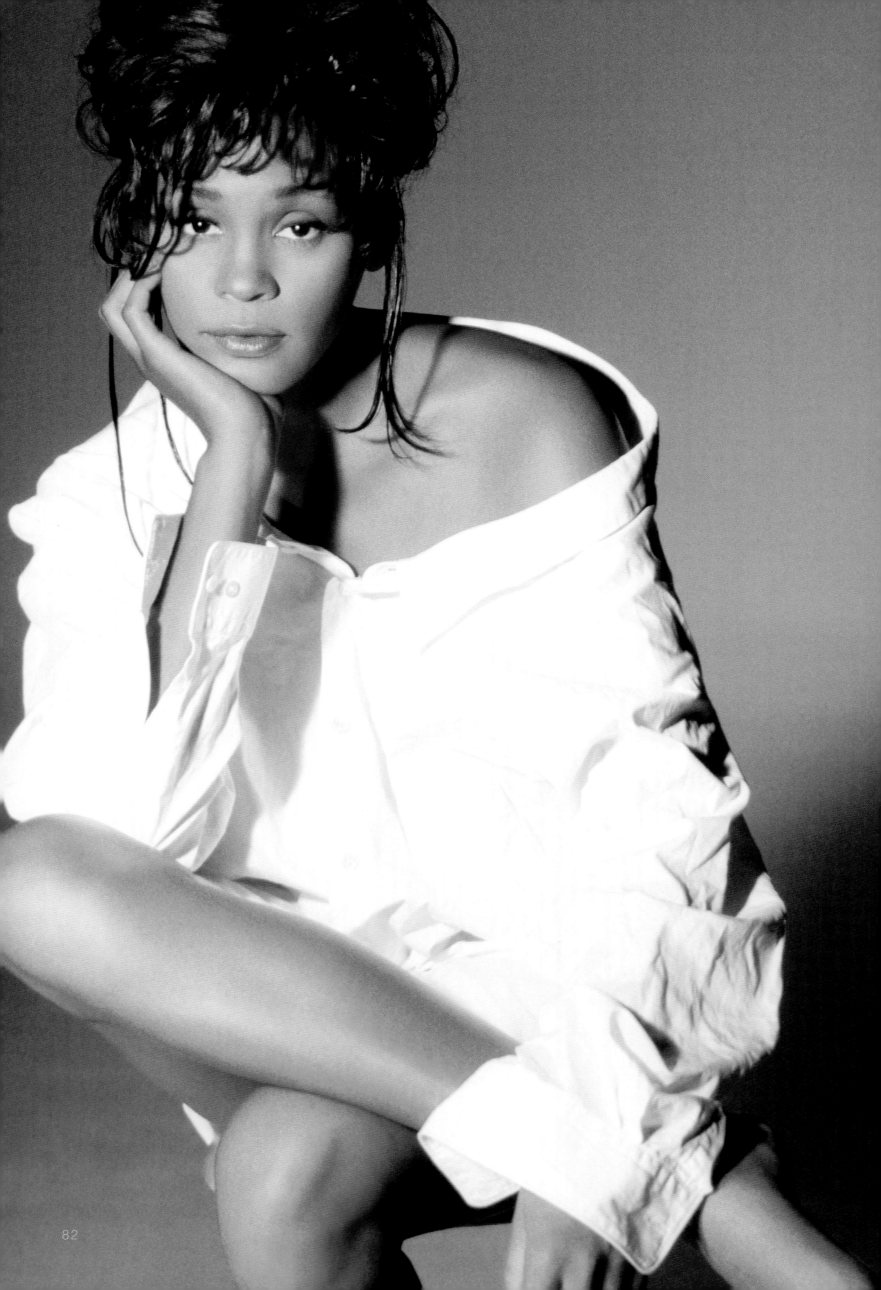

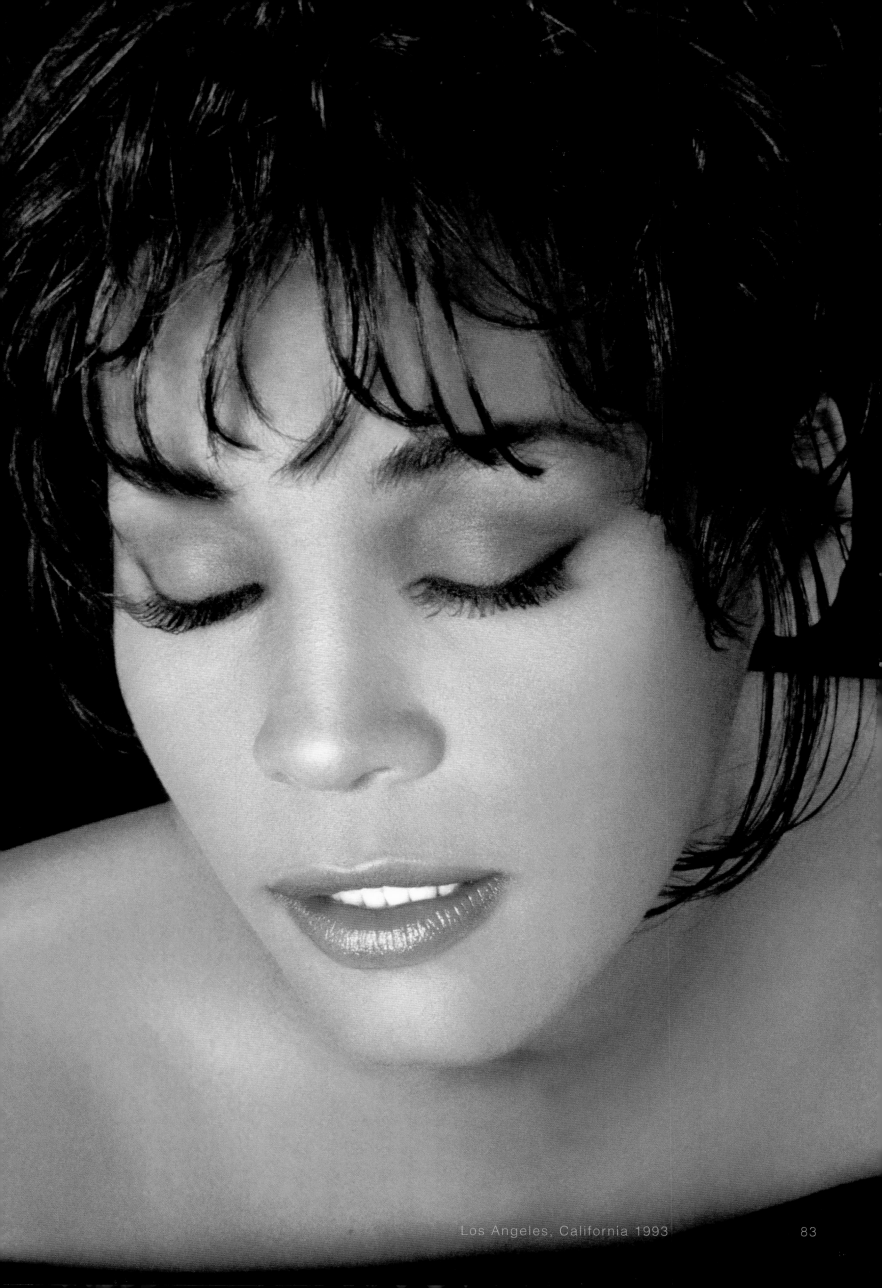

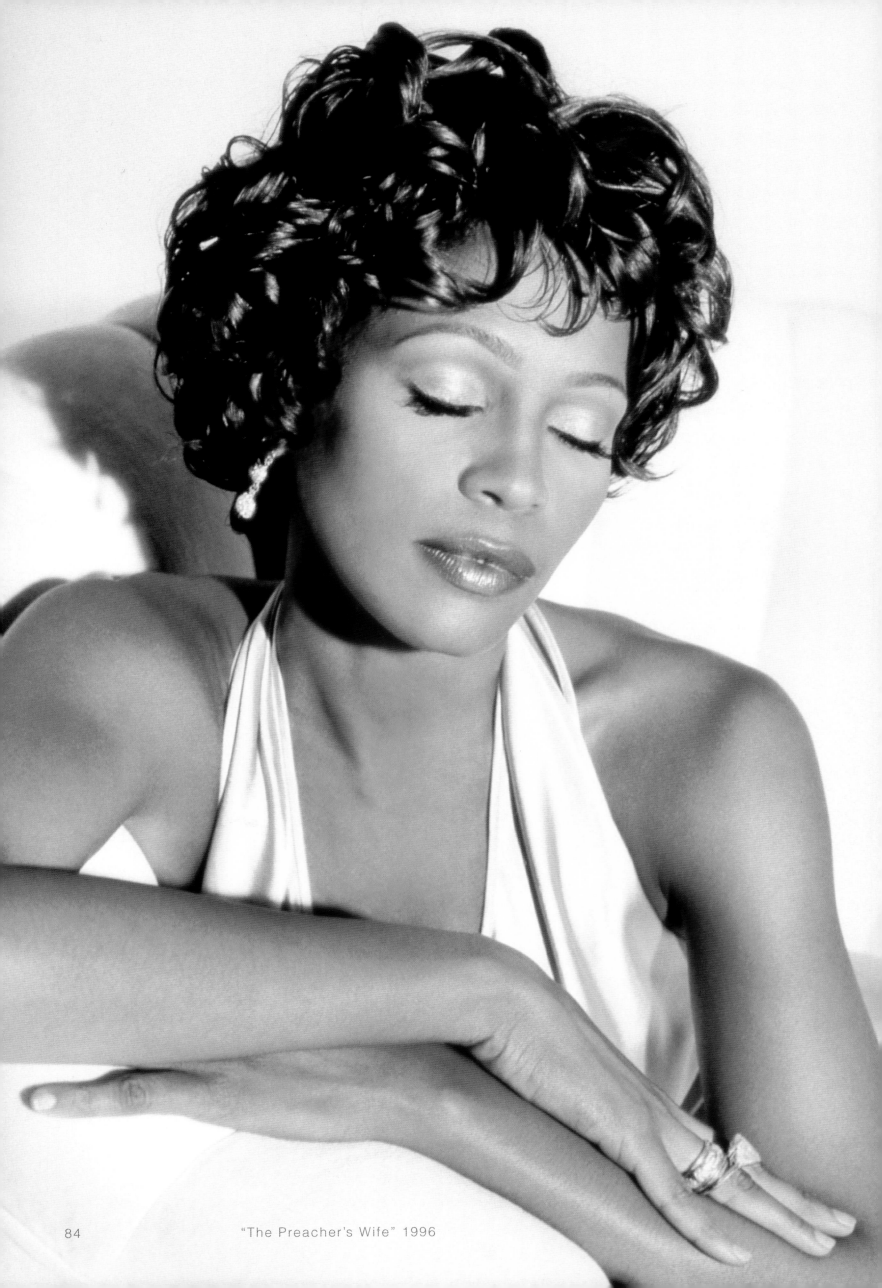

"The Preacher's Wife" 1996

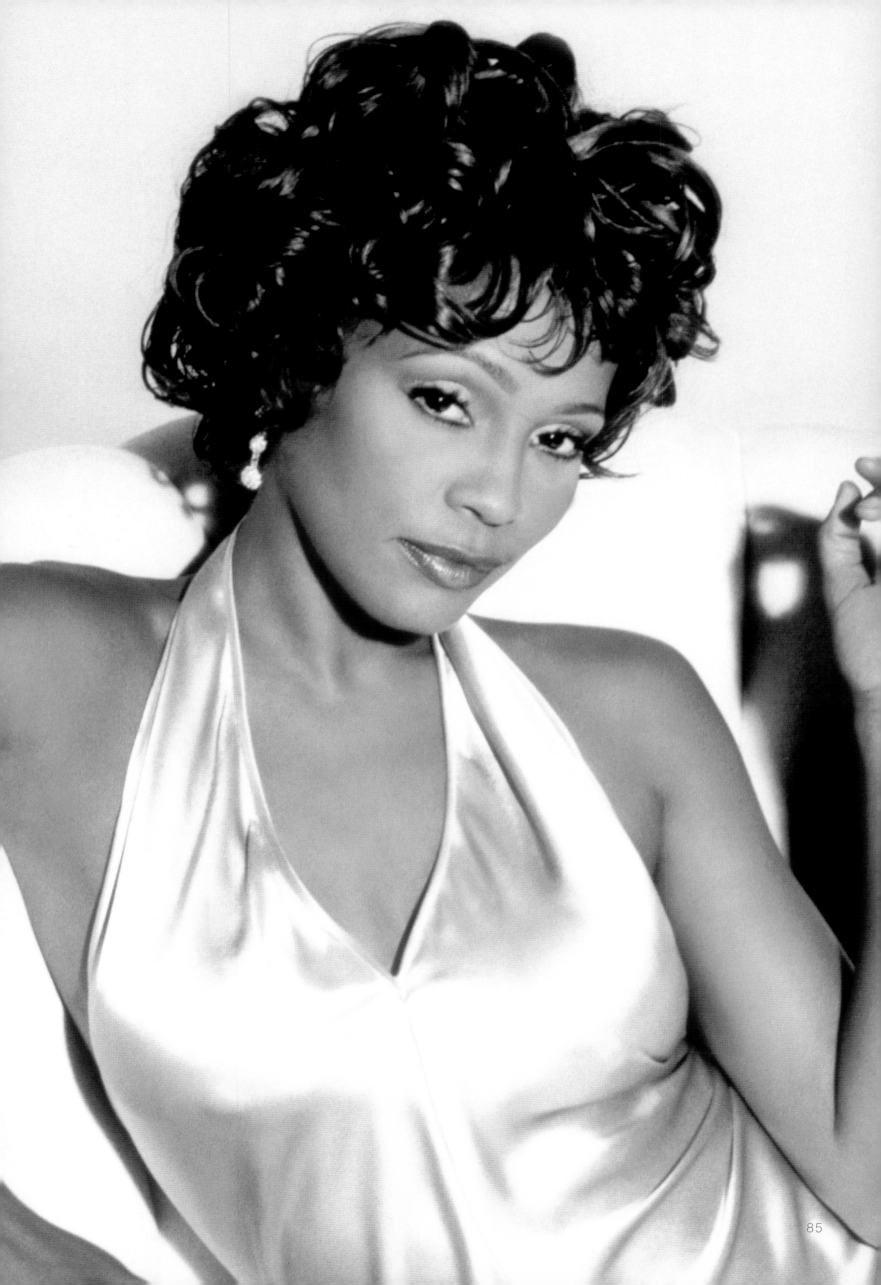

85

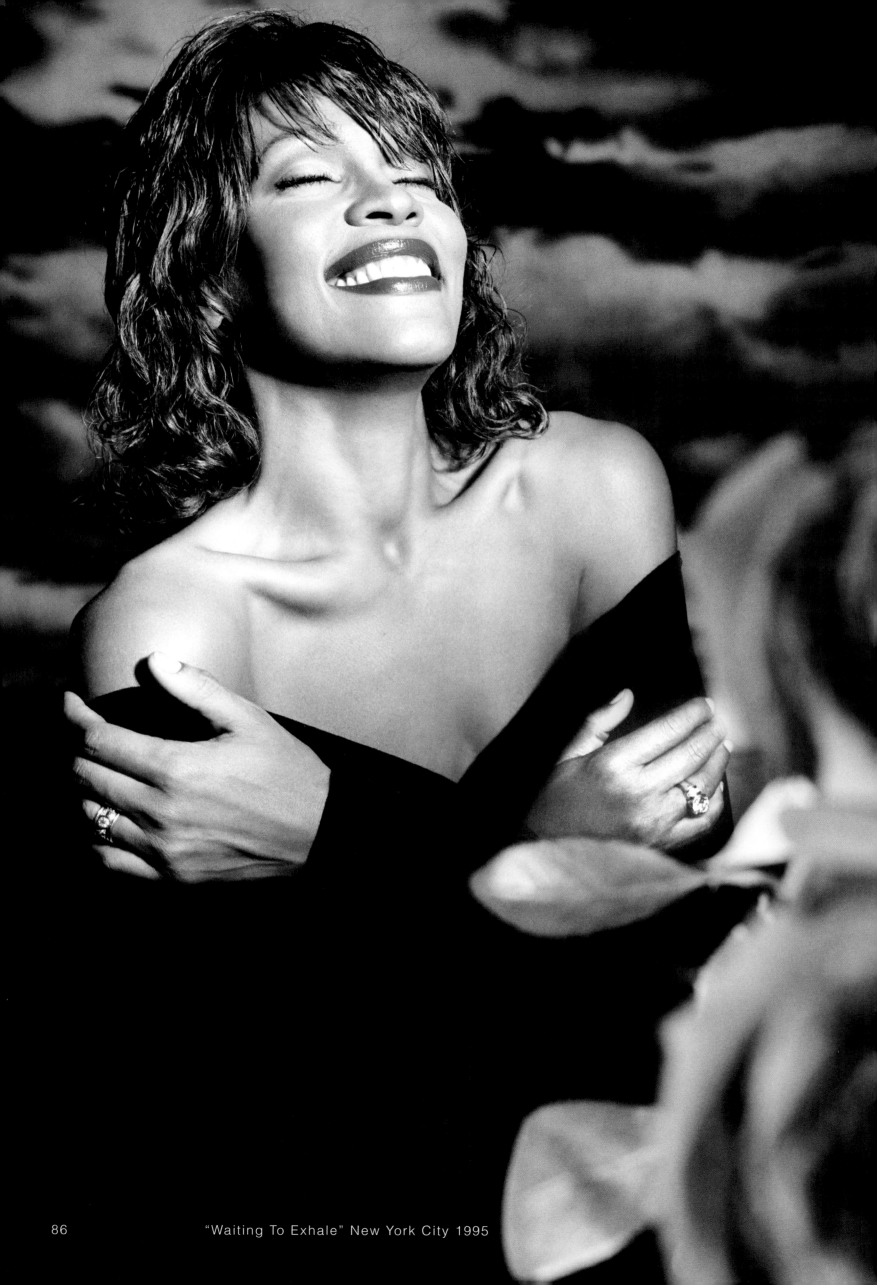

"Waiting To Exhale" New York City 1995

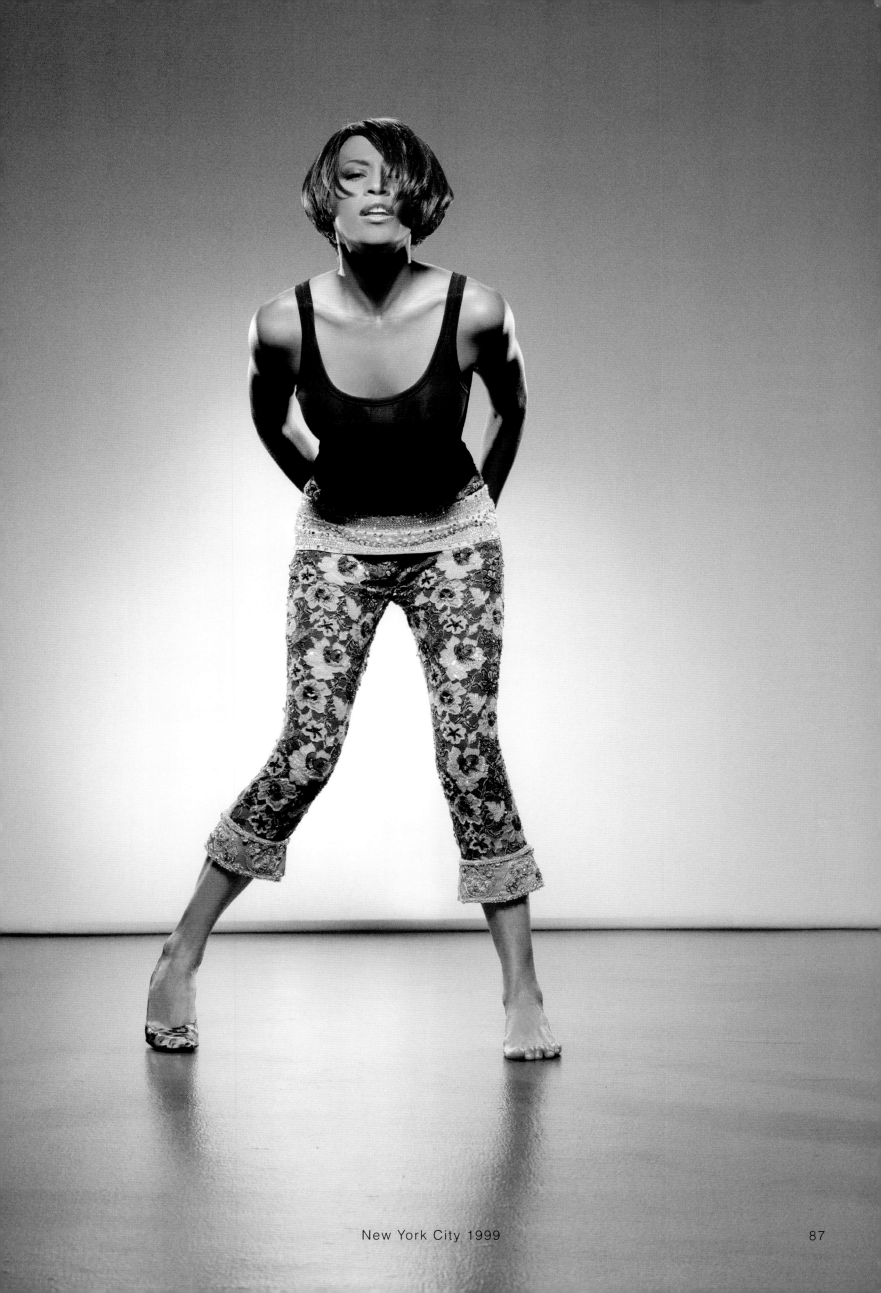

New York City 1999

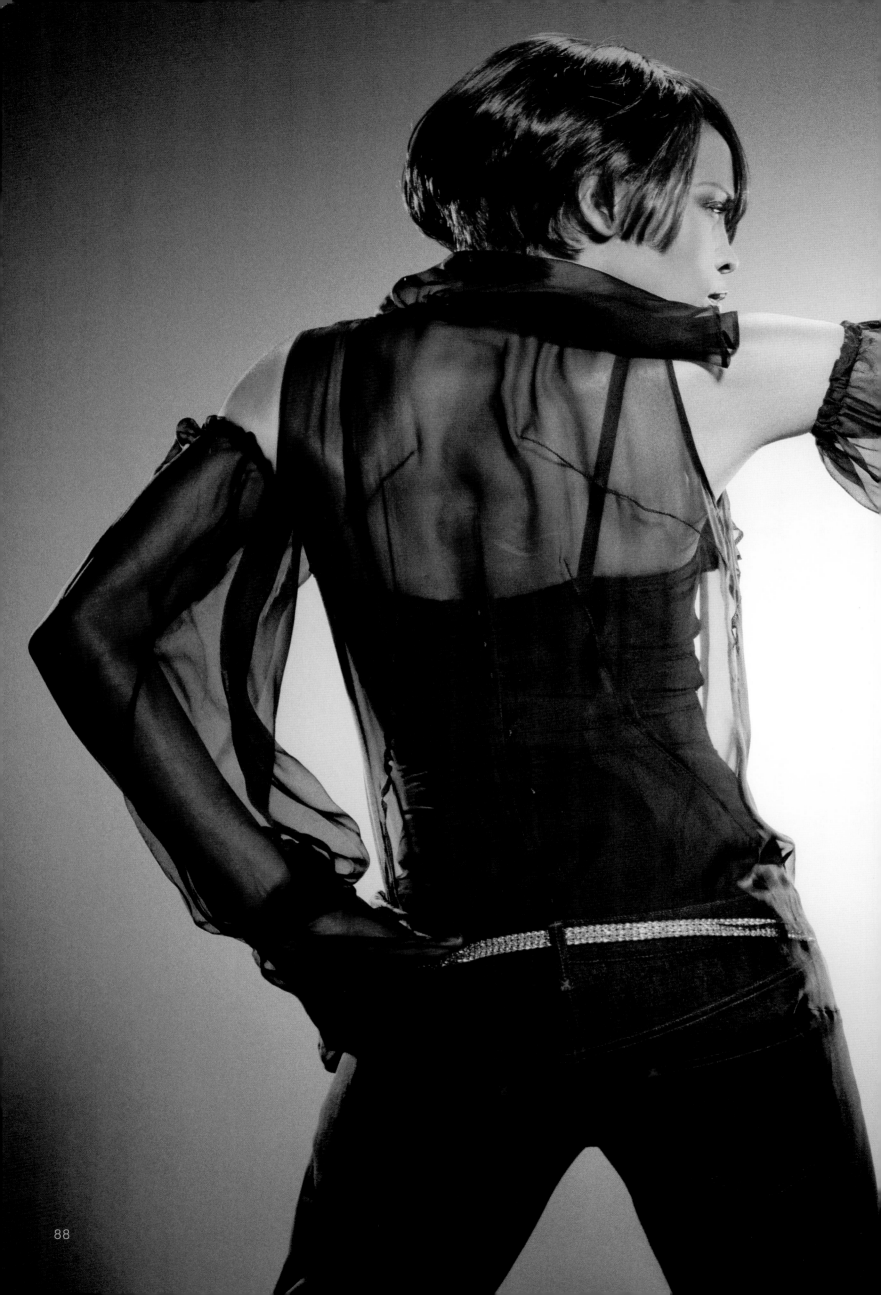

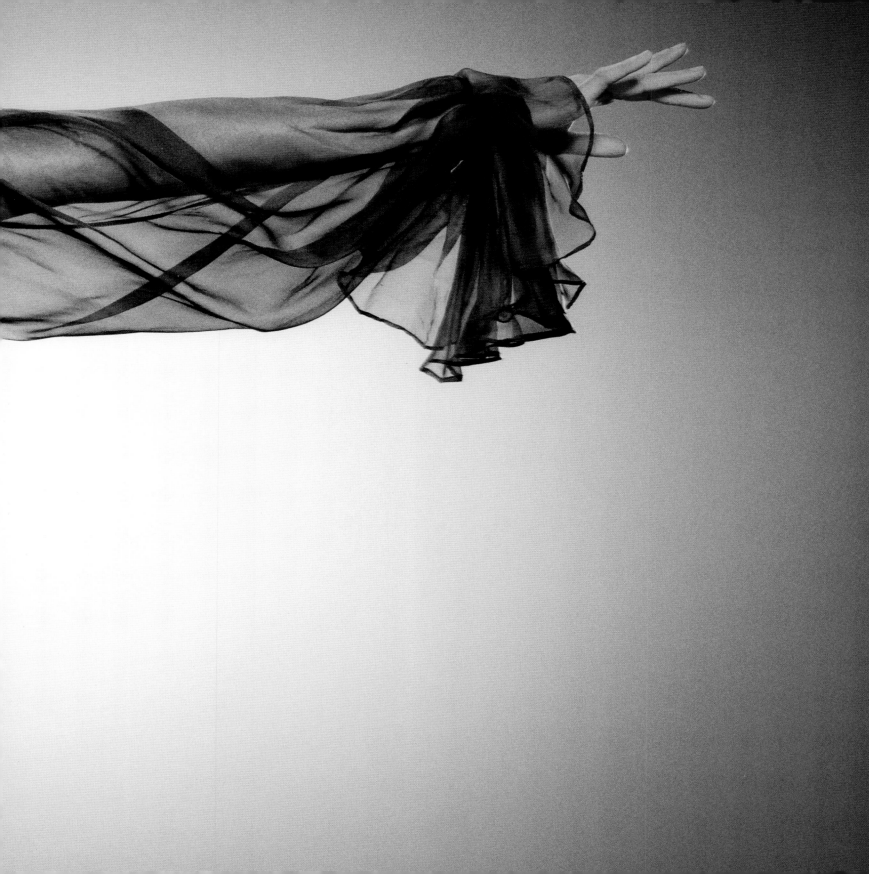

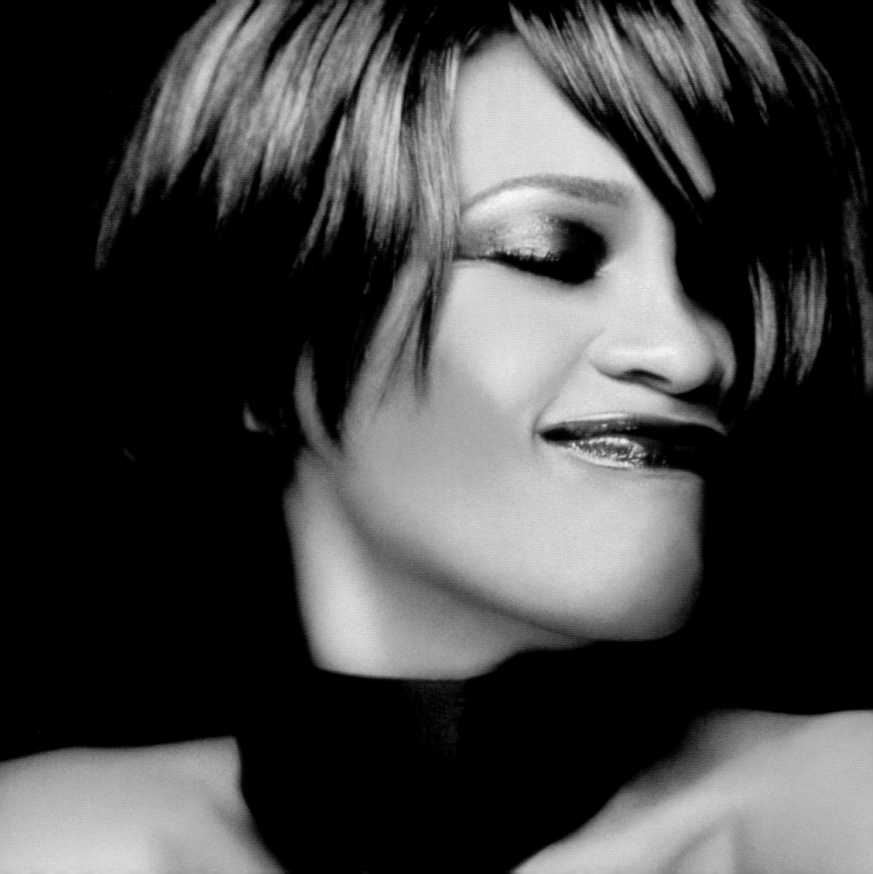

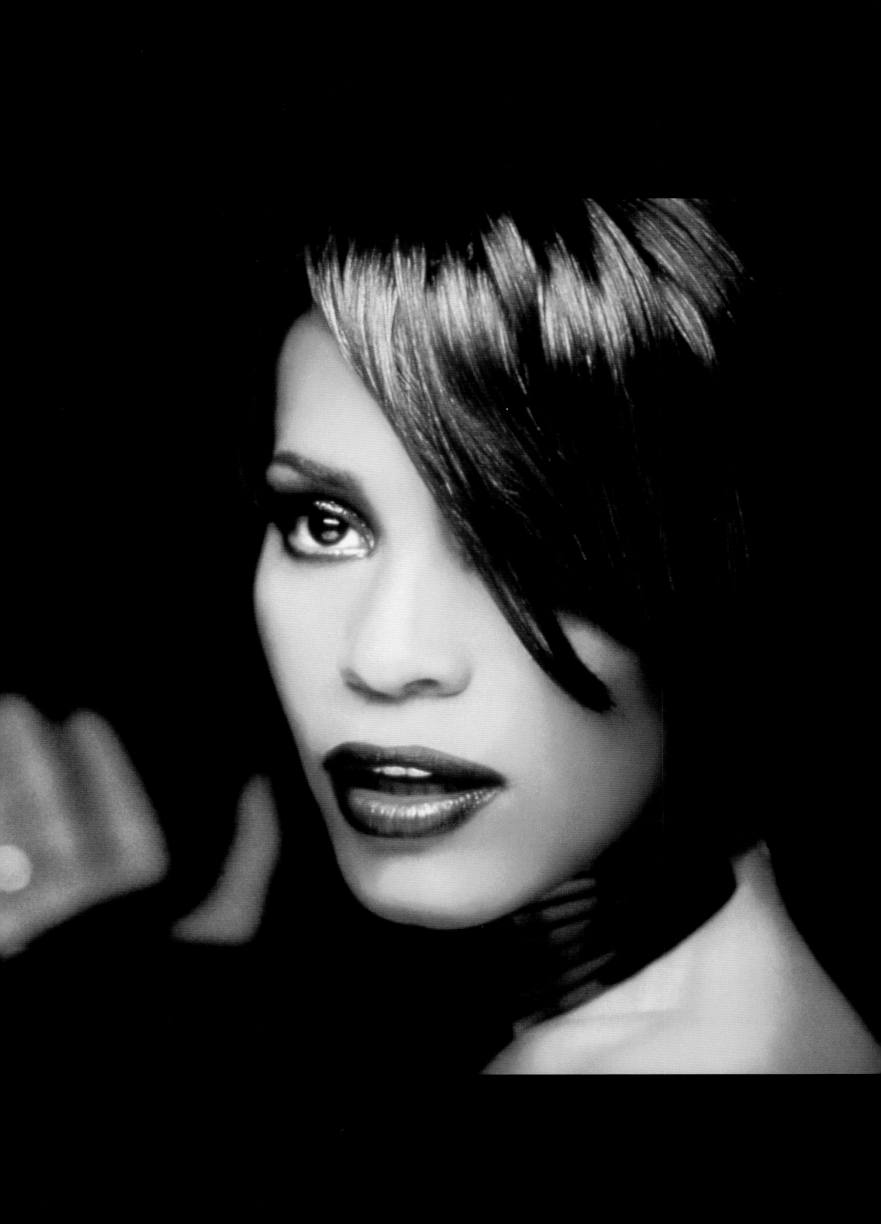

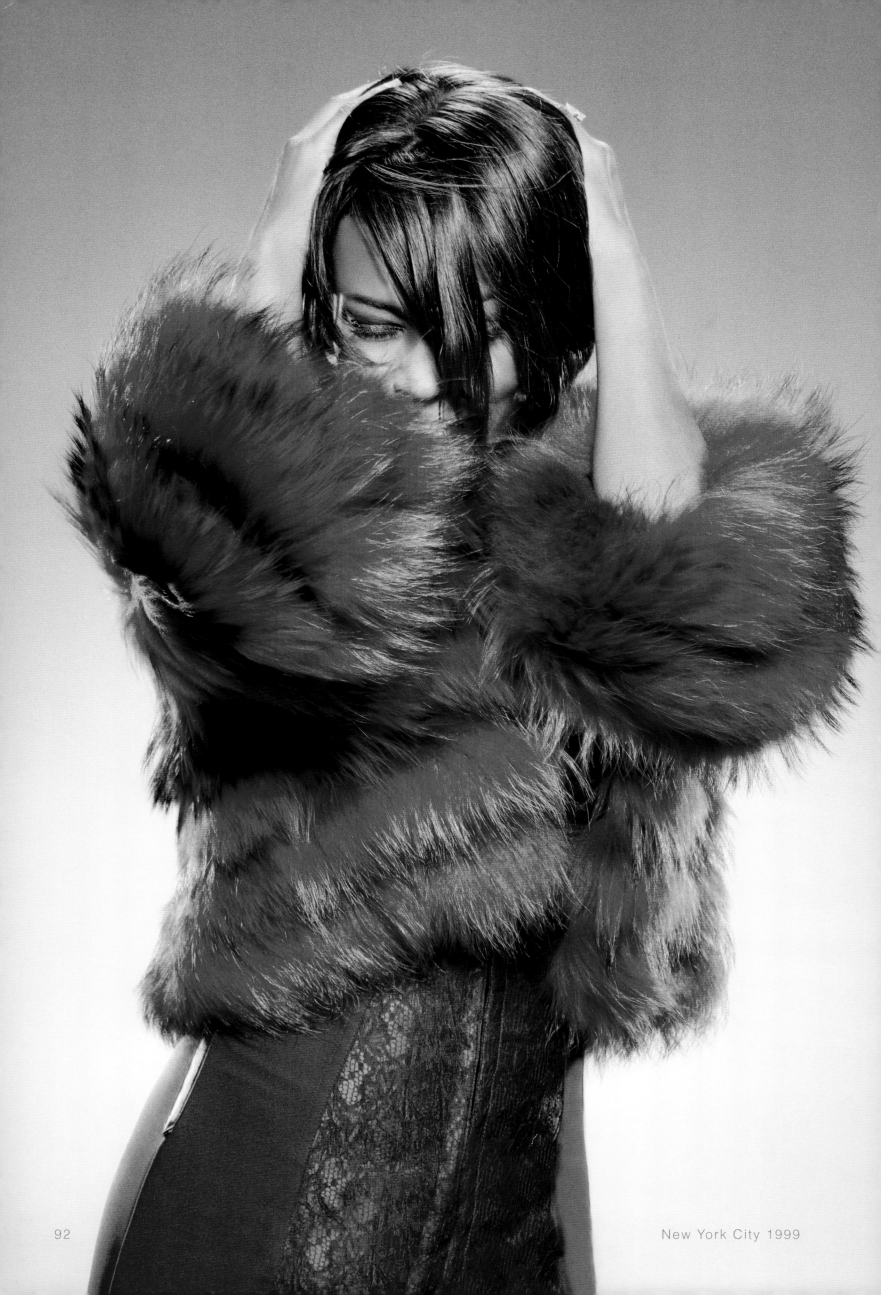

92

New York City 1999

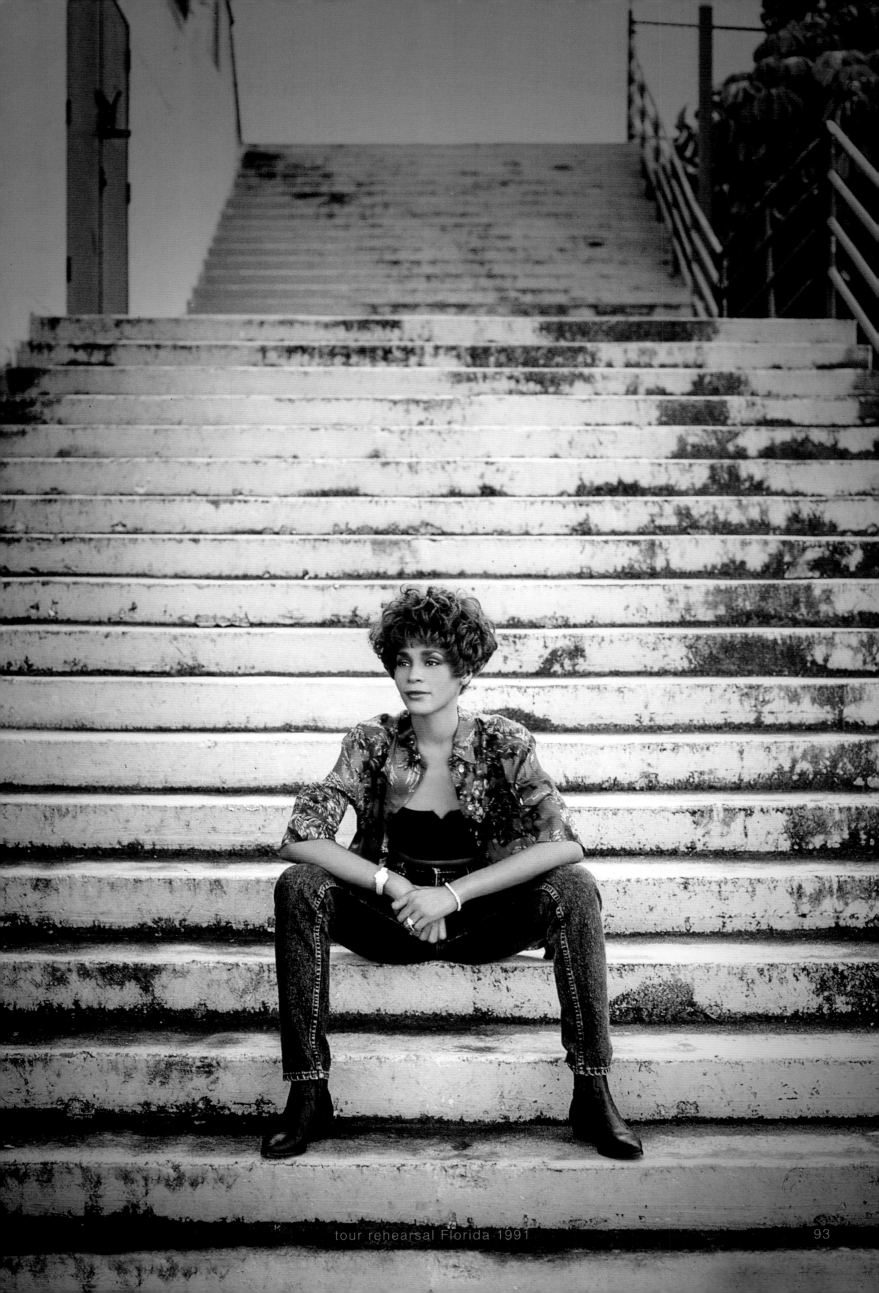

tour rehearsal Florida 1991

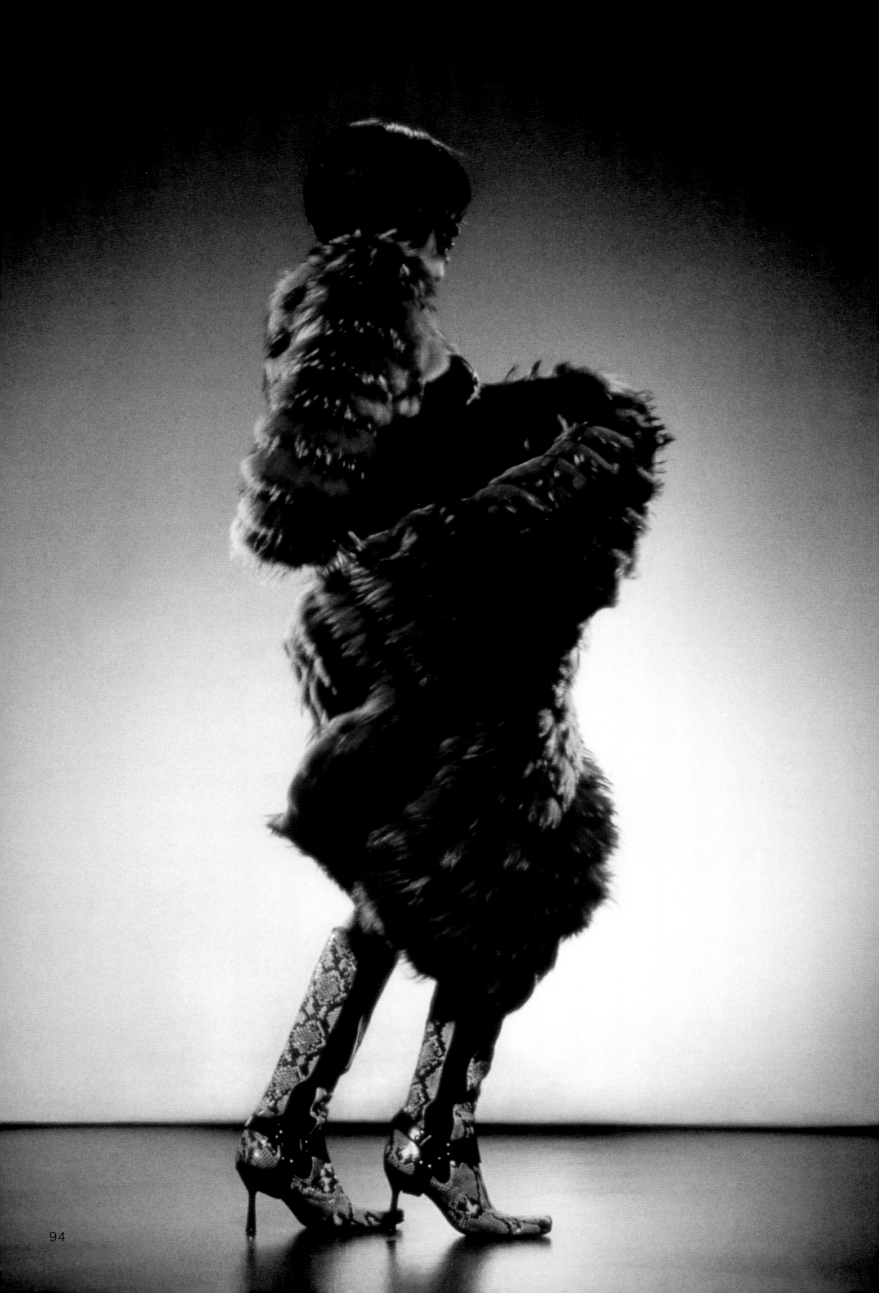

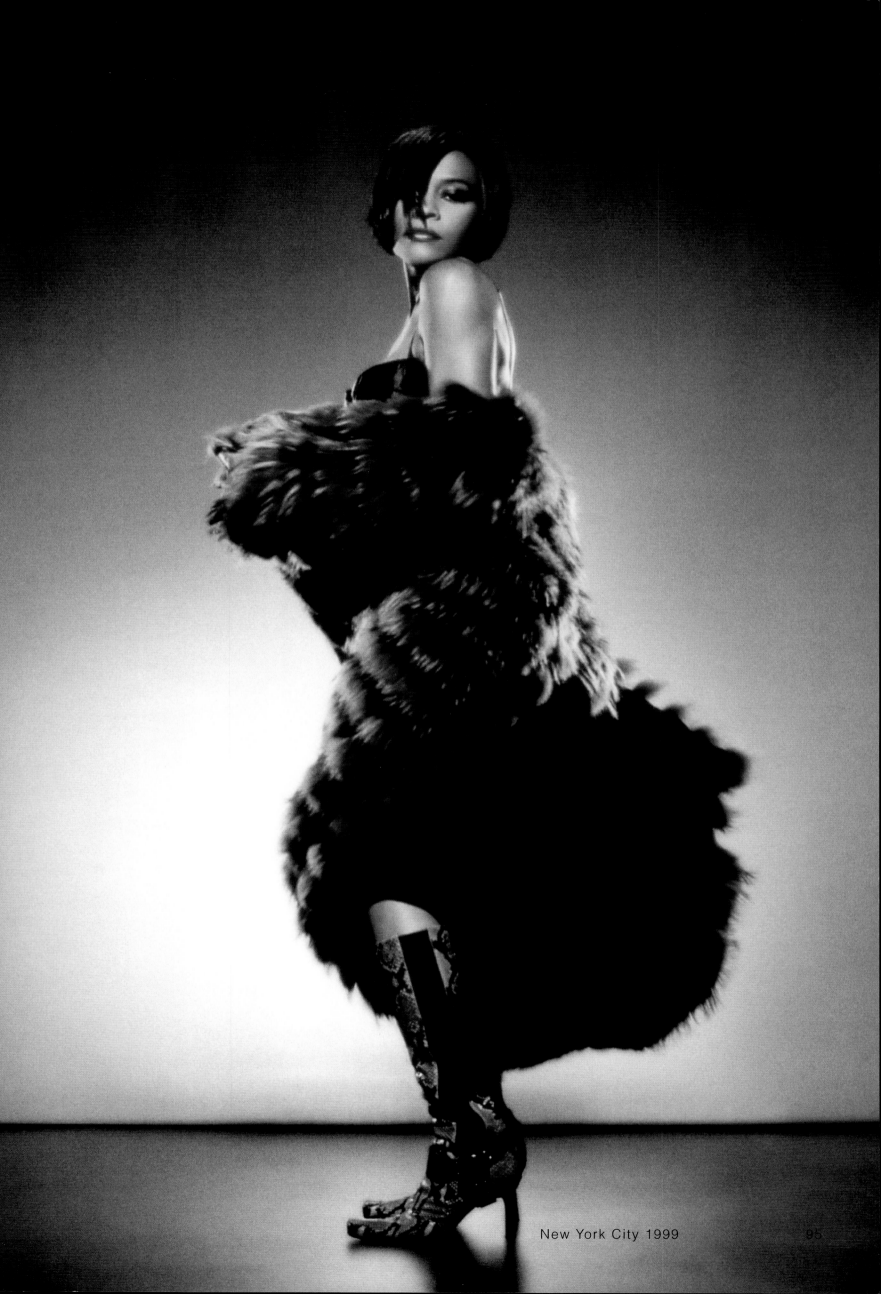

New York City 1999

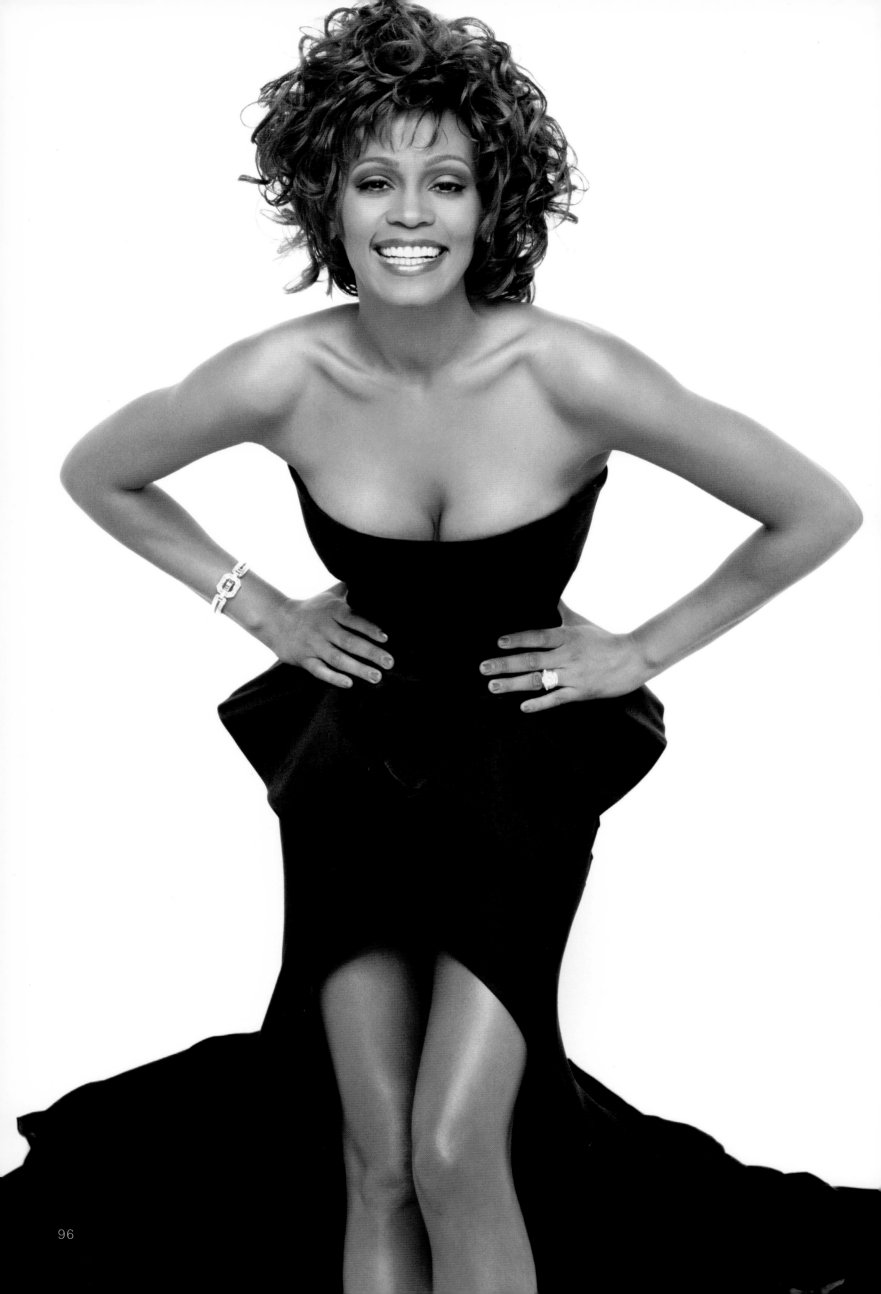

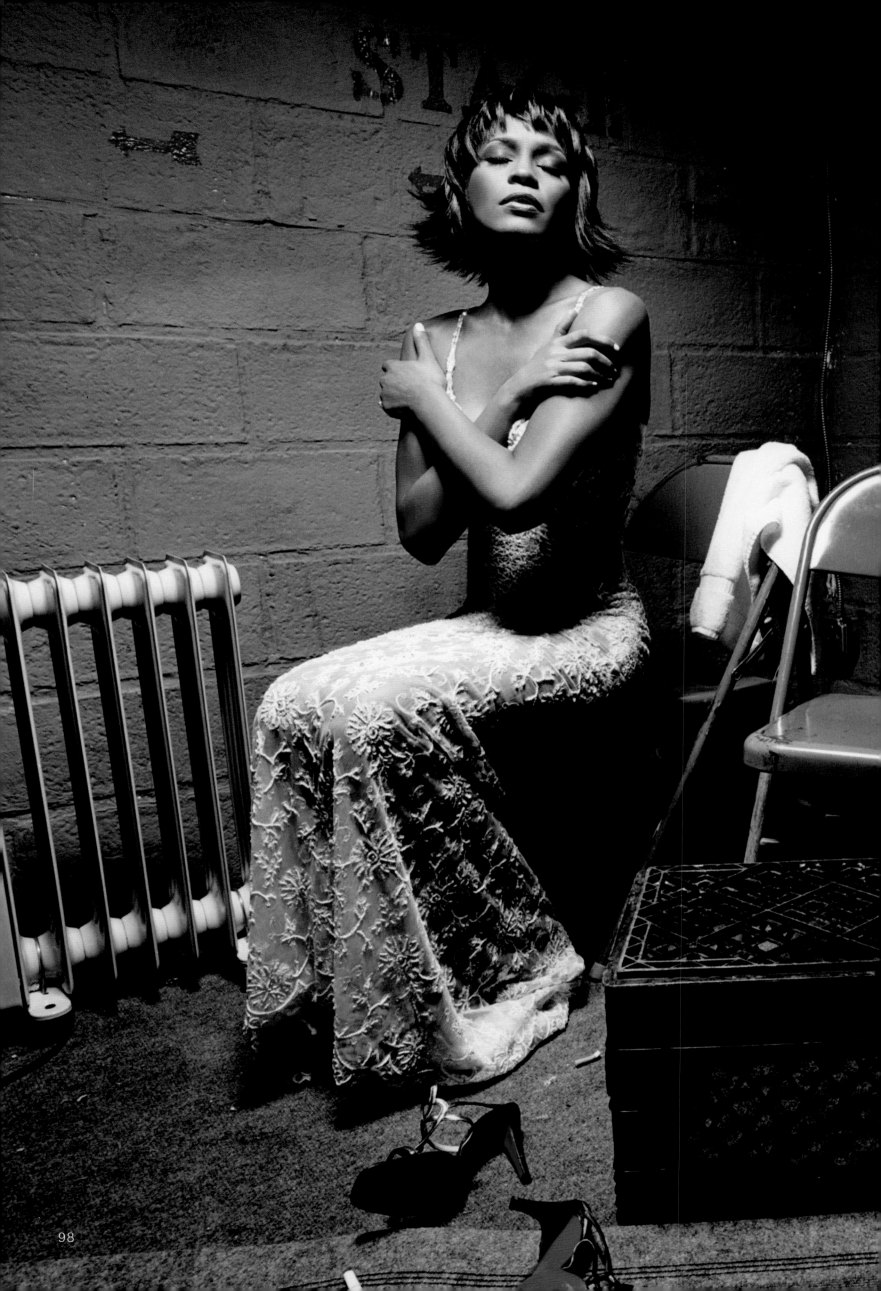

New York City 2000

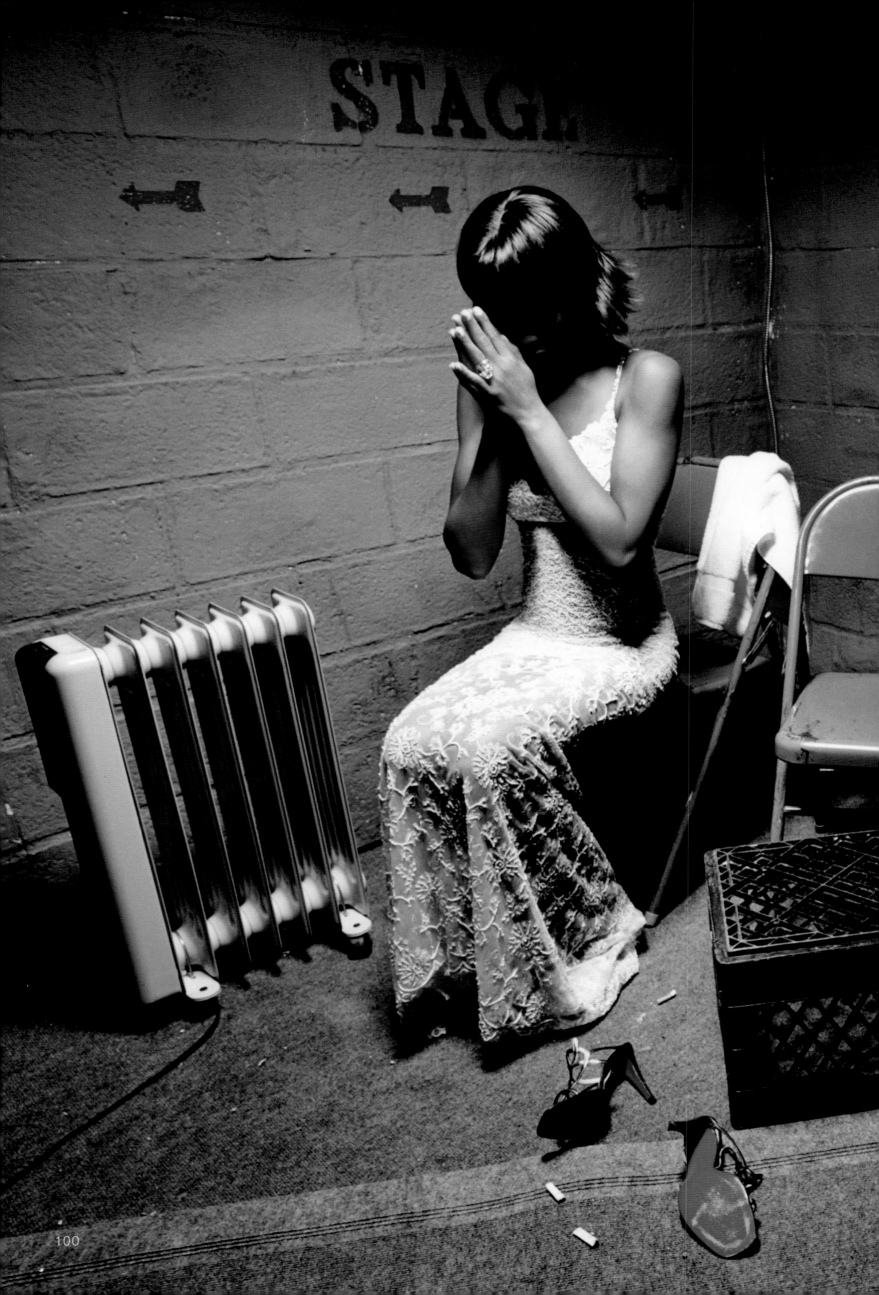

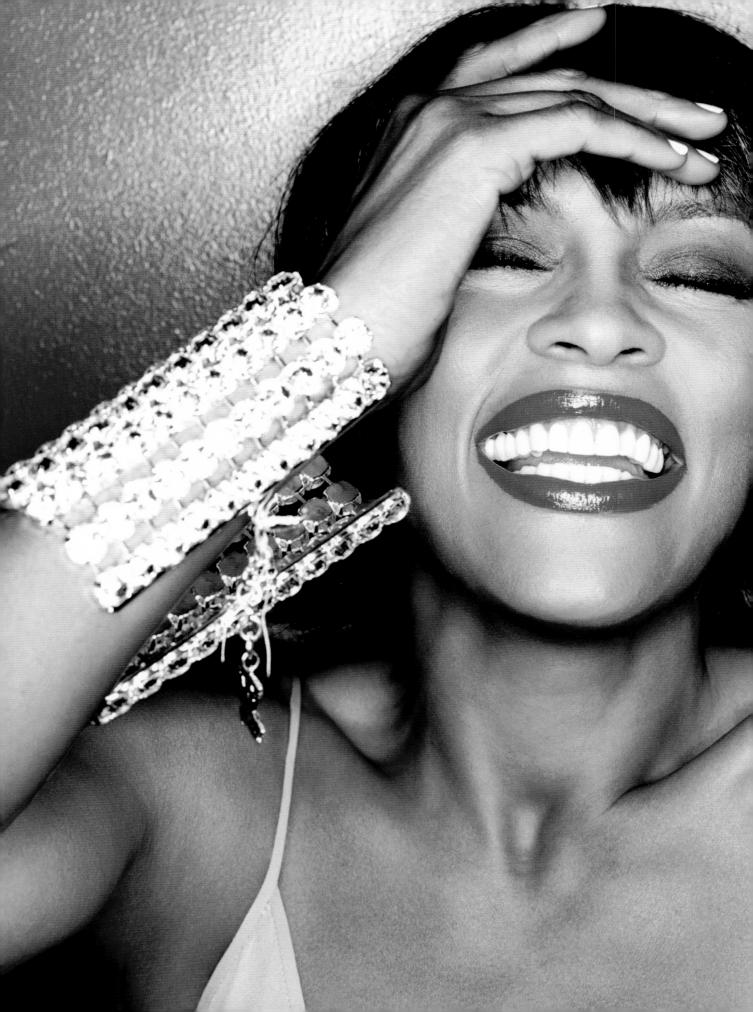

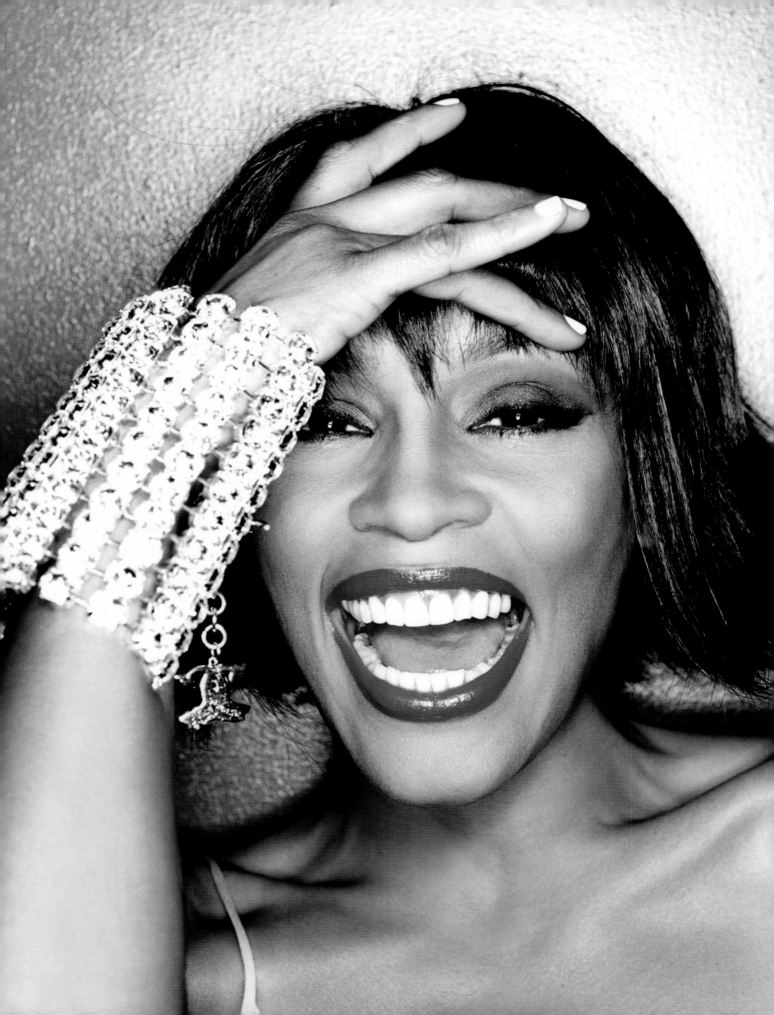

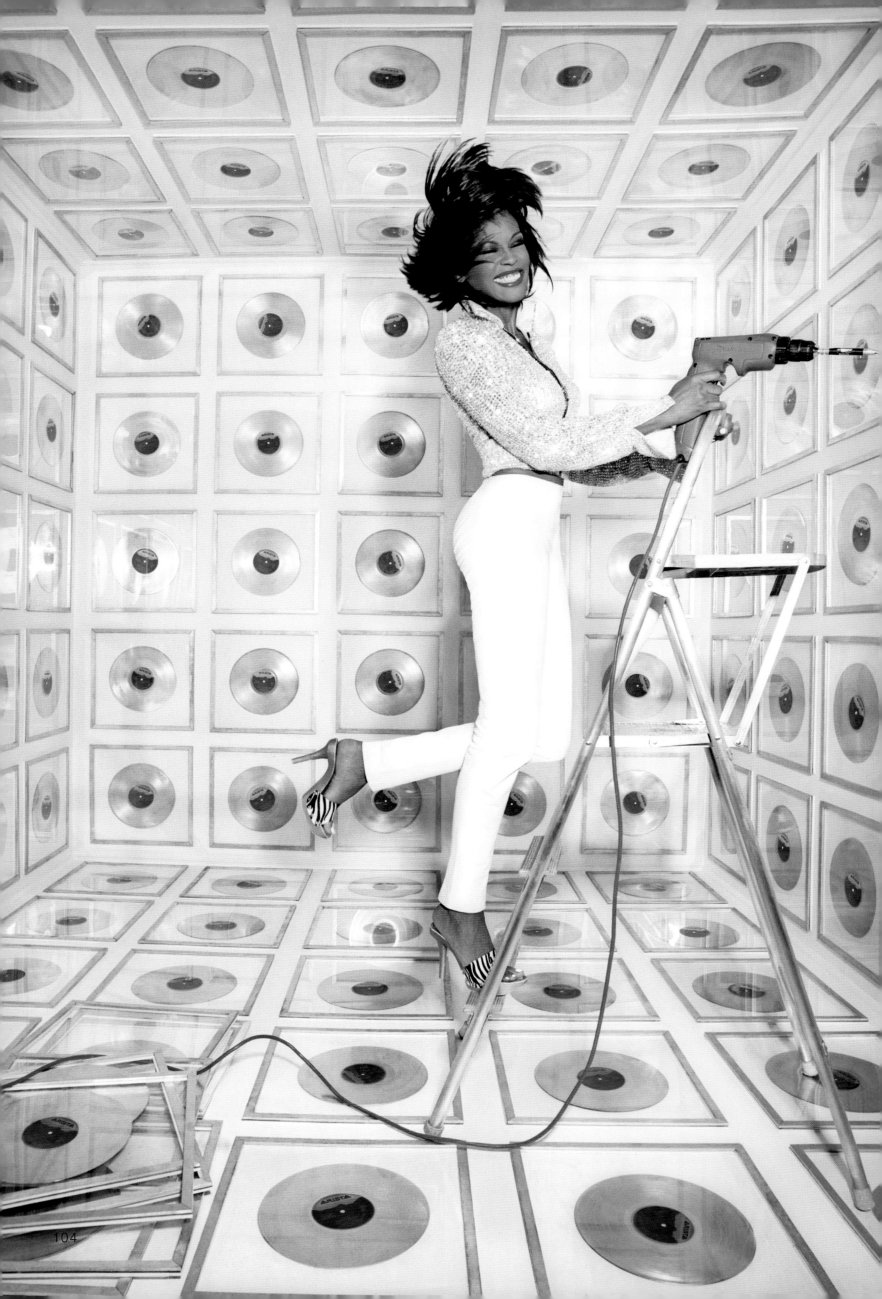

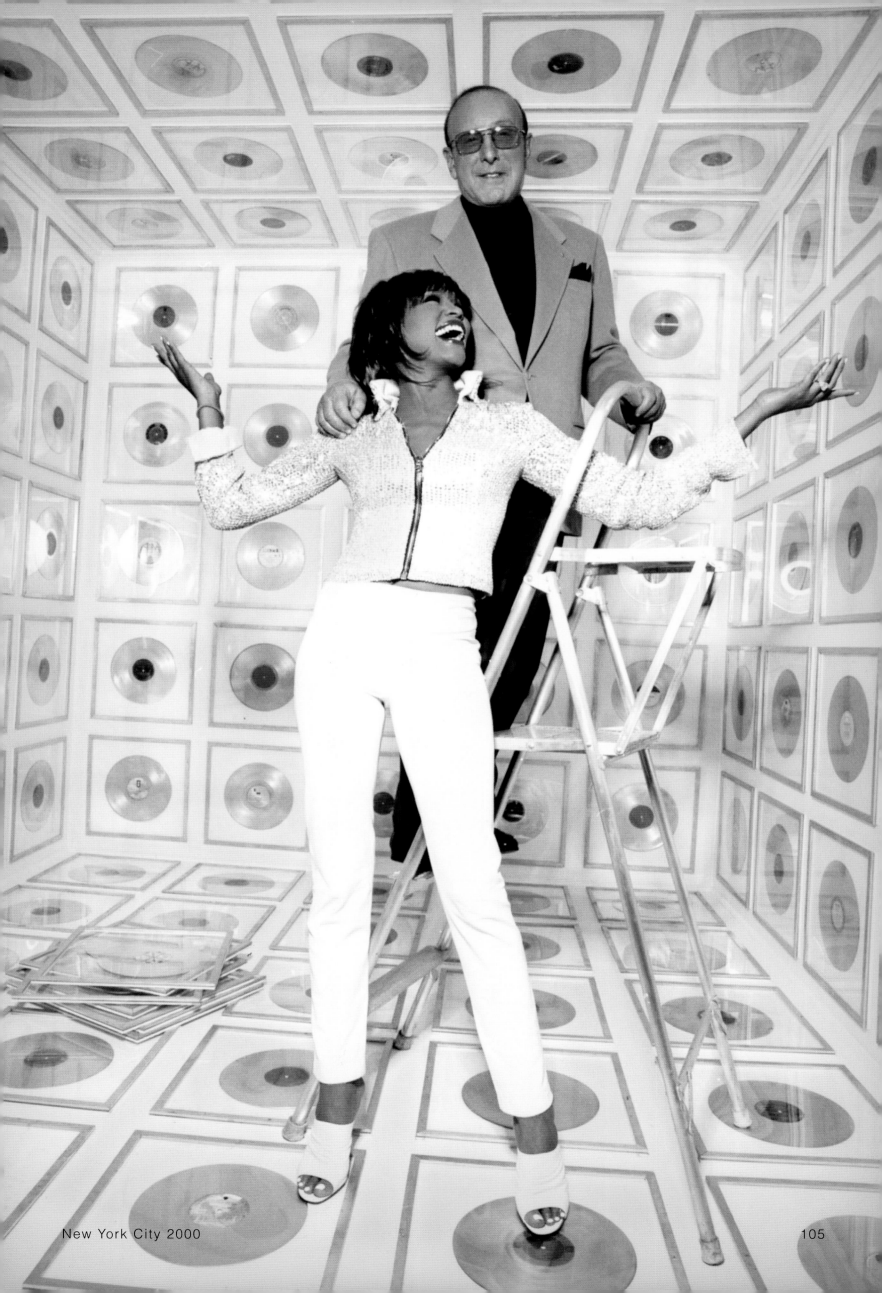

New York City 2000

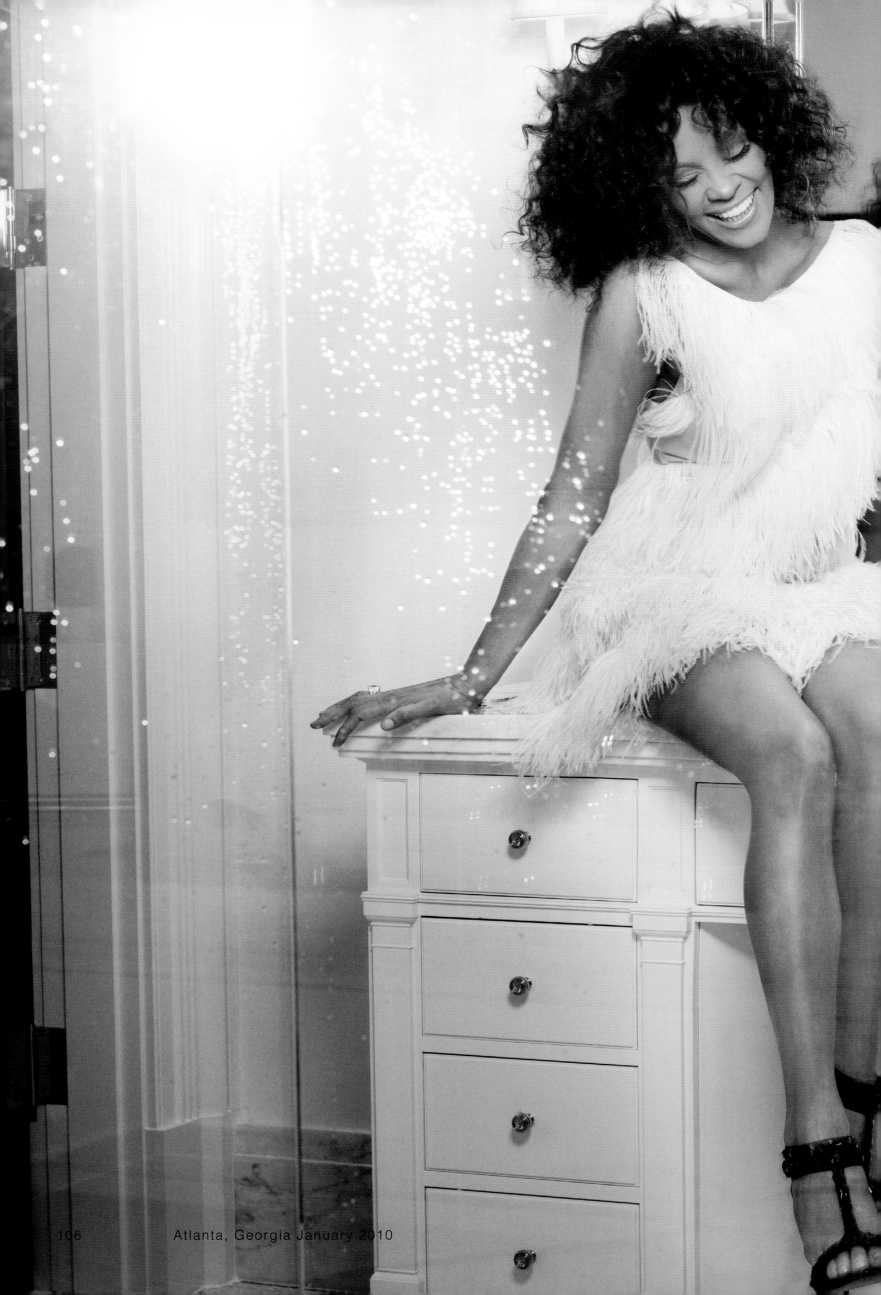

Atlanta, Georgia January 2010

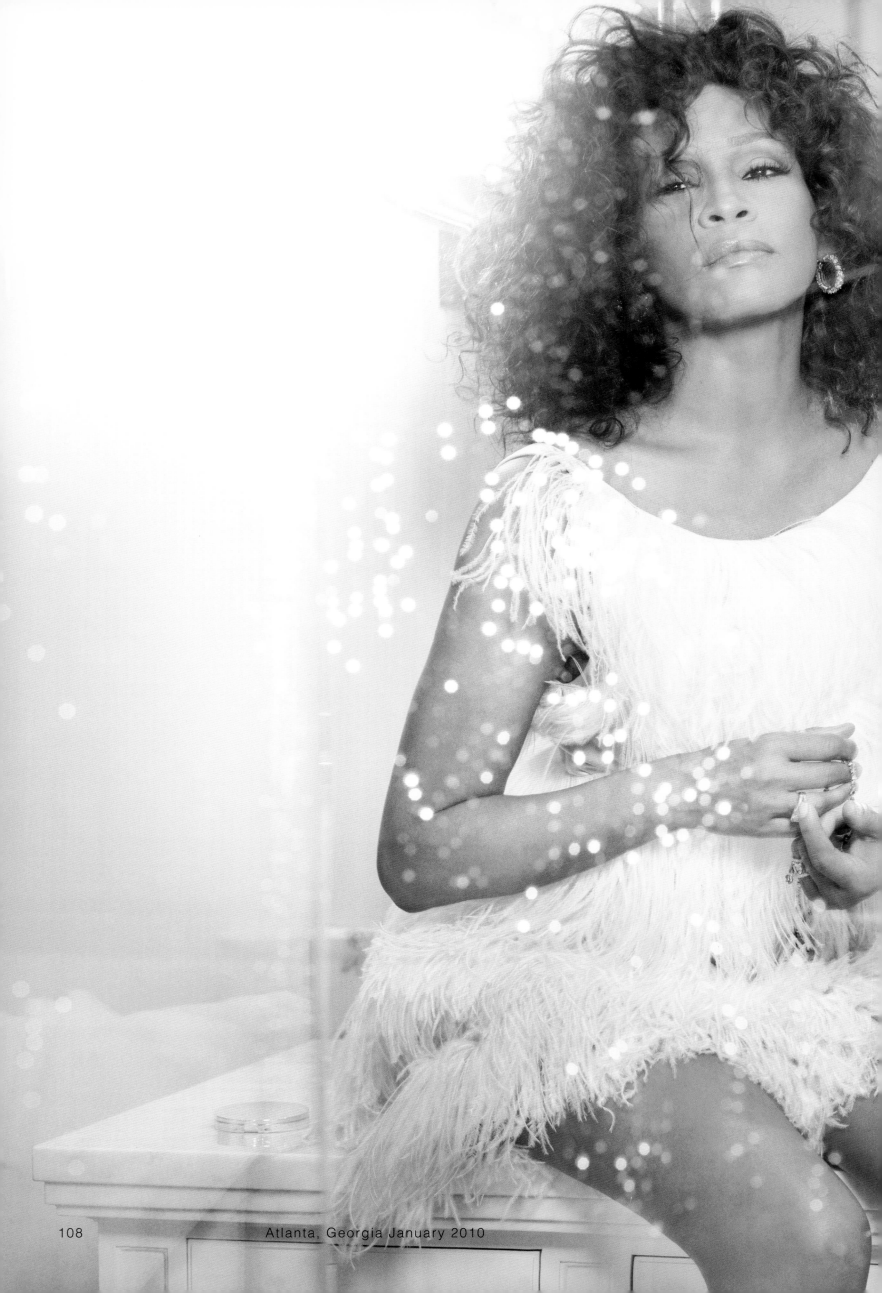

Atlanta, Georgia January 2010

New York City 1990

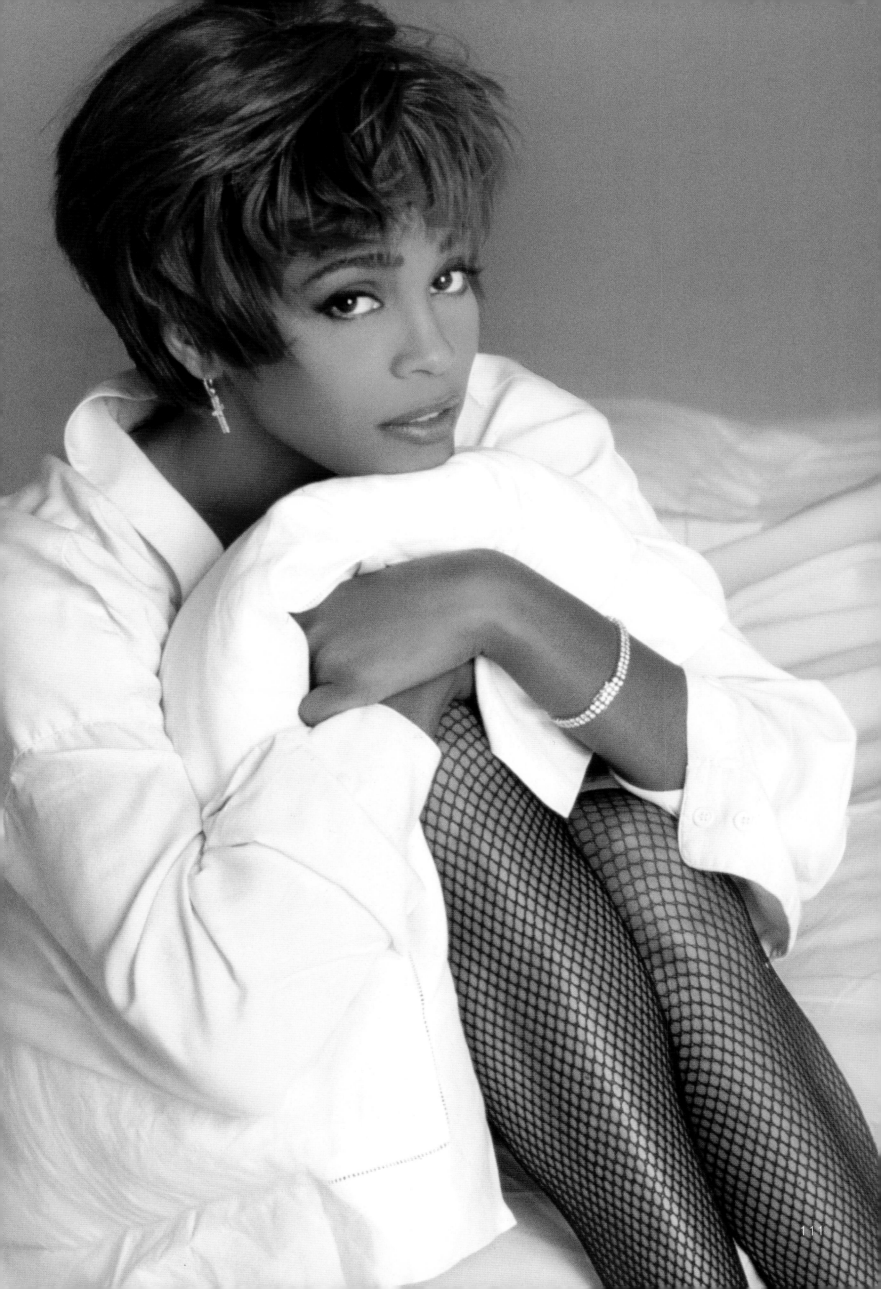

Atlanta, Georgia January 2010

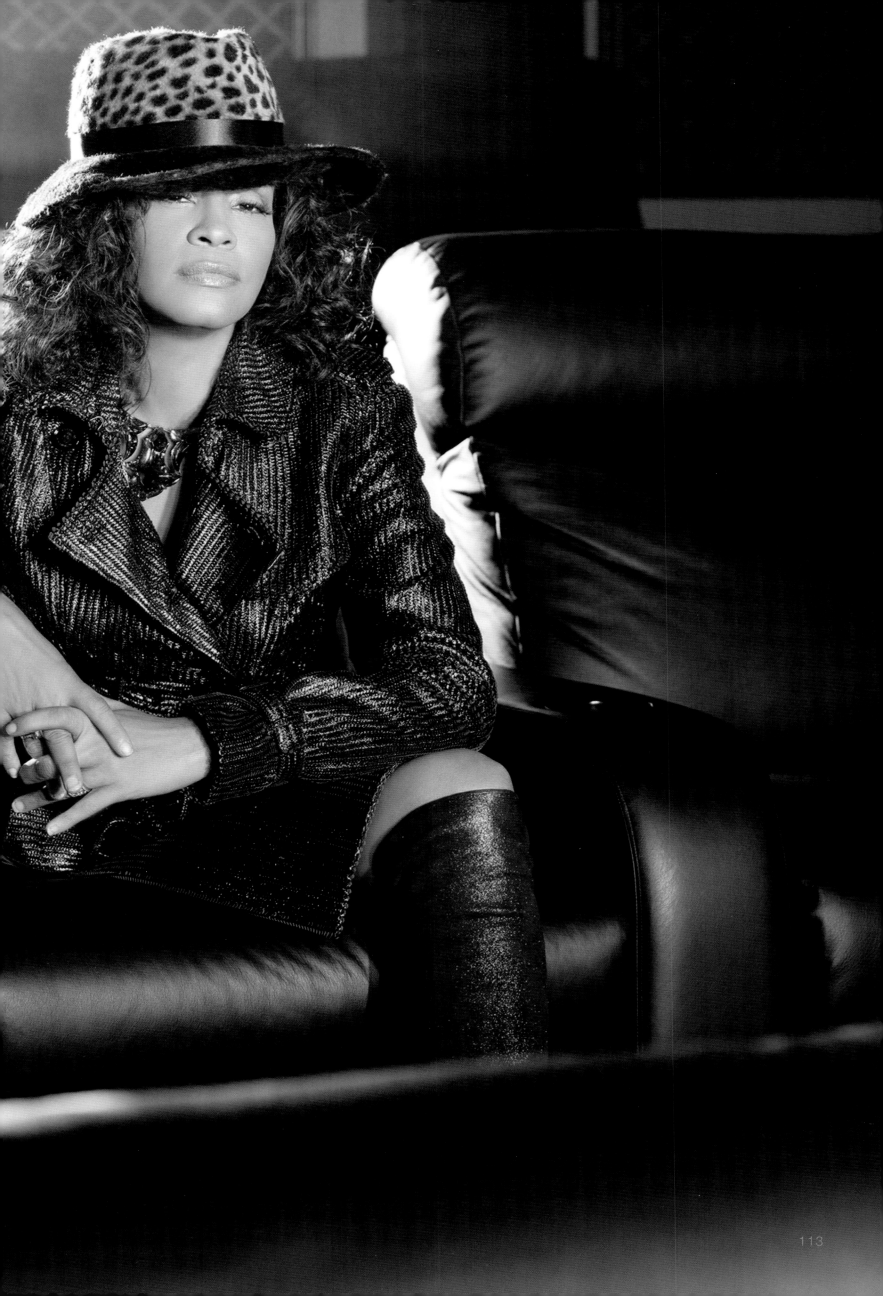

Atlanta, Georgia January 2010

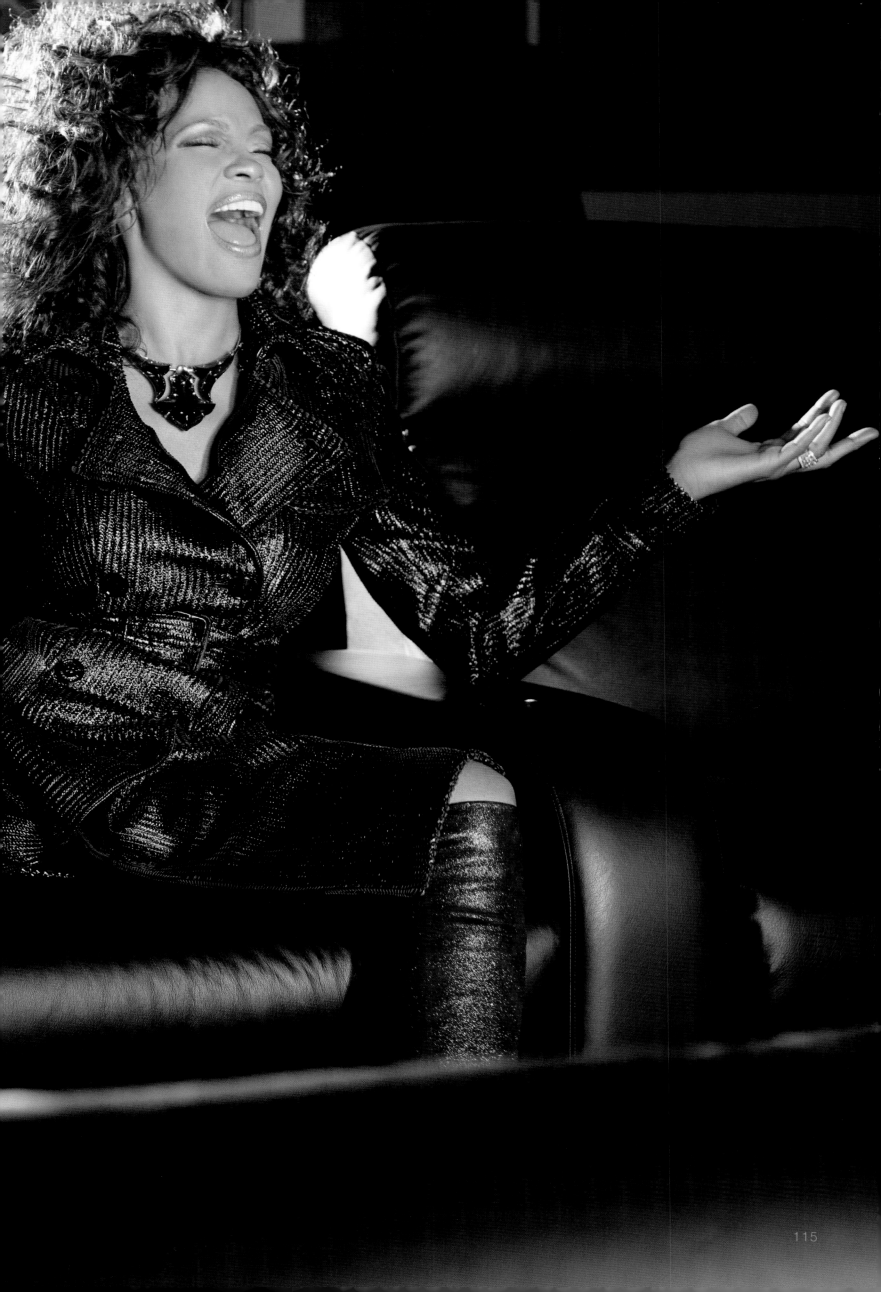

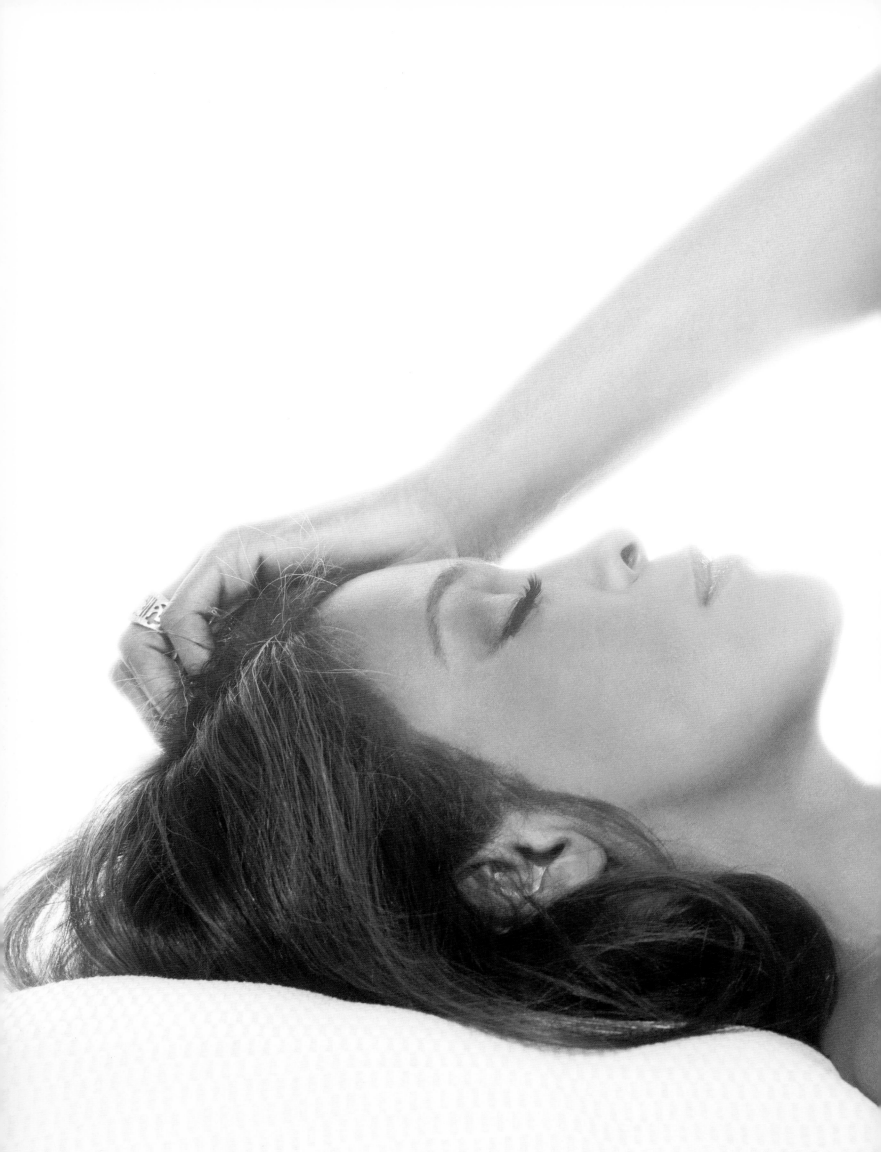

New York City 2009

New York City 2002

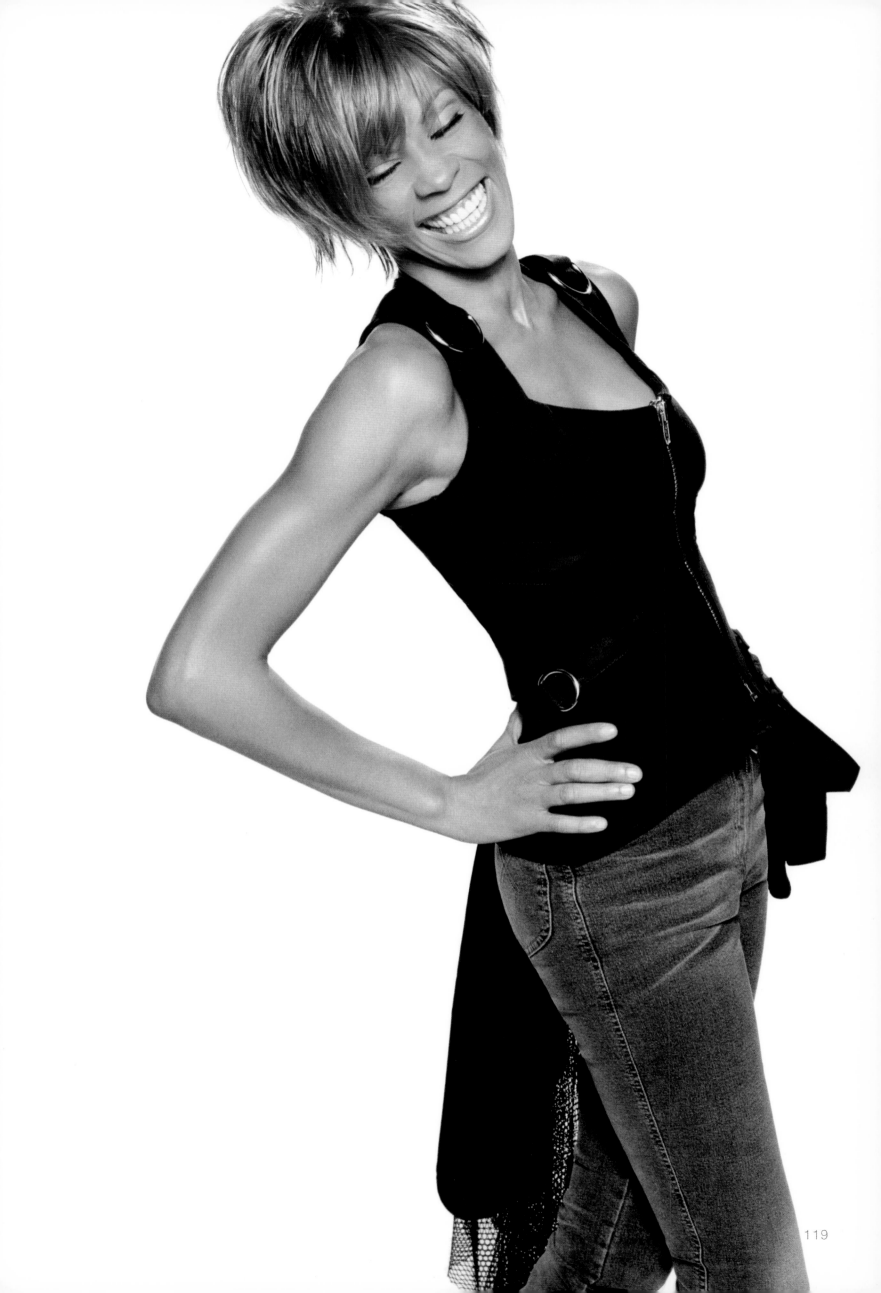

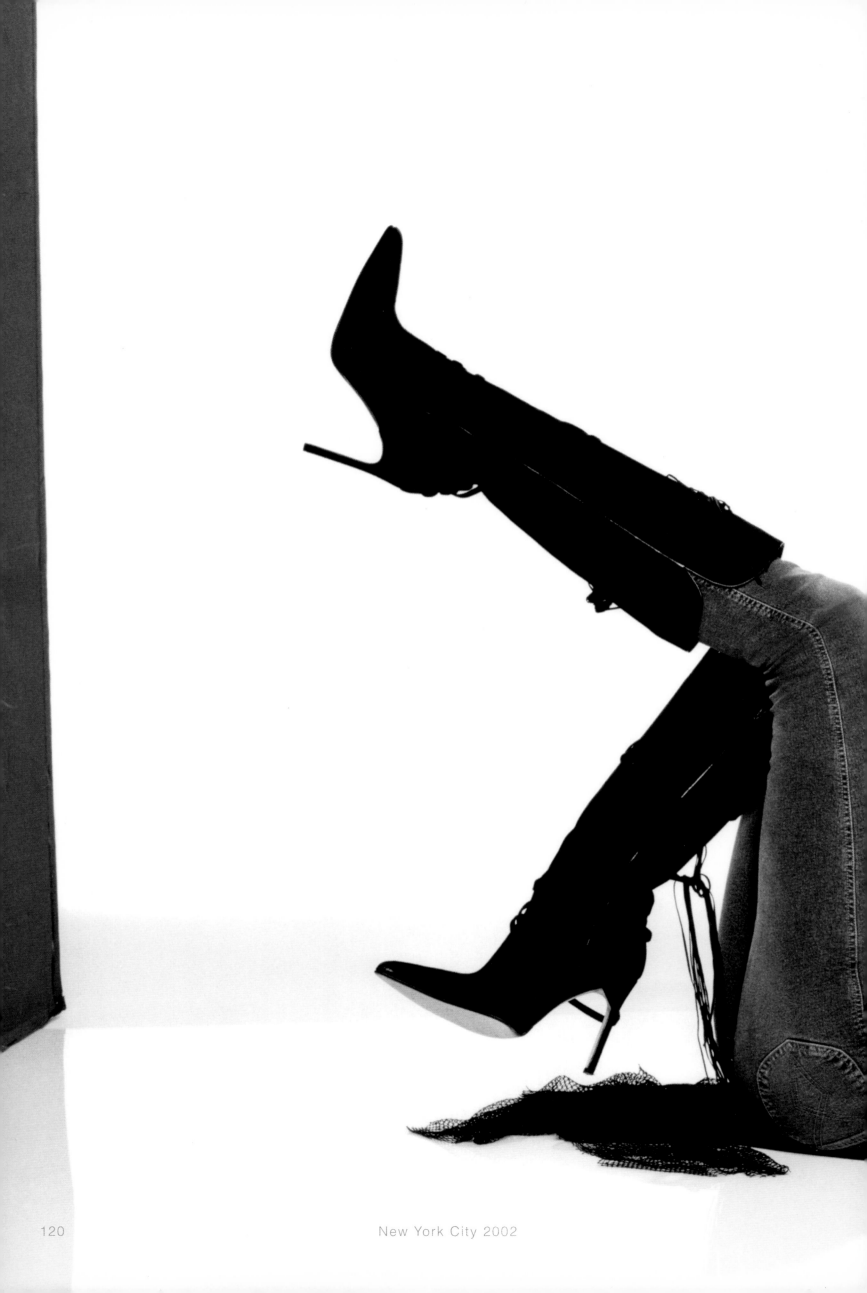

New York City 2002

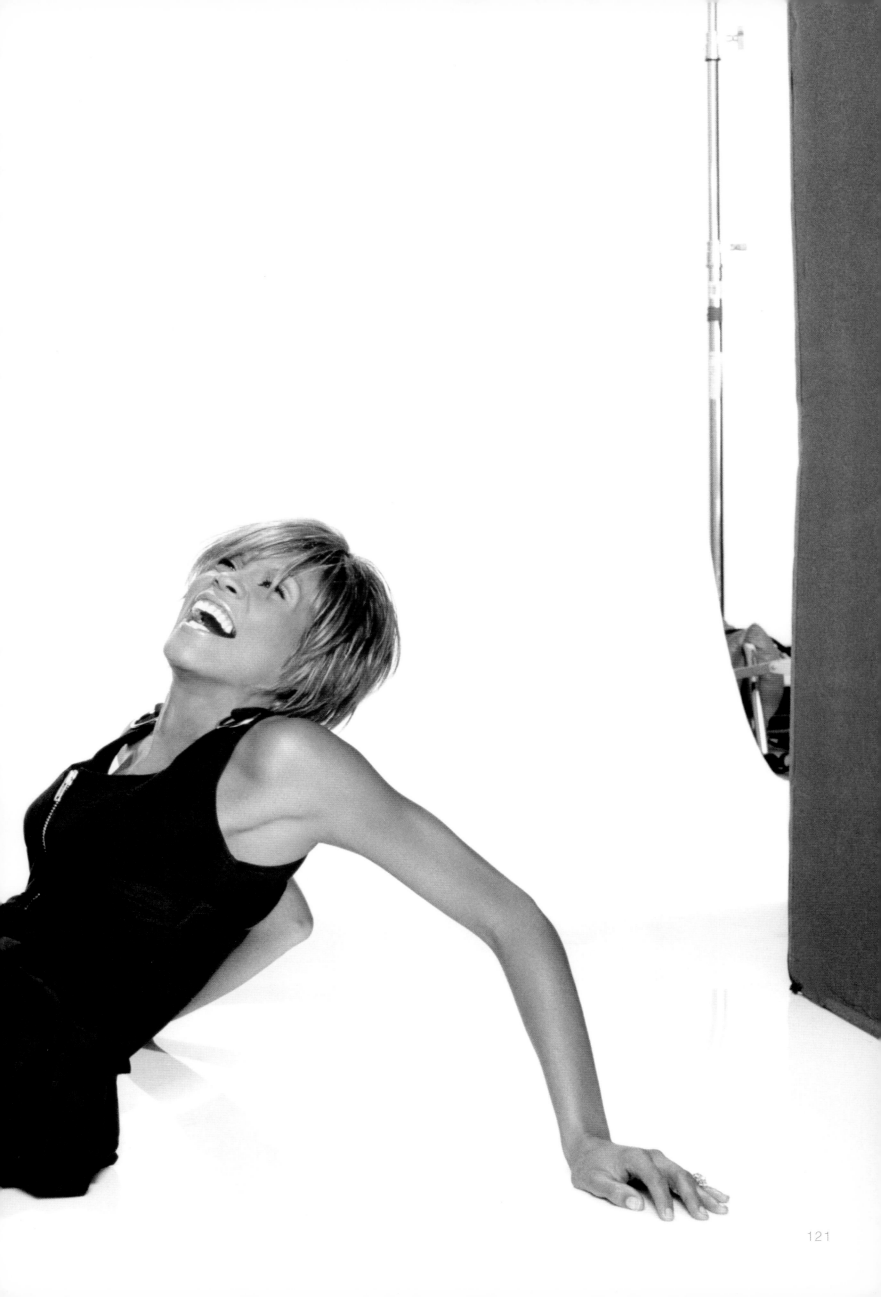

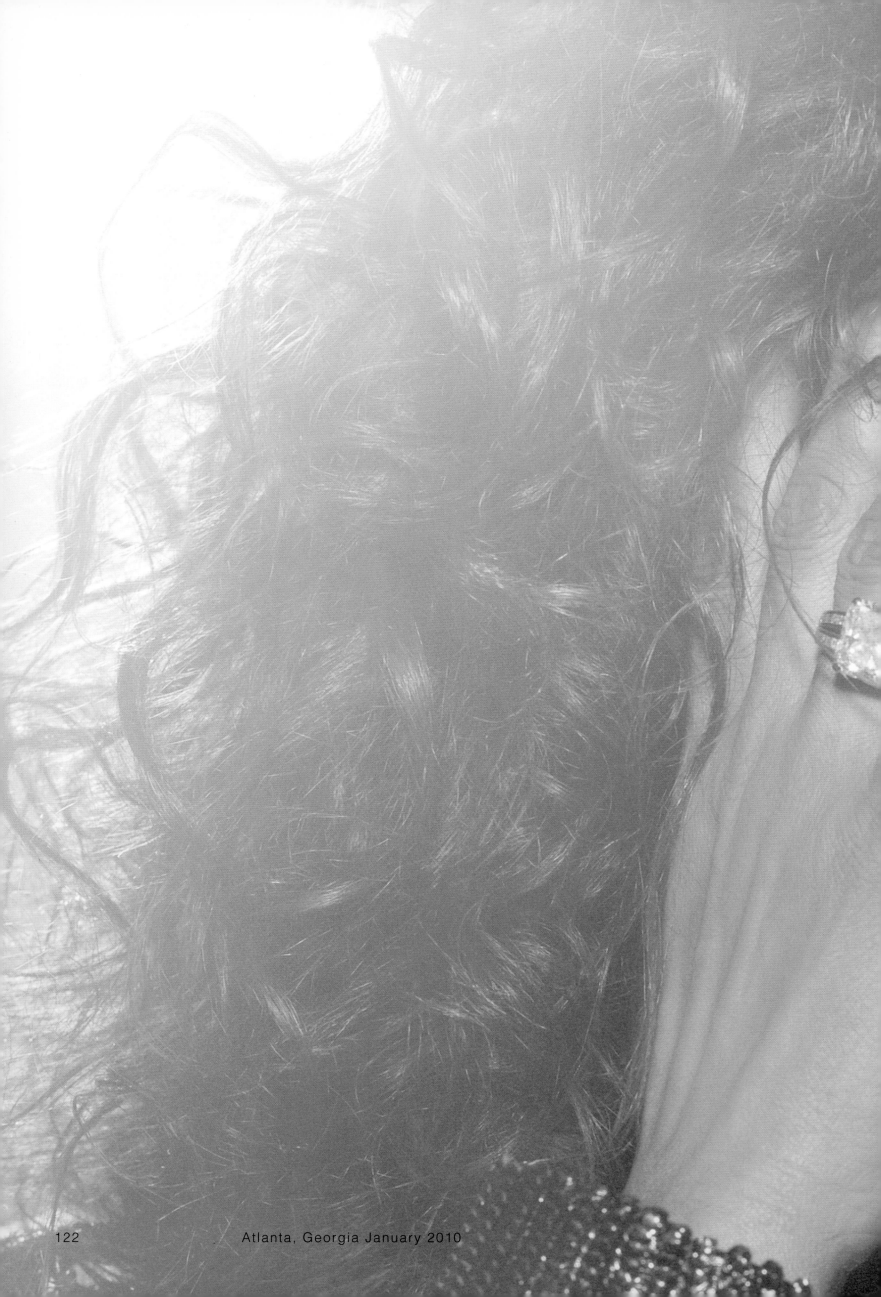

Atlanta, Georgia January 2010

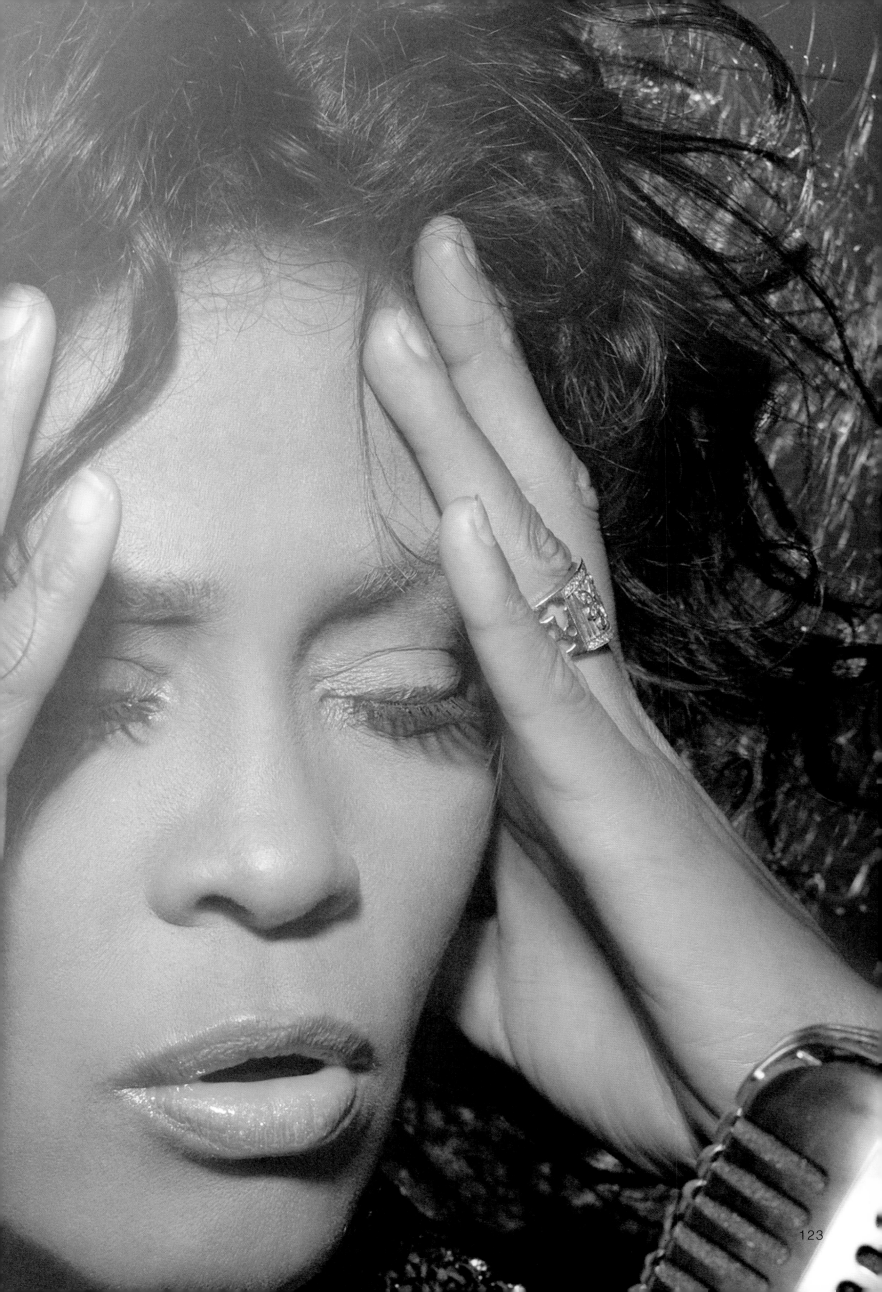

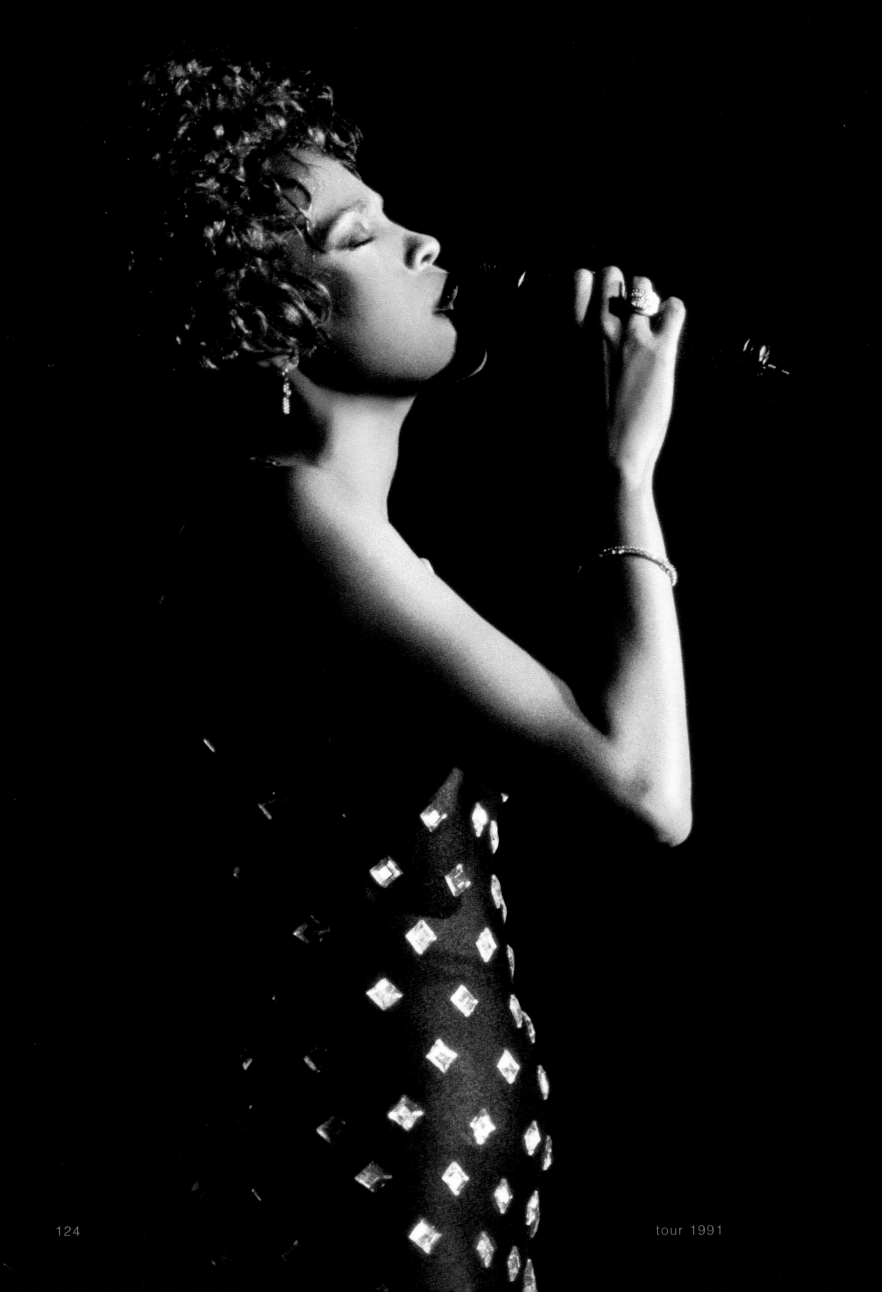

tour 1991

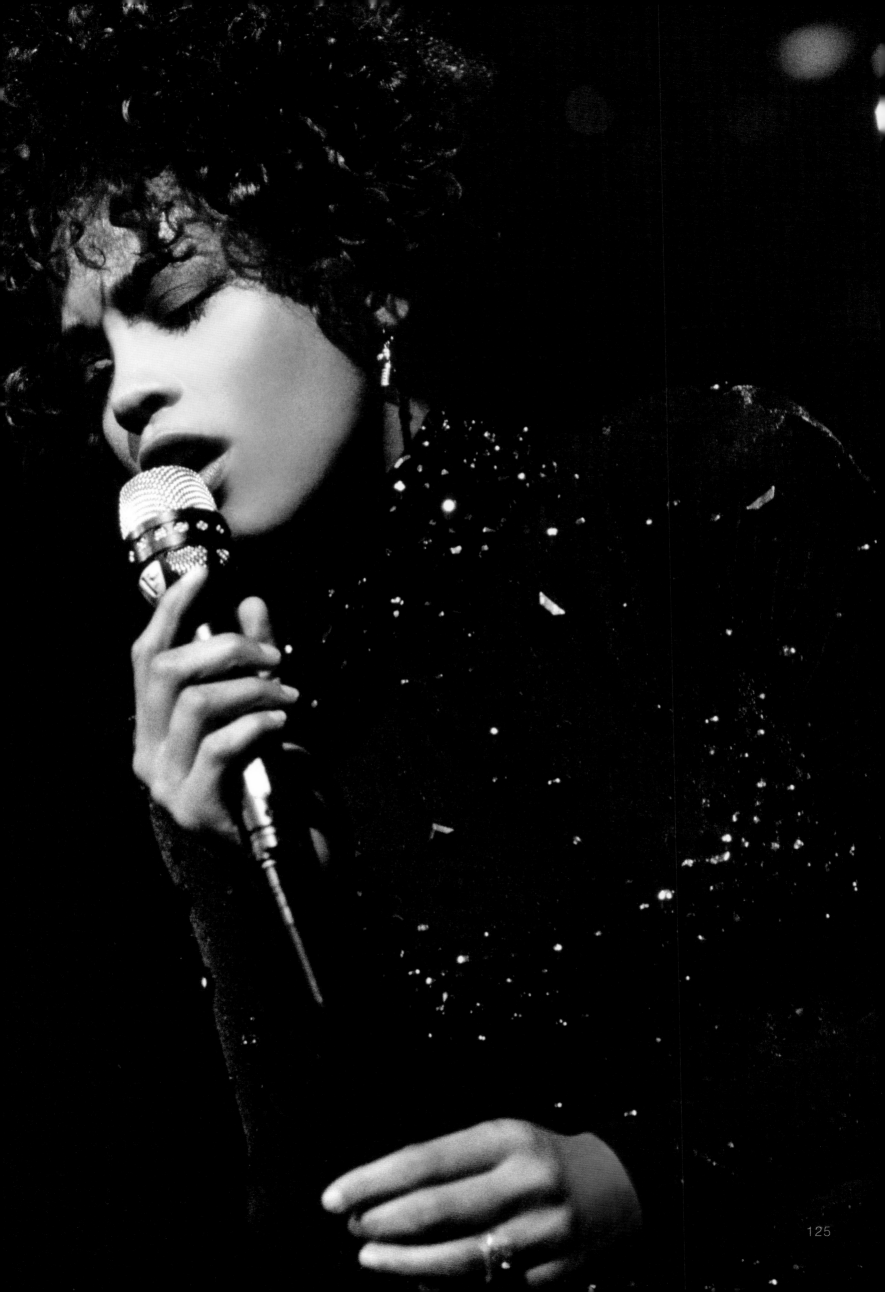

"All The Man That I Need" video shoot New Jersey 1989

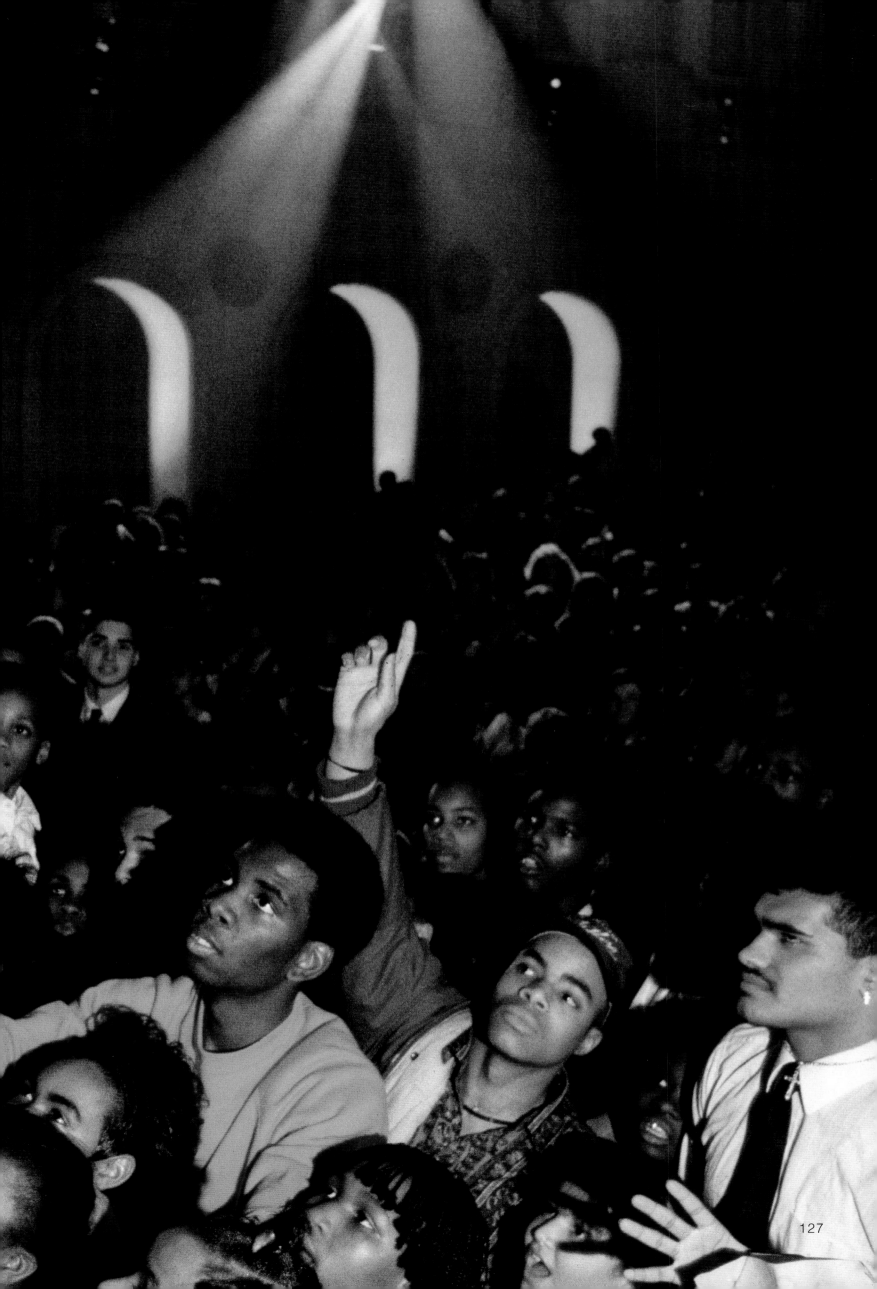

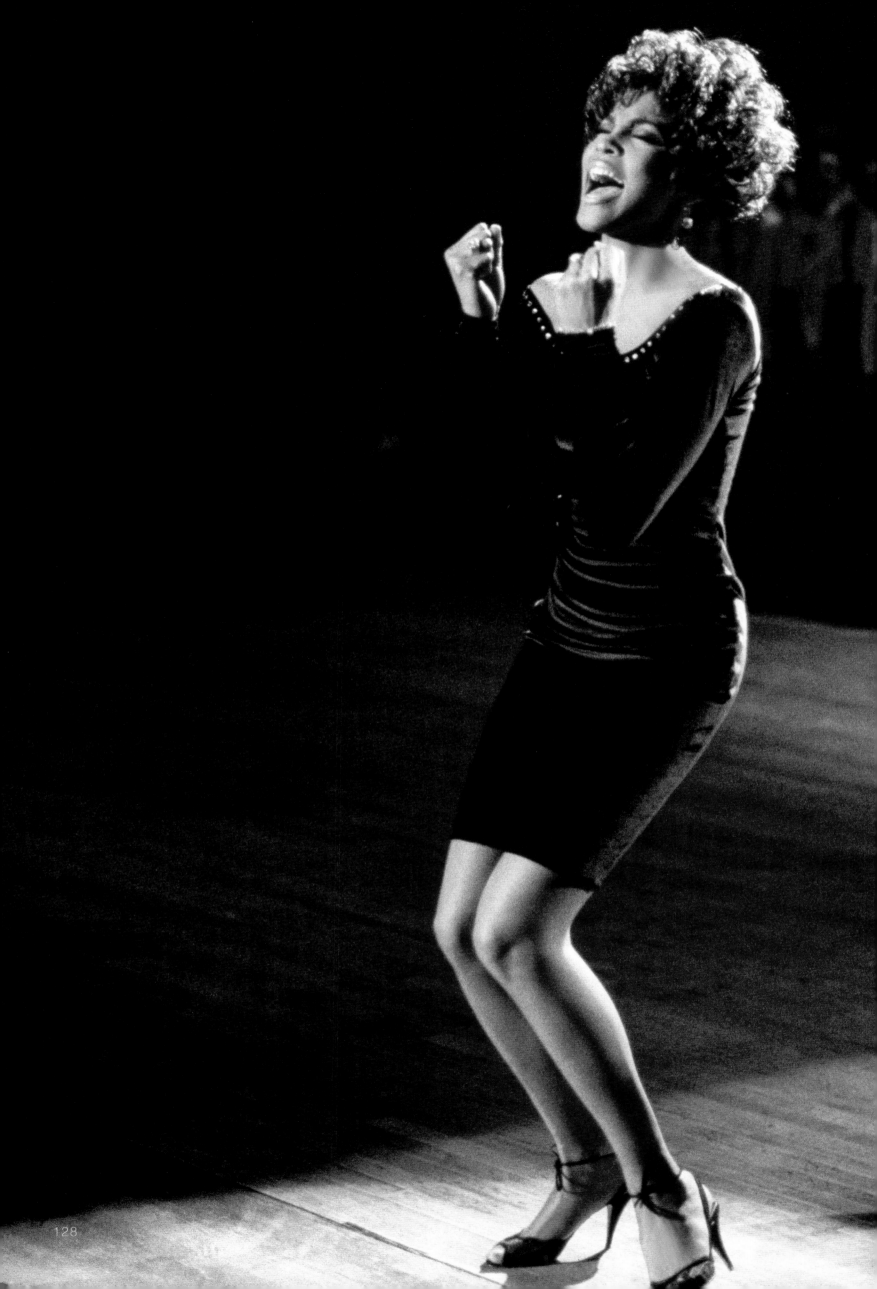

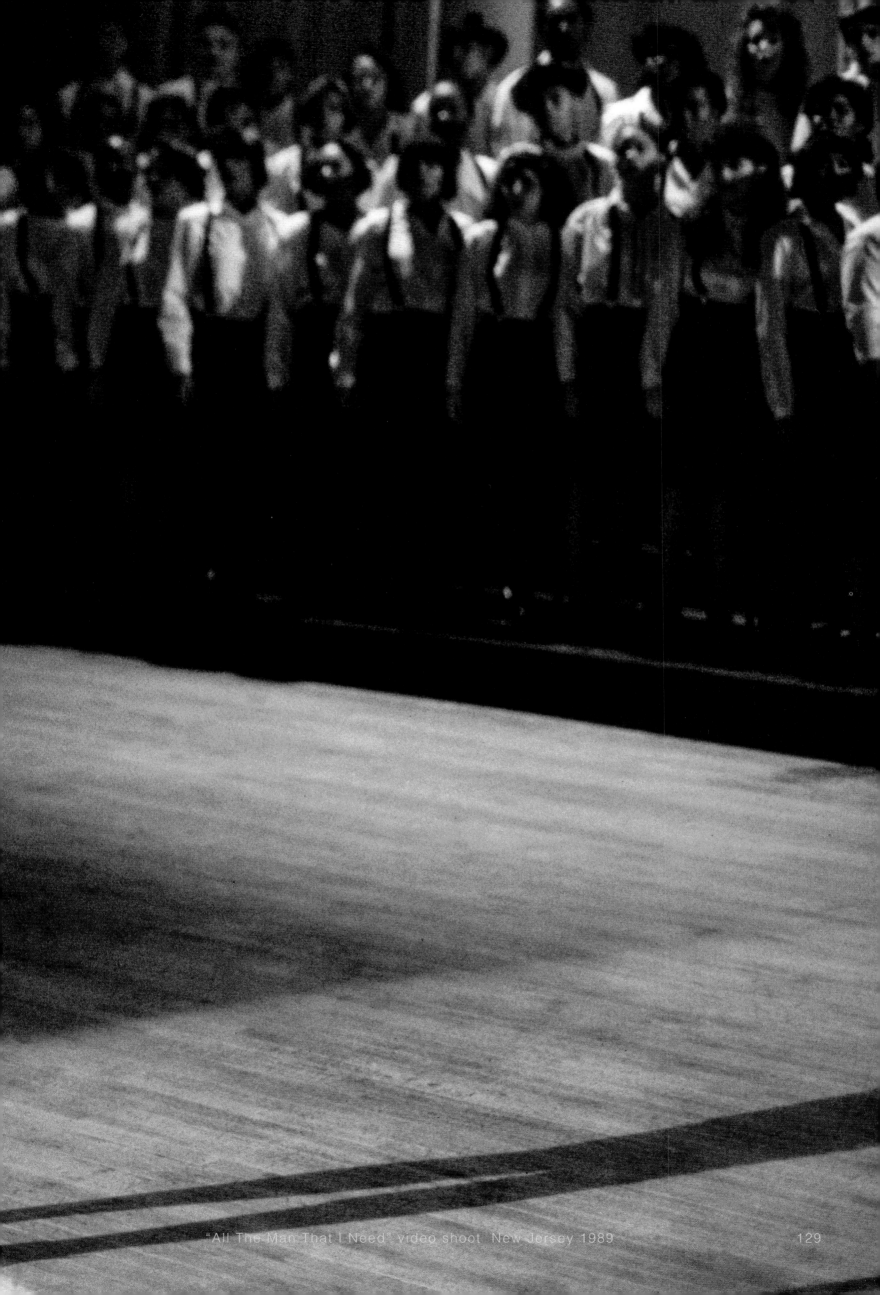

"All The Man That I Need" video shoot. New Jersey 1989

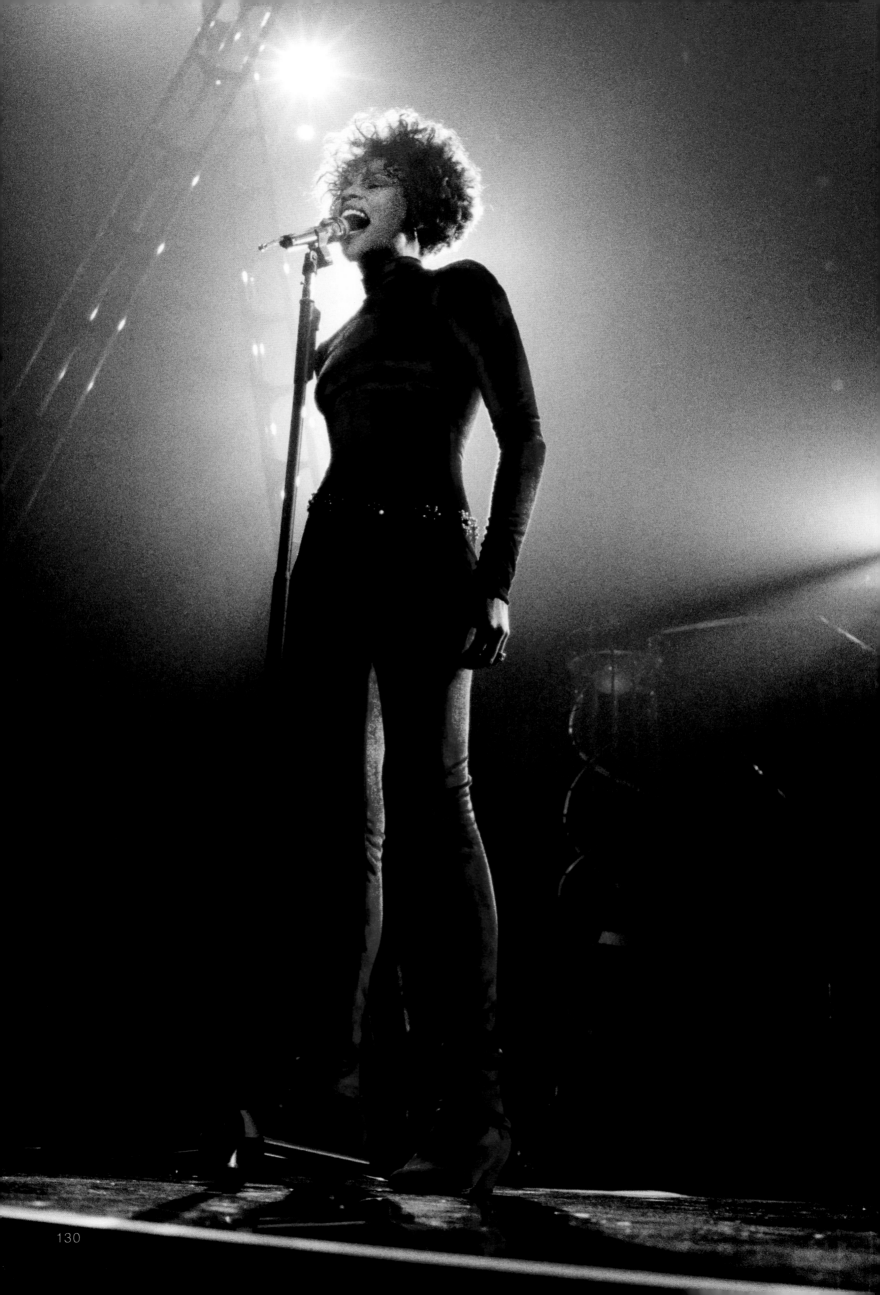

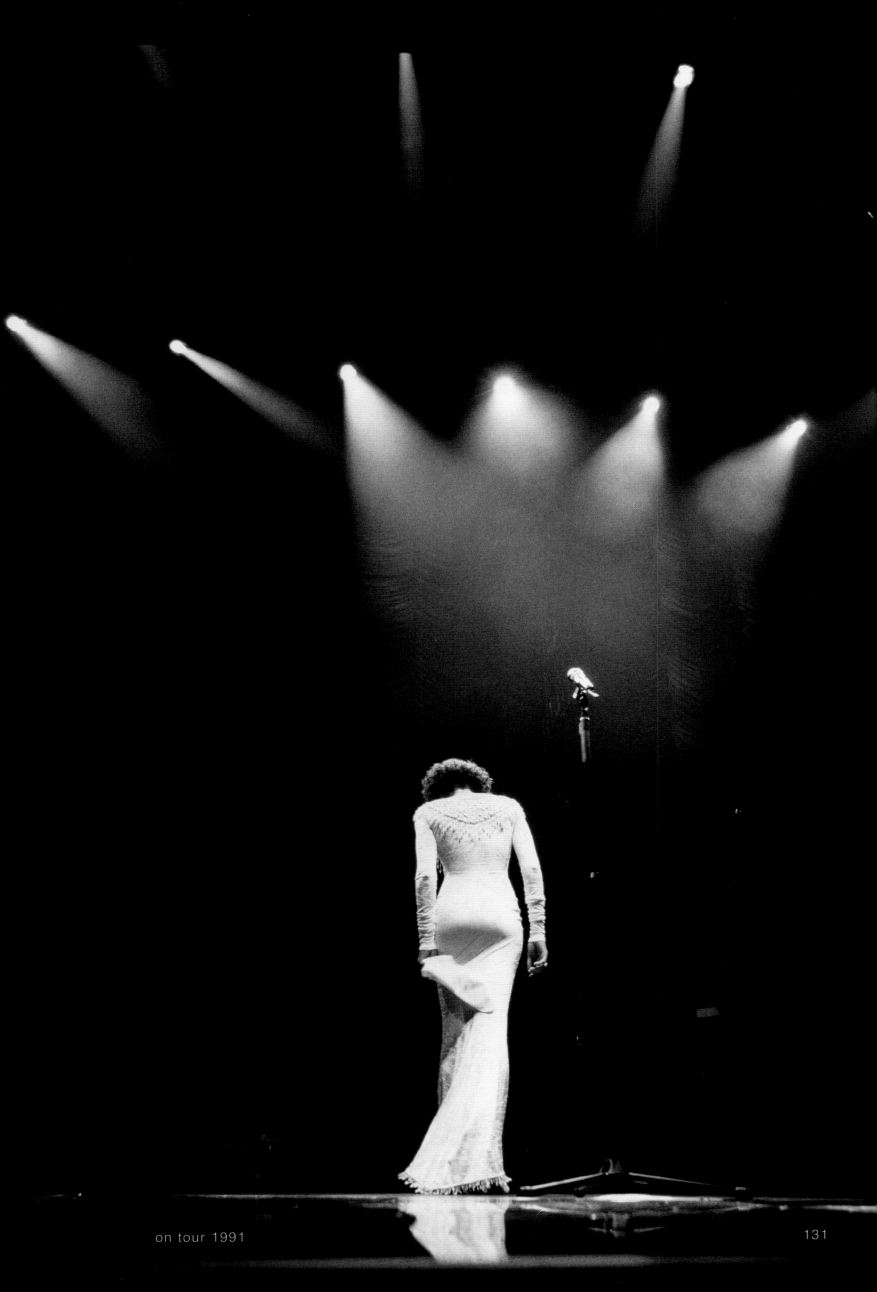

on tour 1991

Atlanta, Georgia 2009

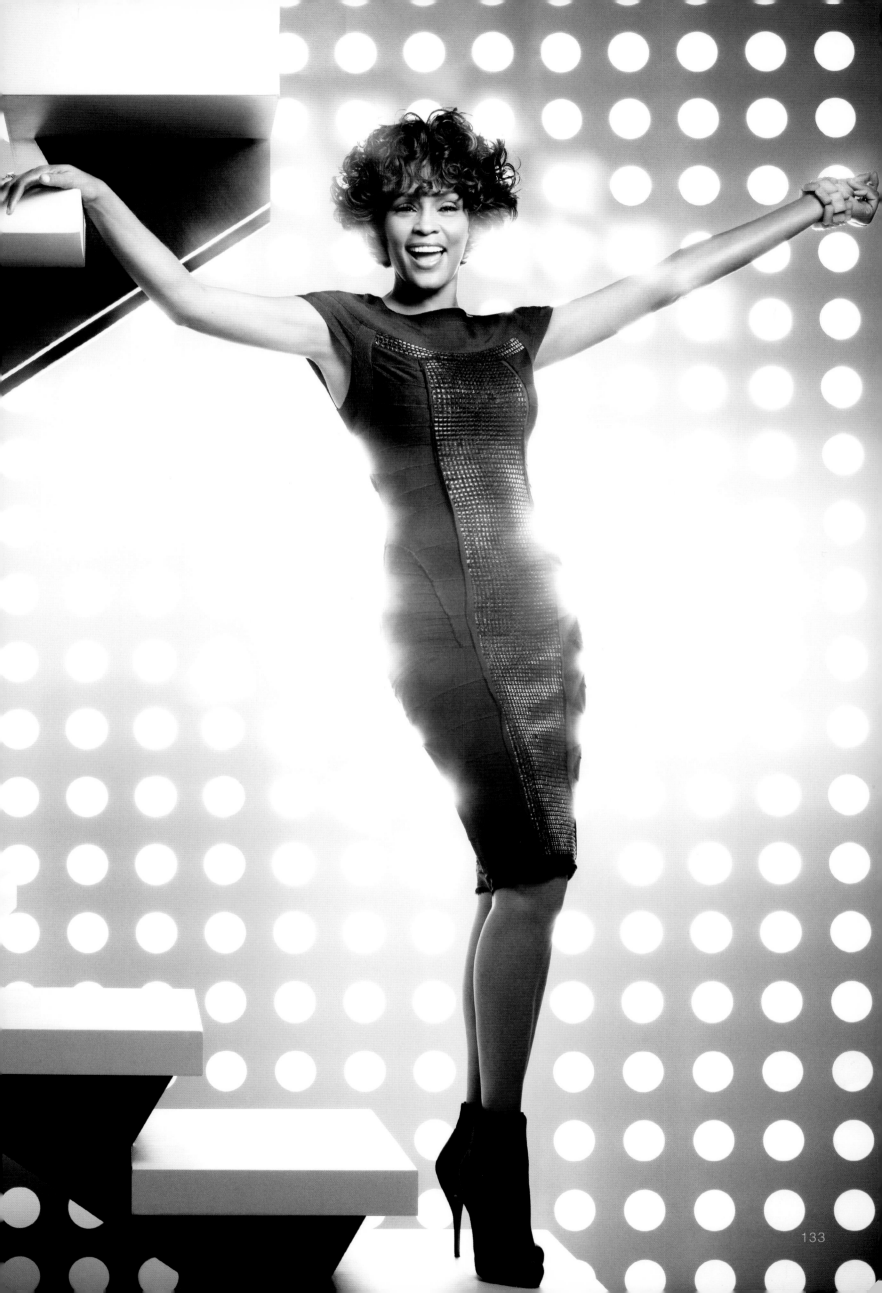

Atlanta, Georgia 2009

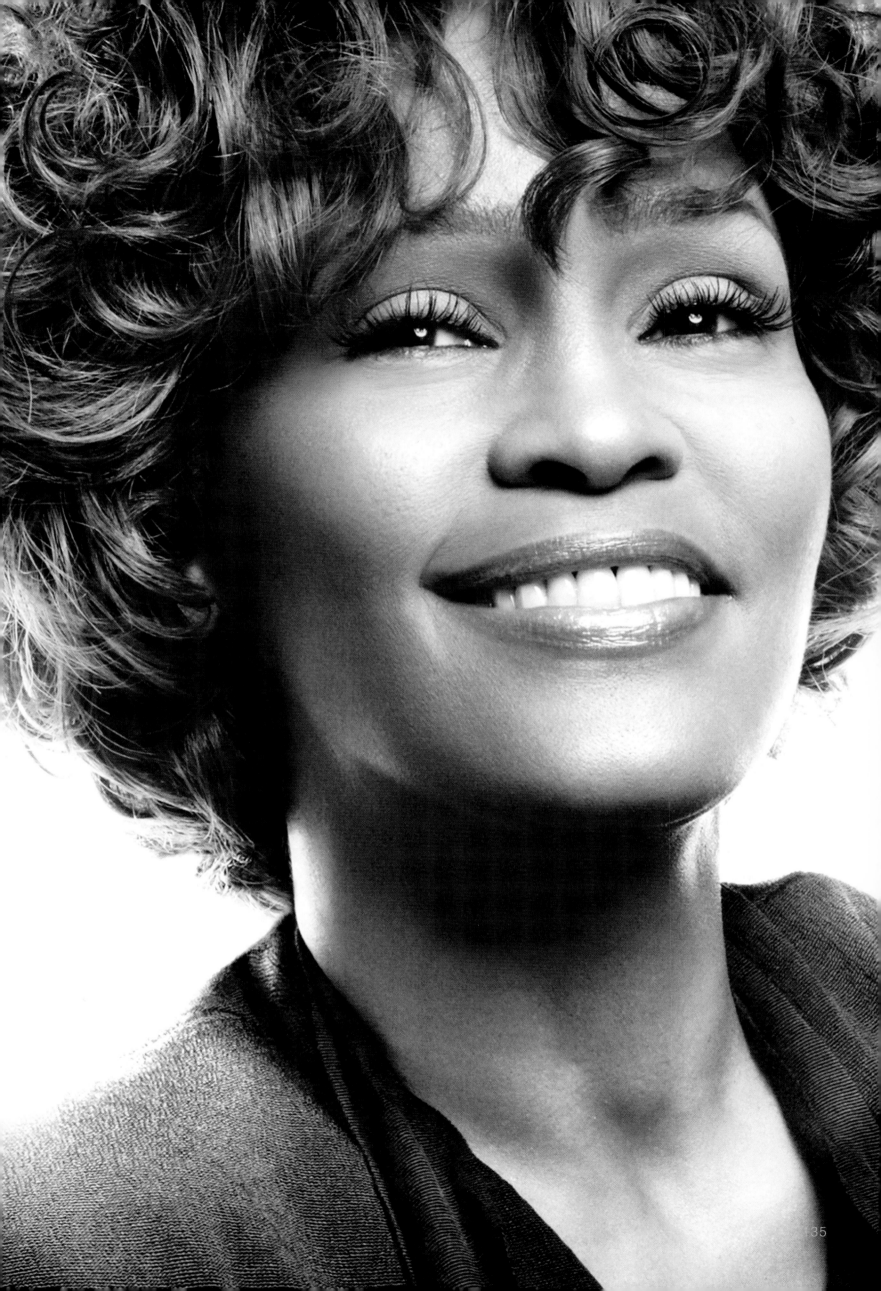

Atlanta, Georgia 2009

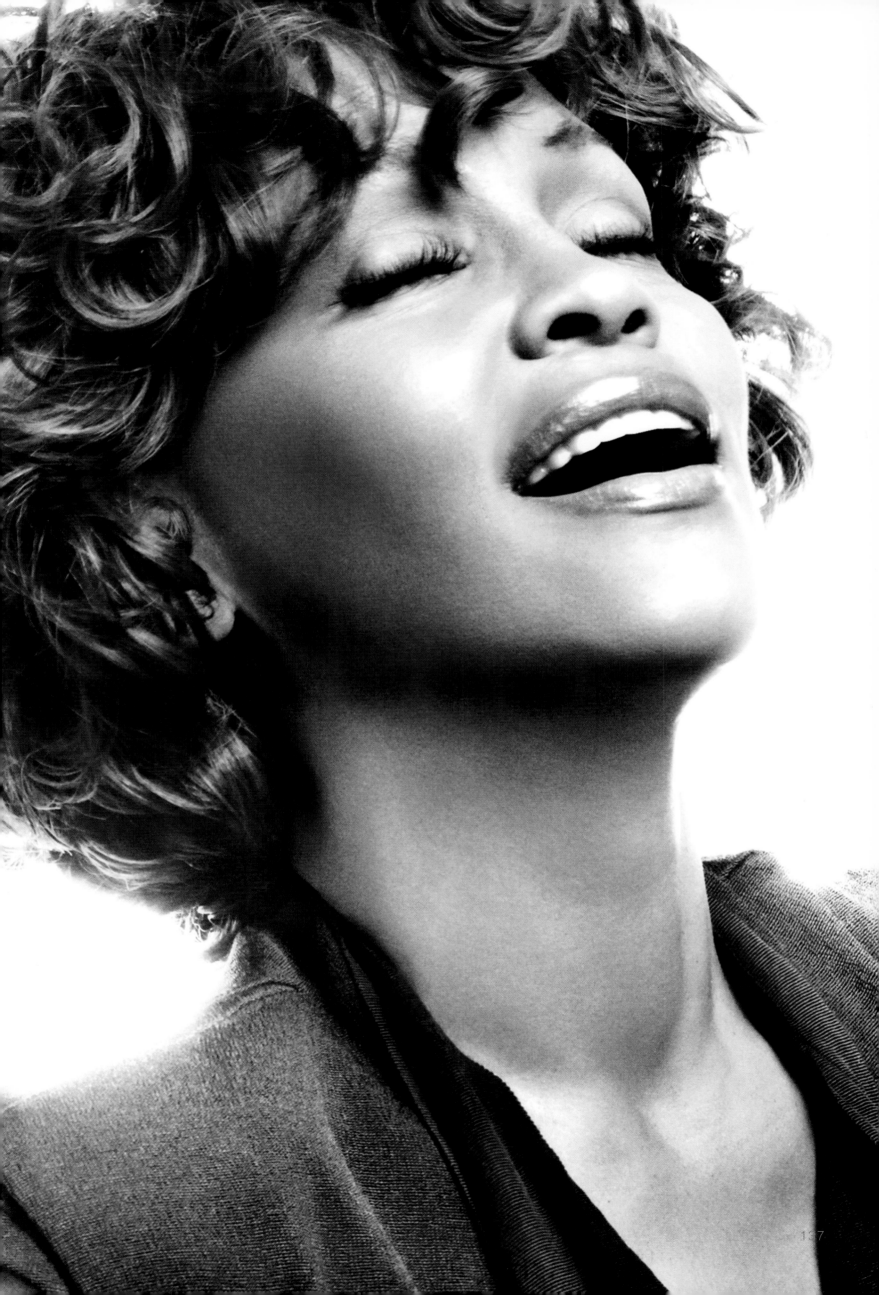

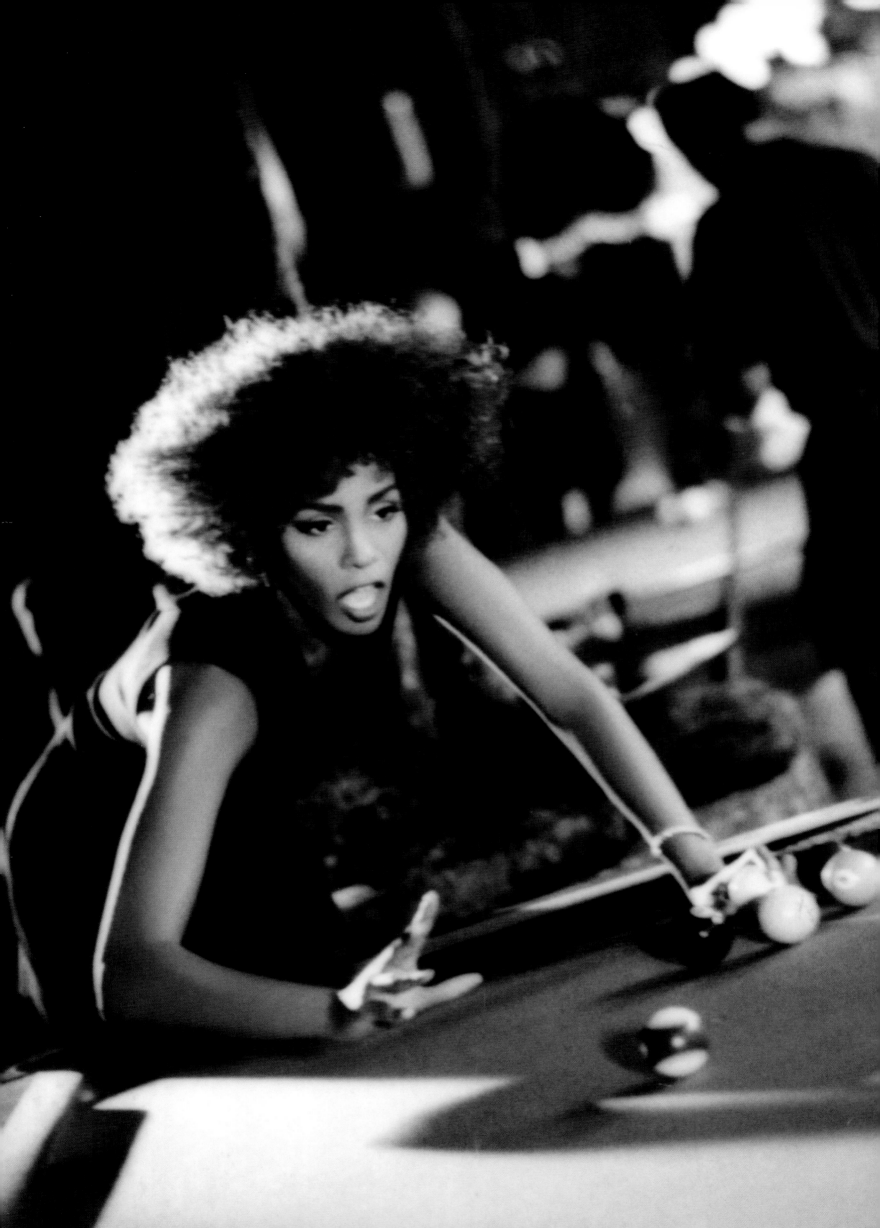

New York City 1990

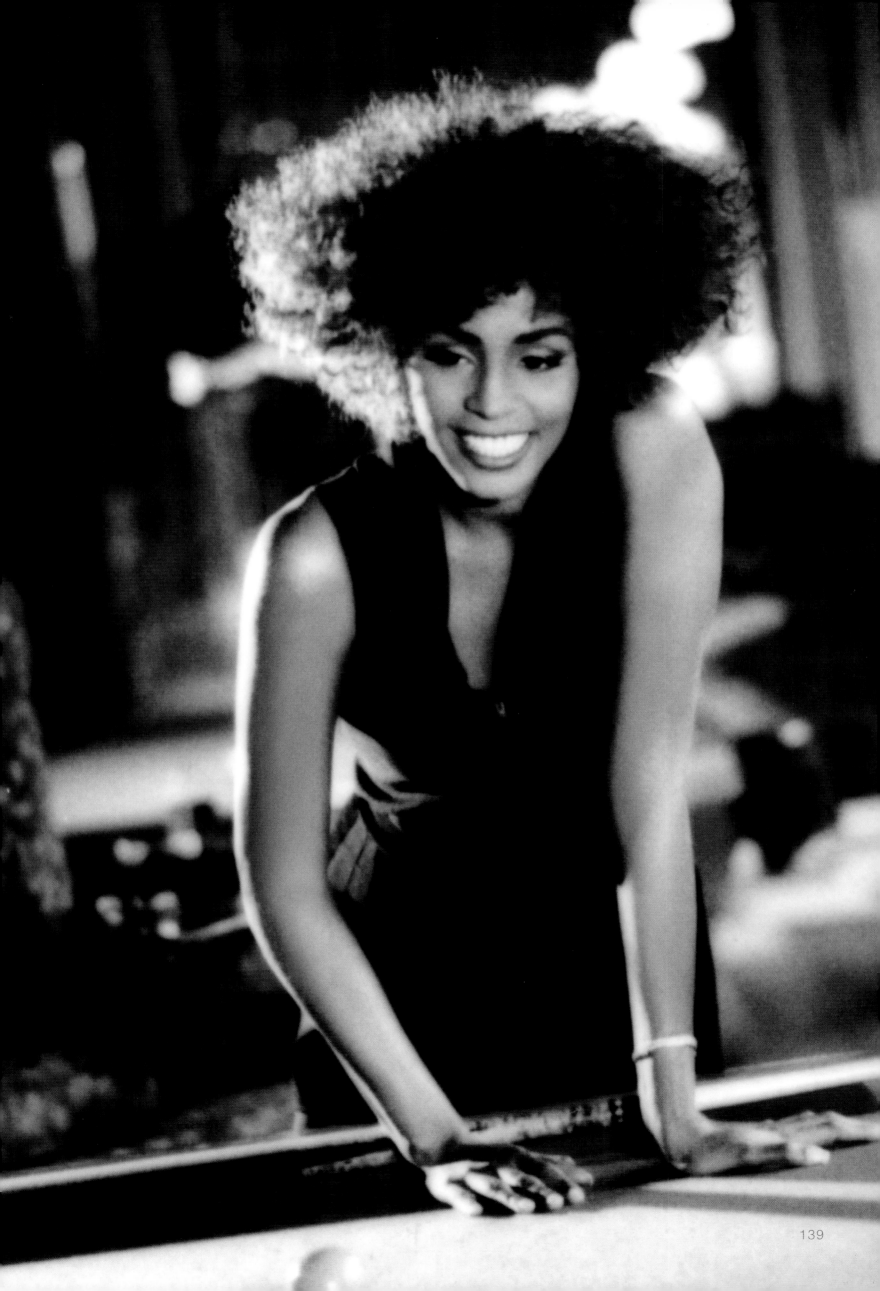

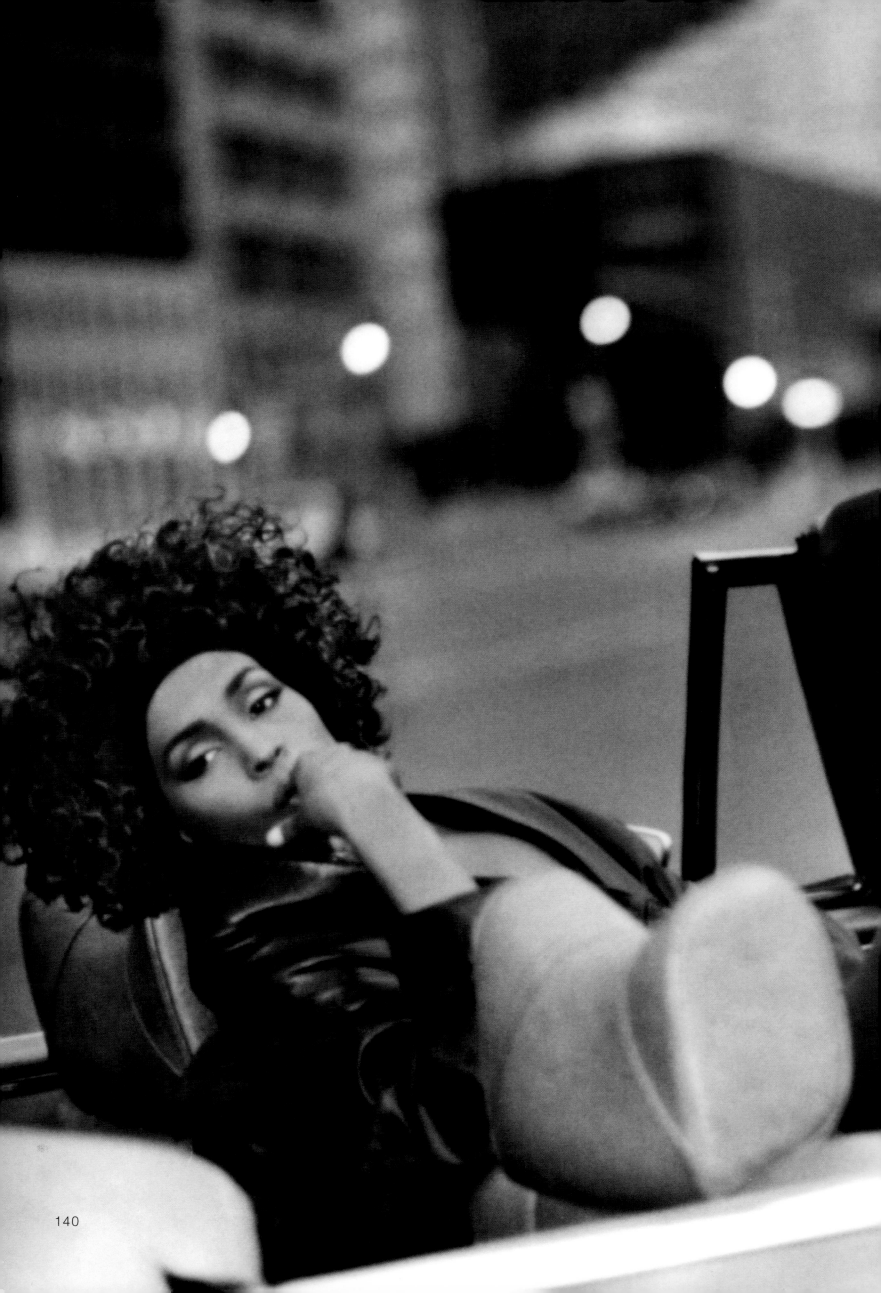

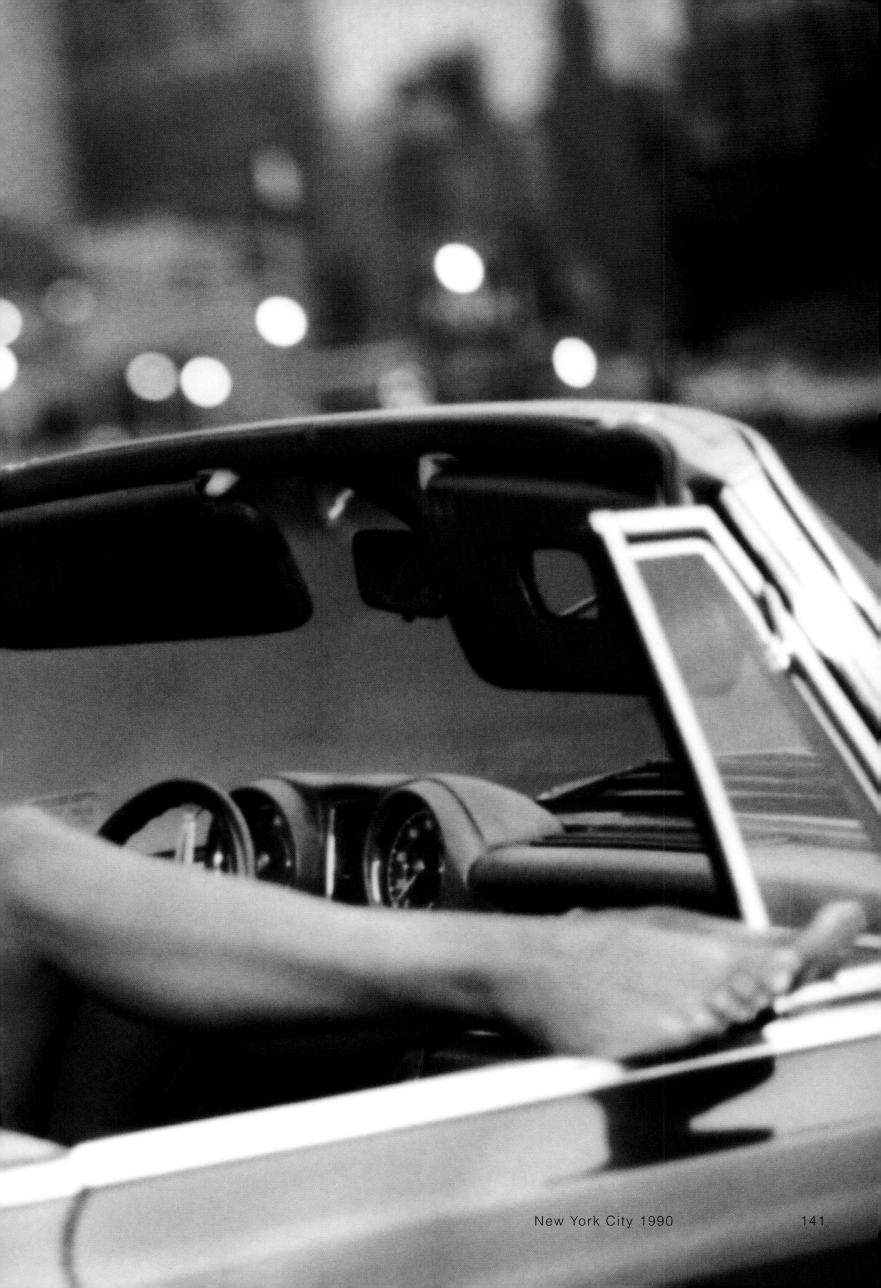

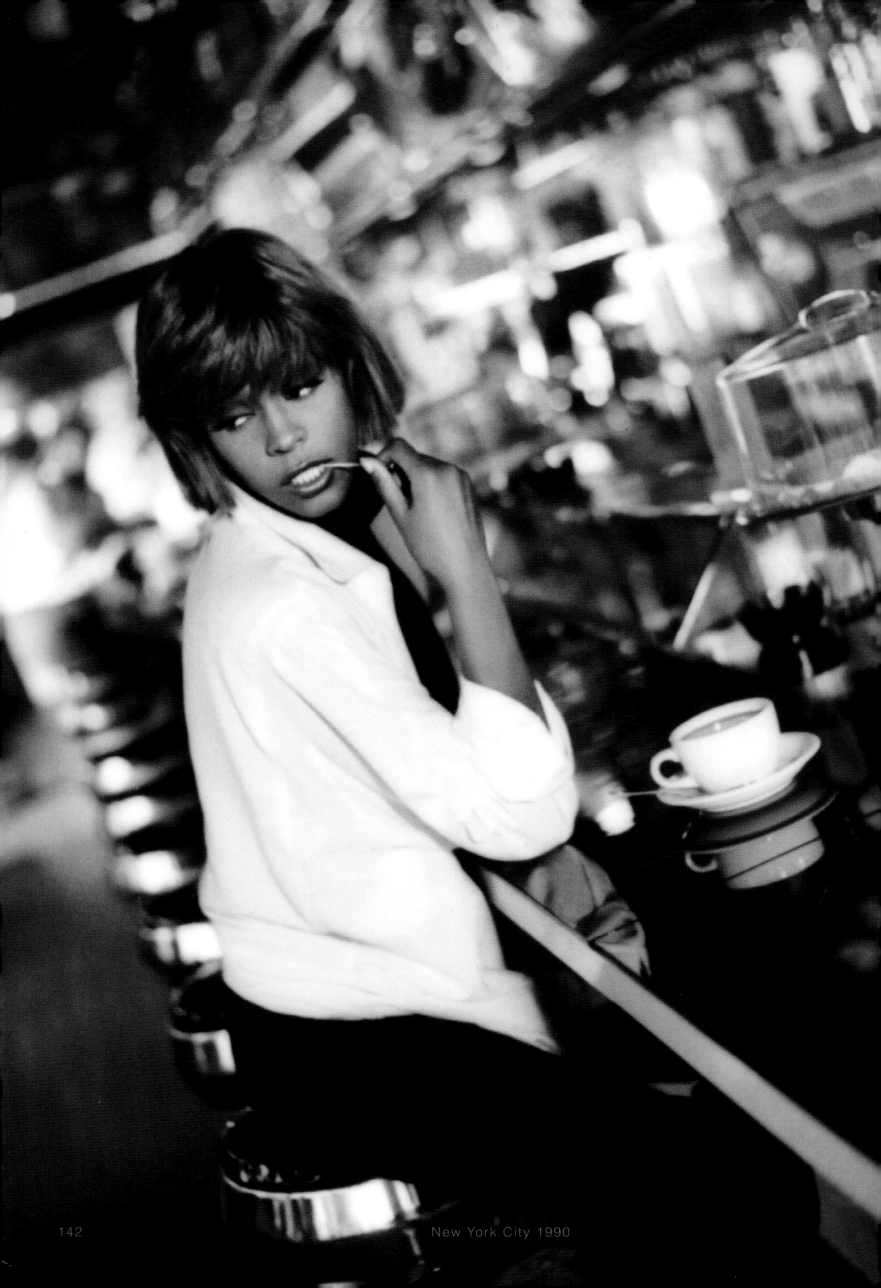

New York City 1990

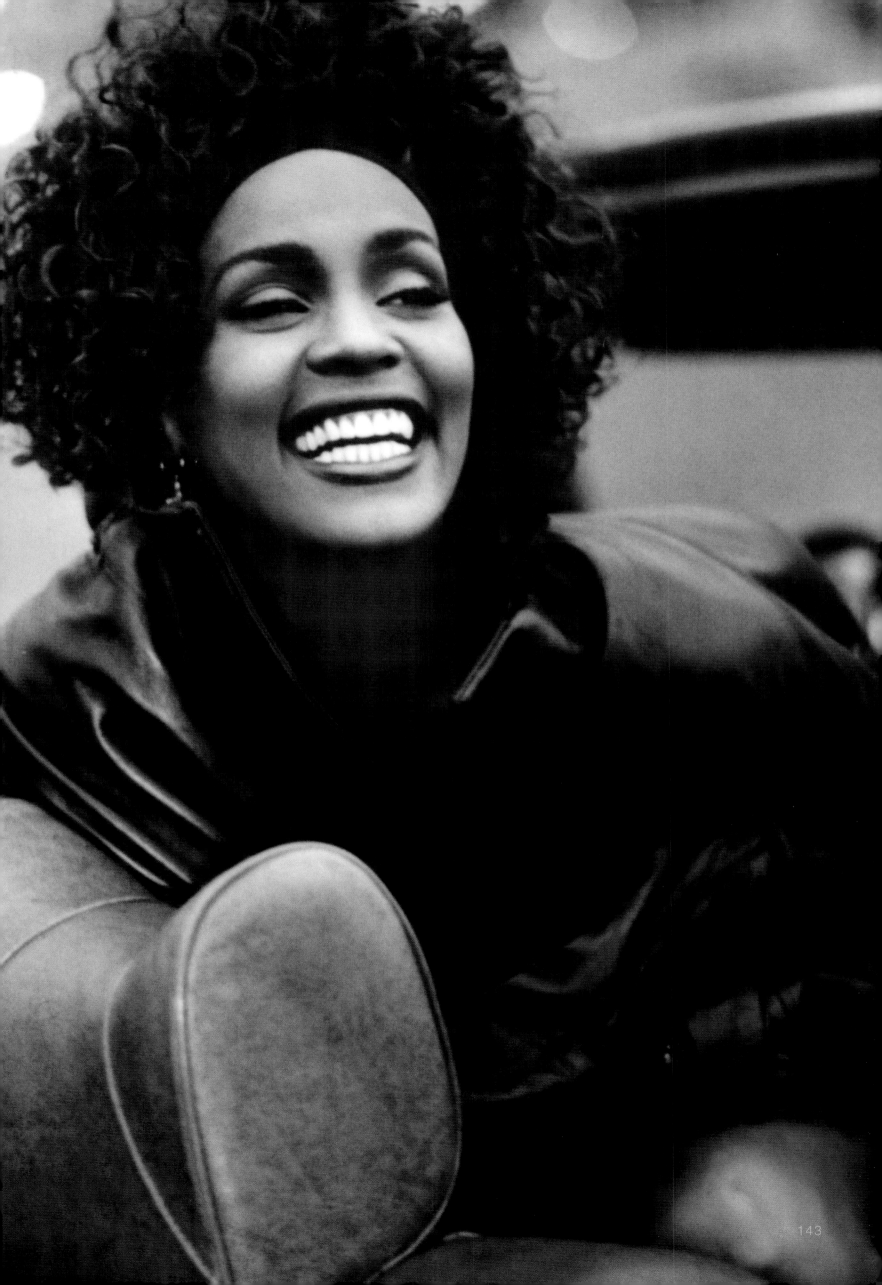

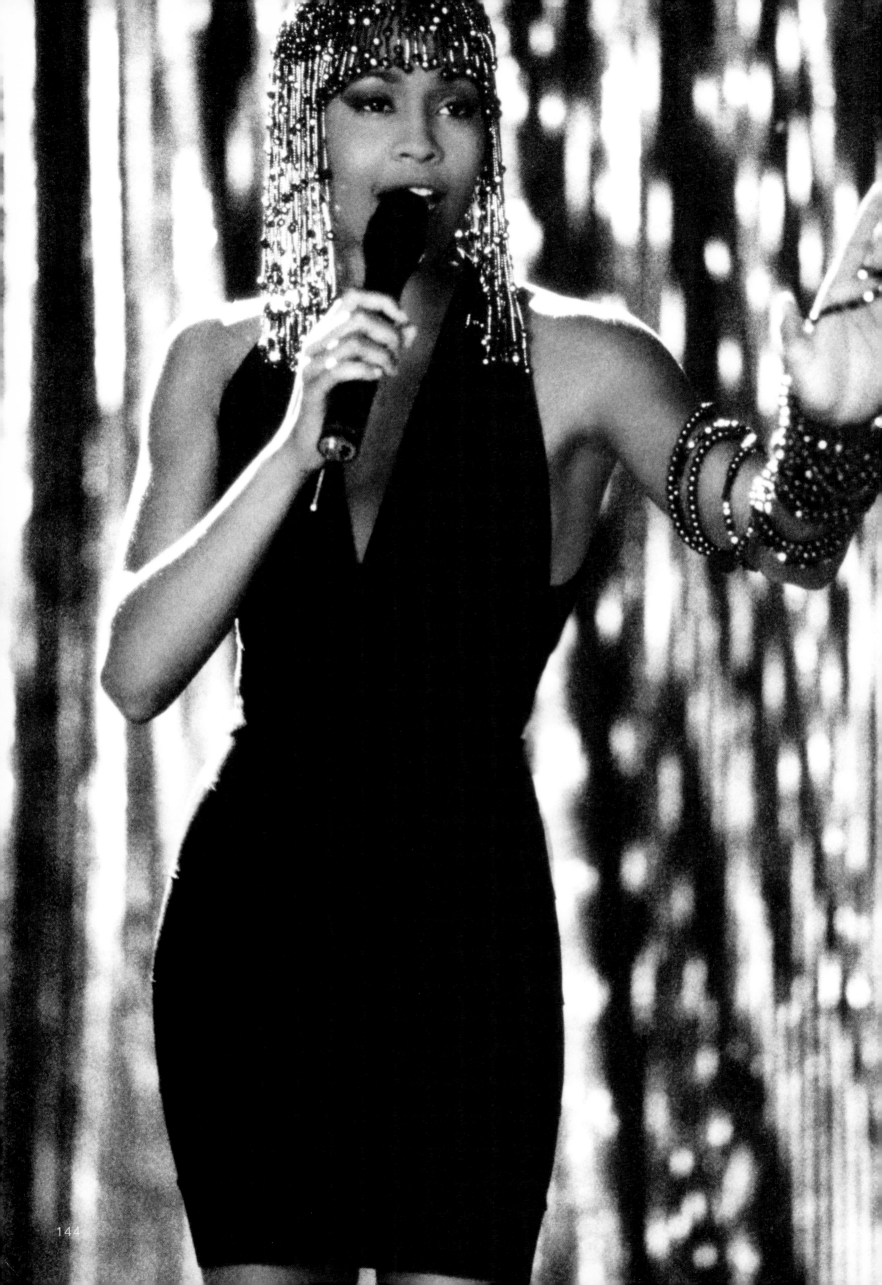

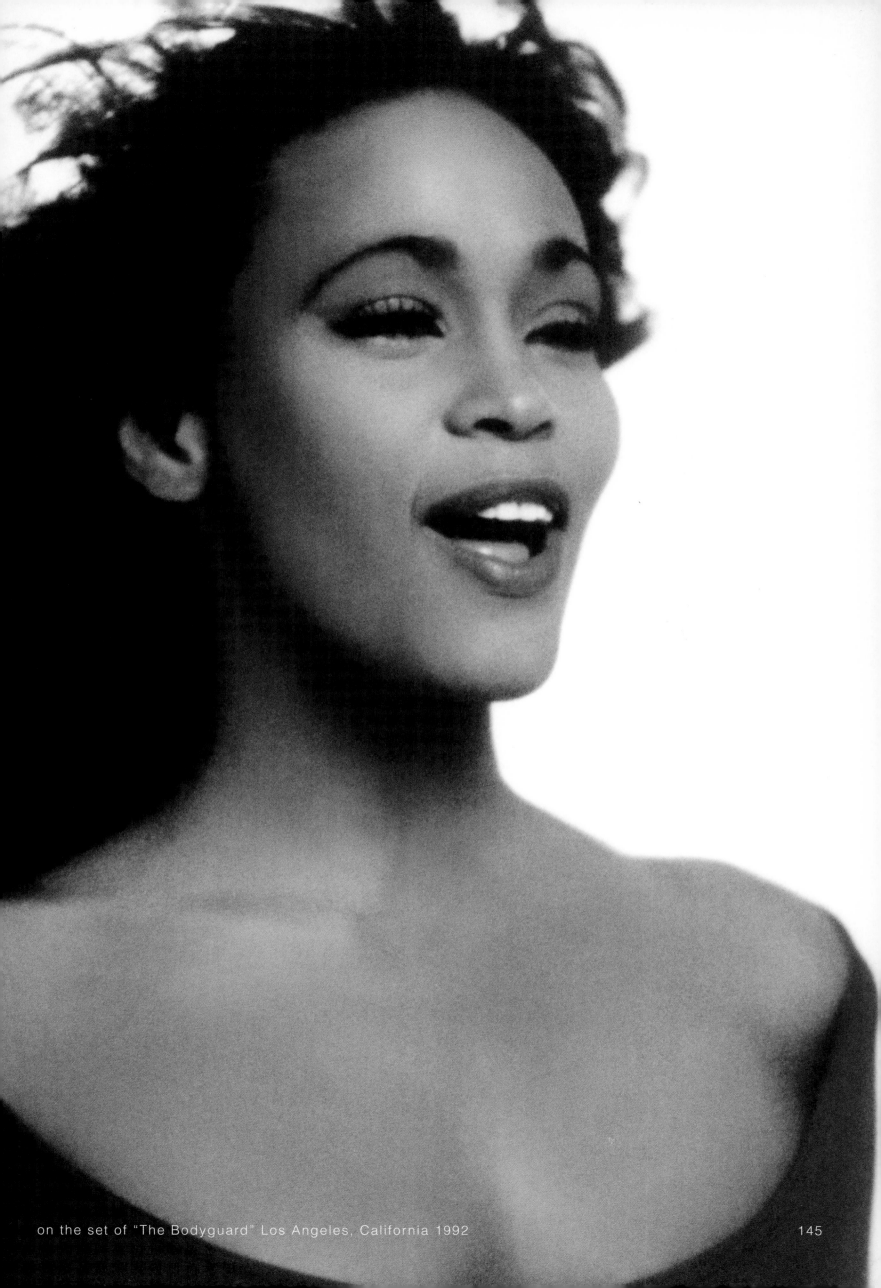

on the set of "The Bodyguard" Los Angeles, California 1992

"Your Love Is My Love" album shoot Mendham, New Jersey 1998

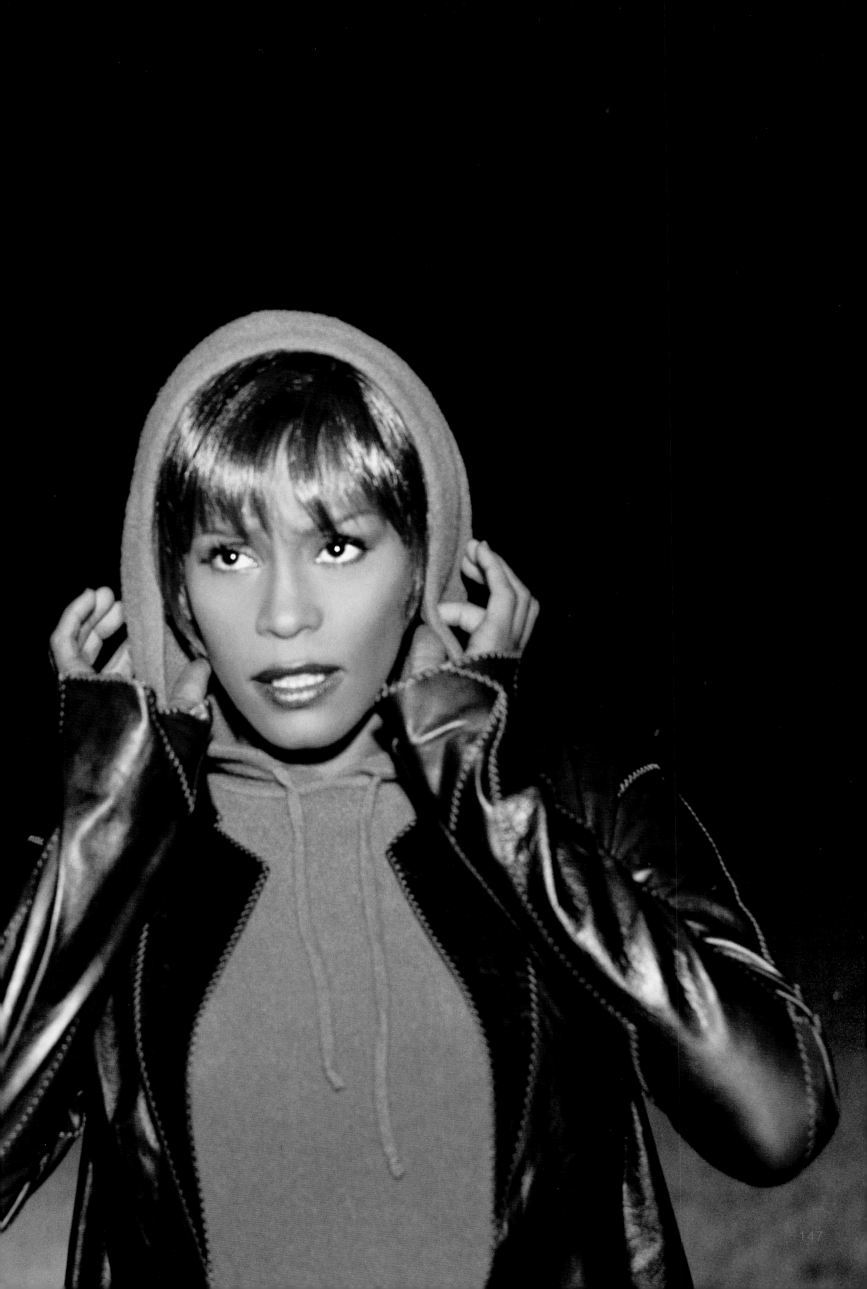

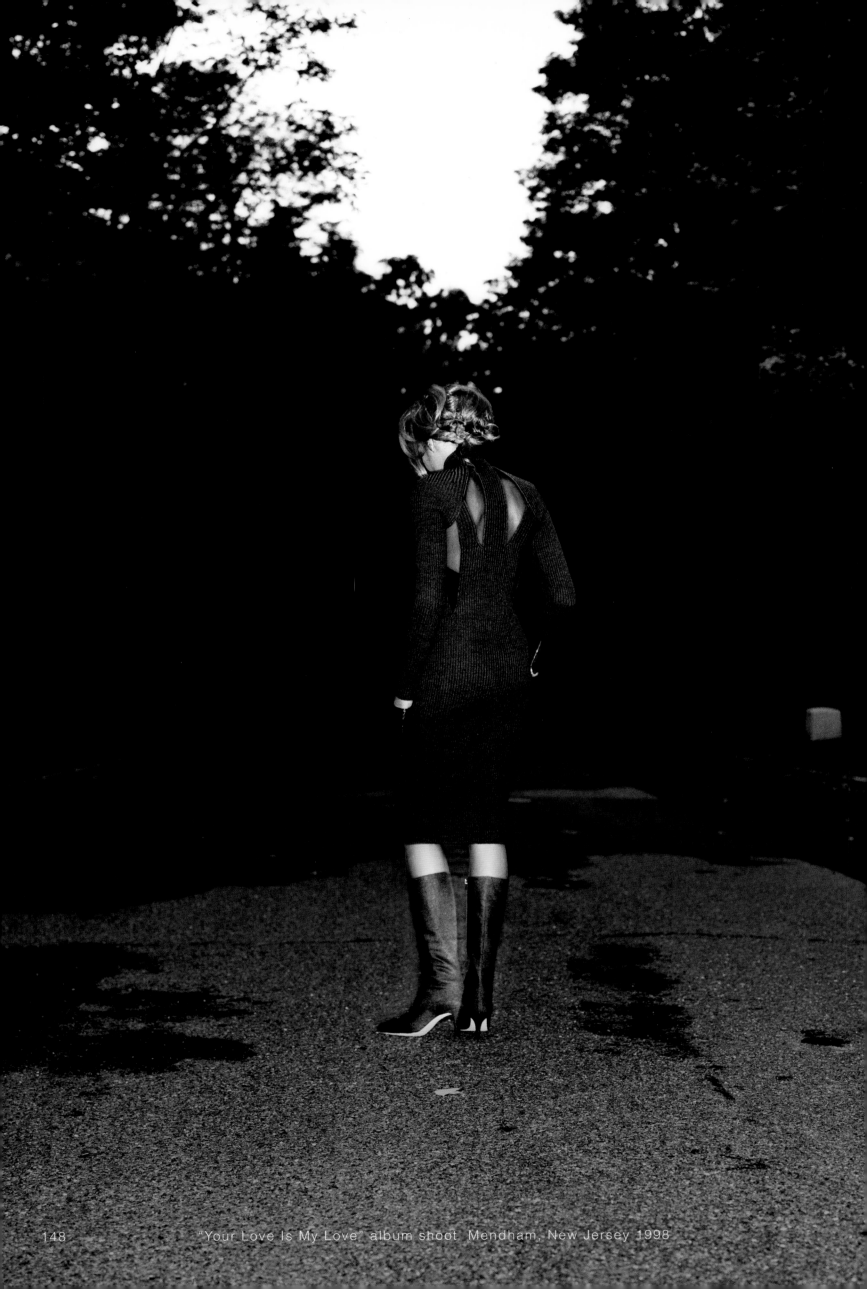

"Your Love Is My Love" album shoot, Mendham, New Jersey 1998

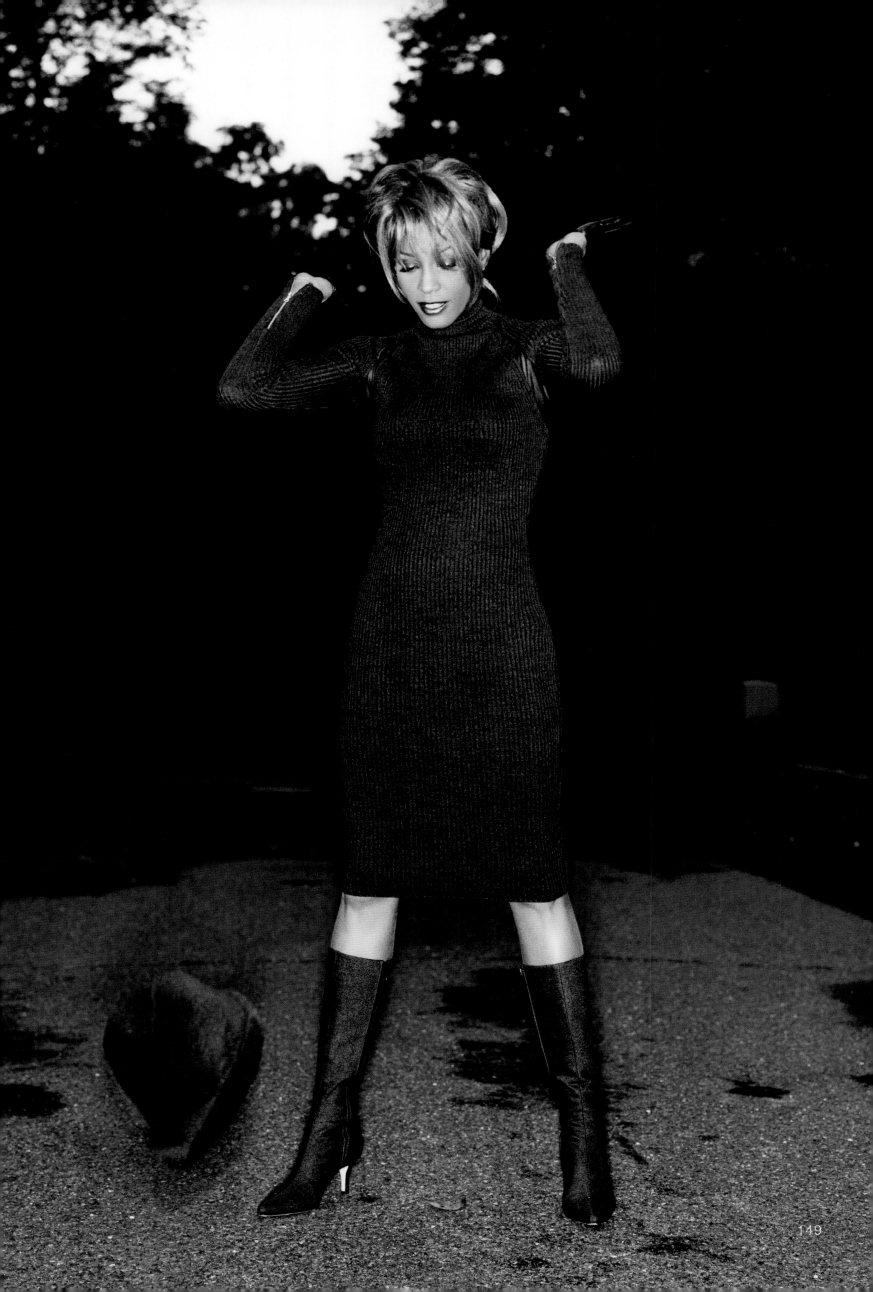

Wembley Stadium London 1988

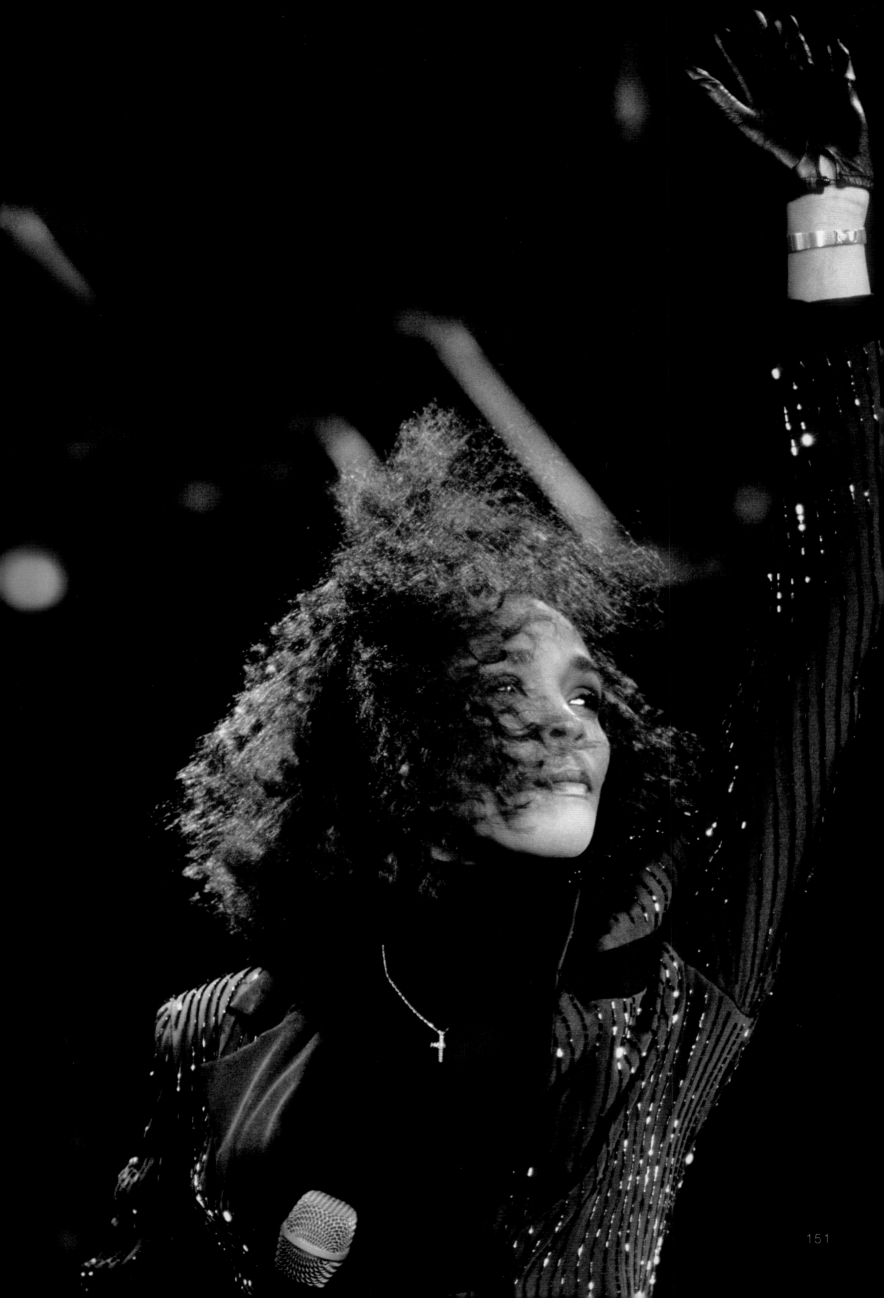

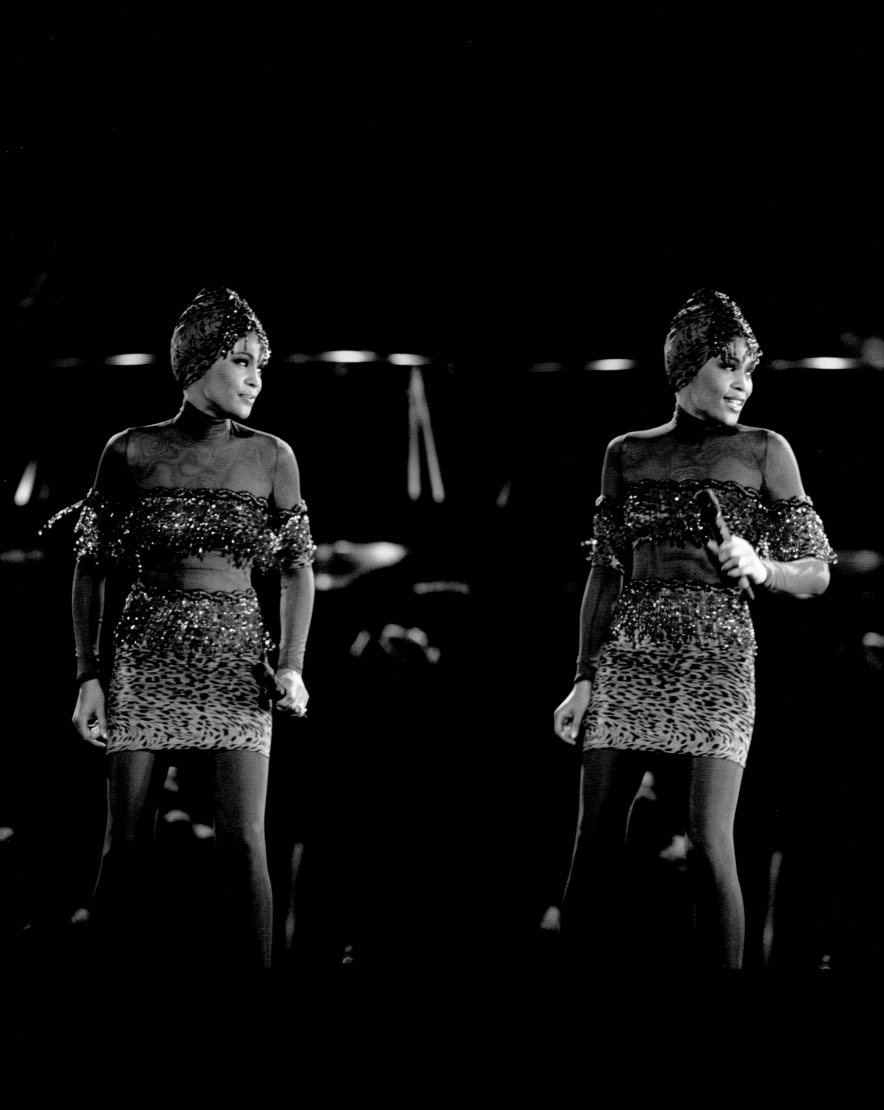

South Africa Tour Durban 1994

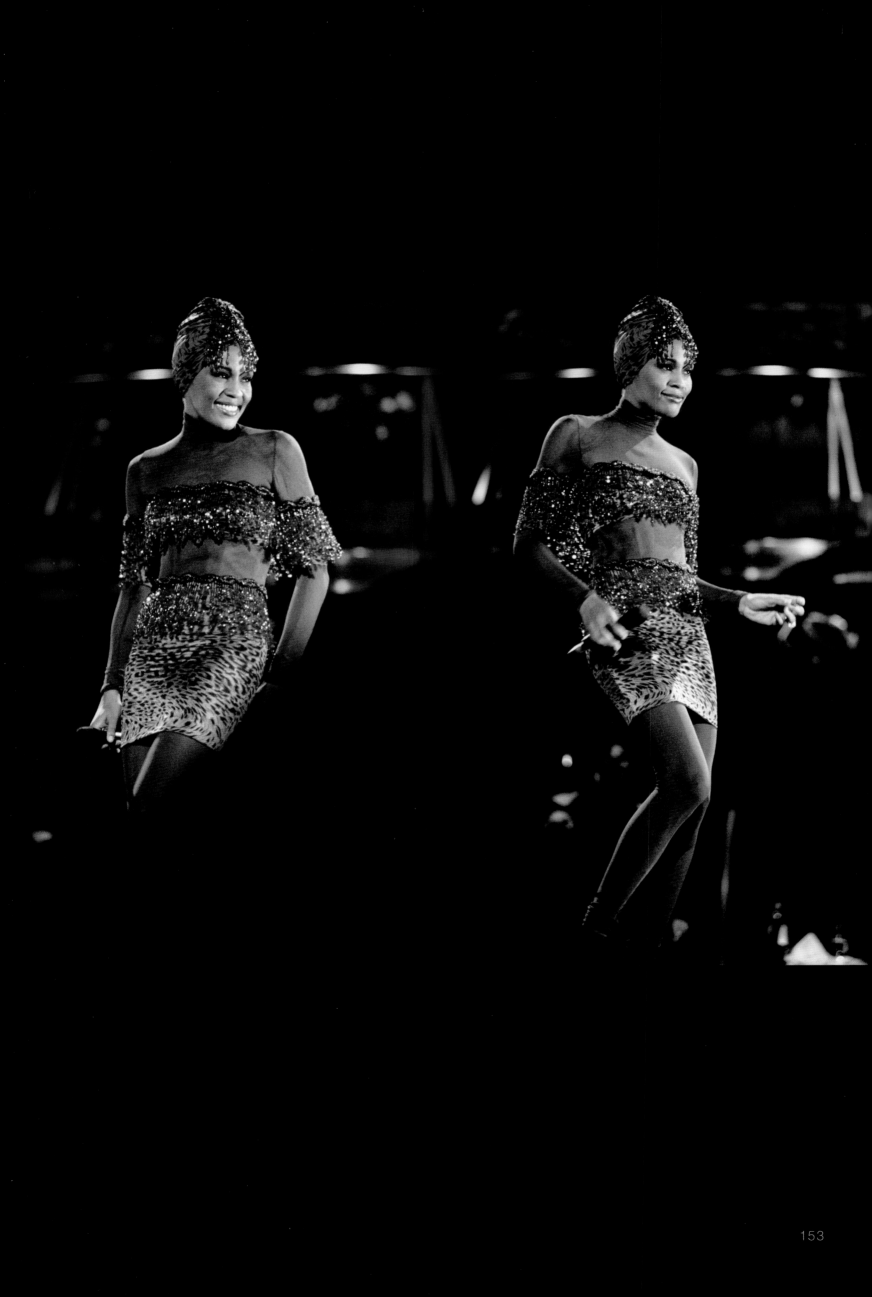

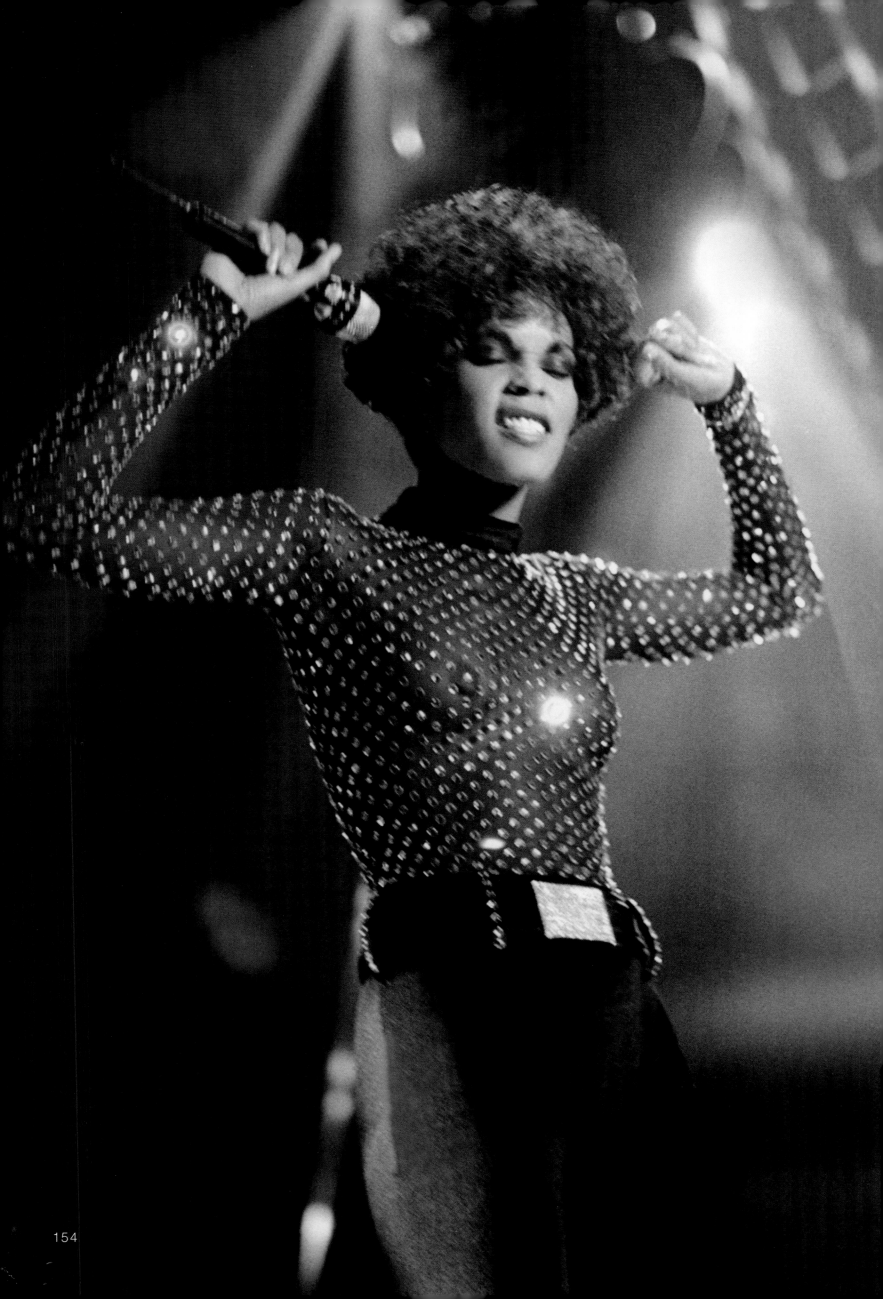

"Soul Train" 1990s

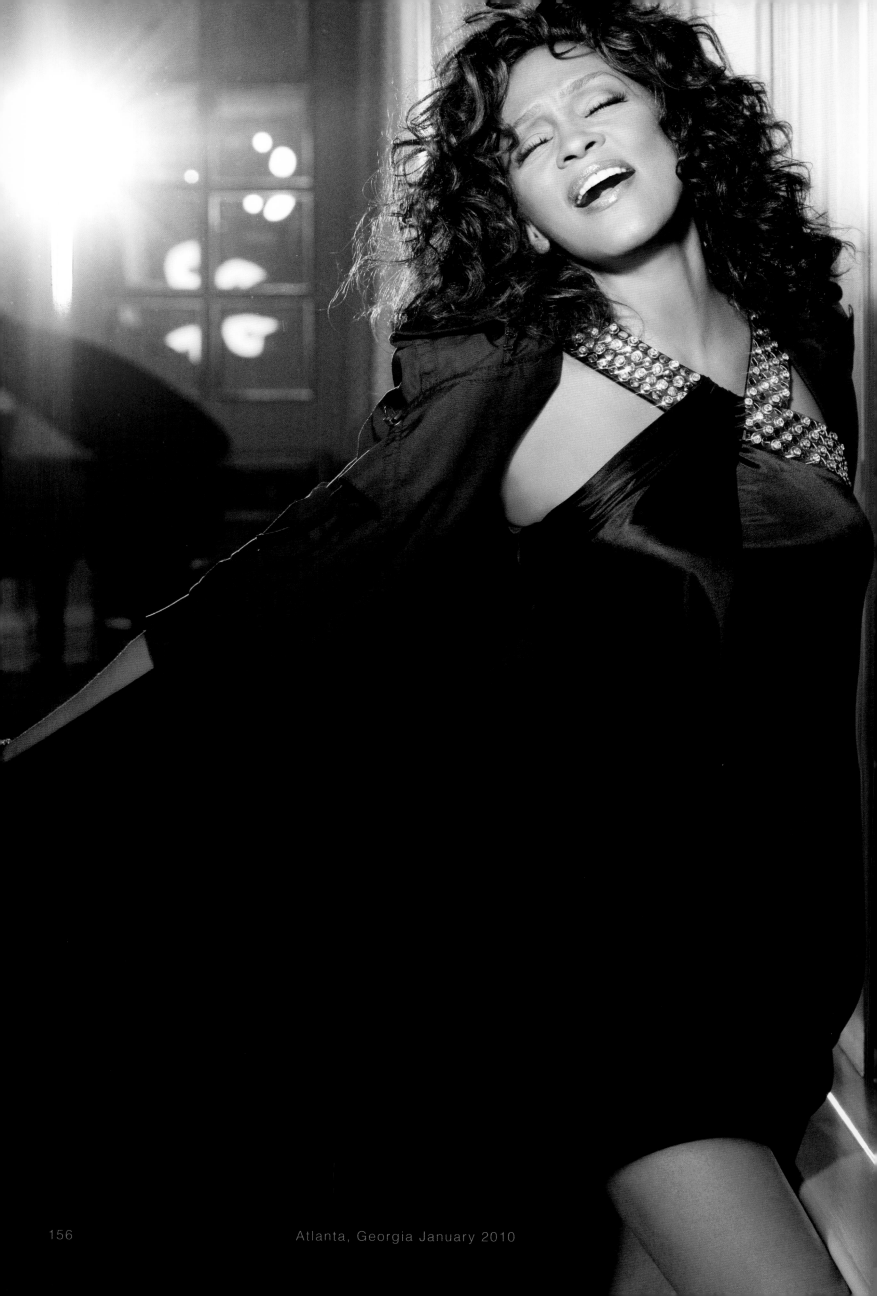

Atlanta, Georgia January 2010

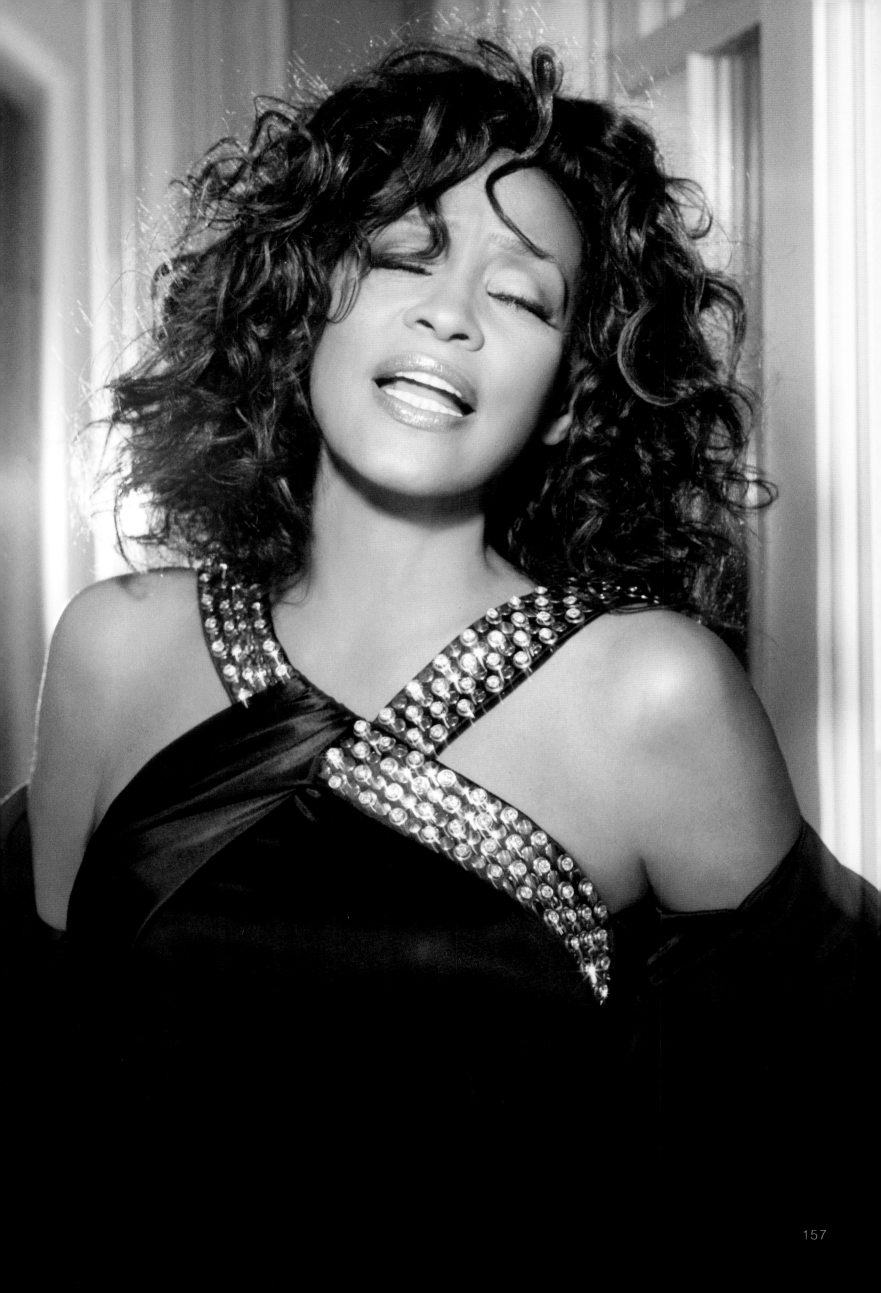

158

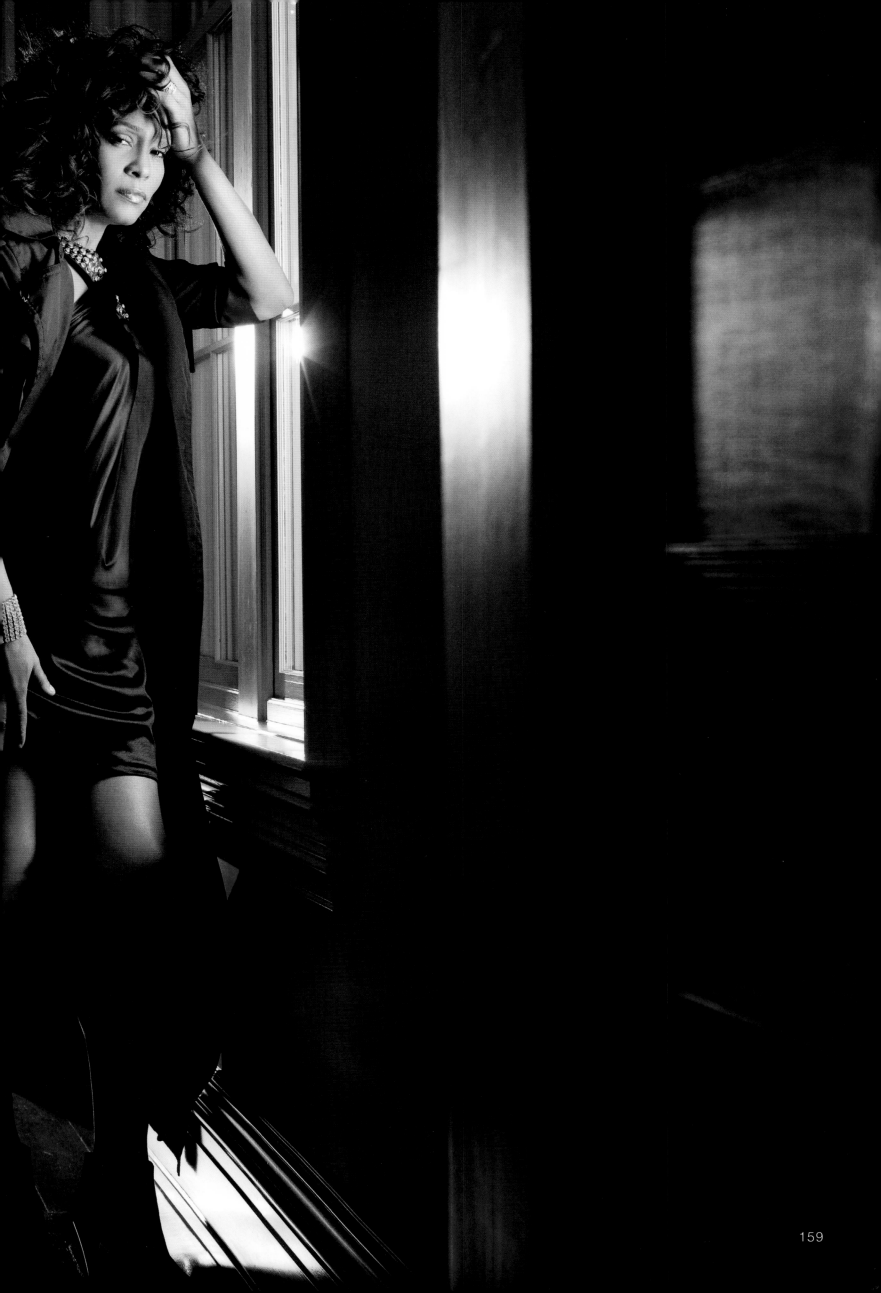

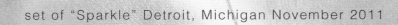

set of "Sparkle" Detroit, Michigan November 2011

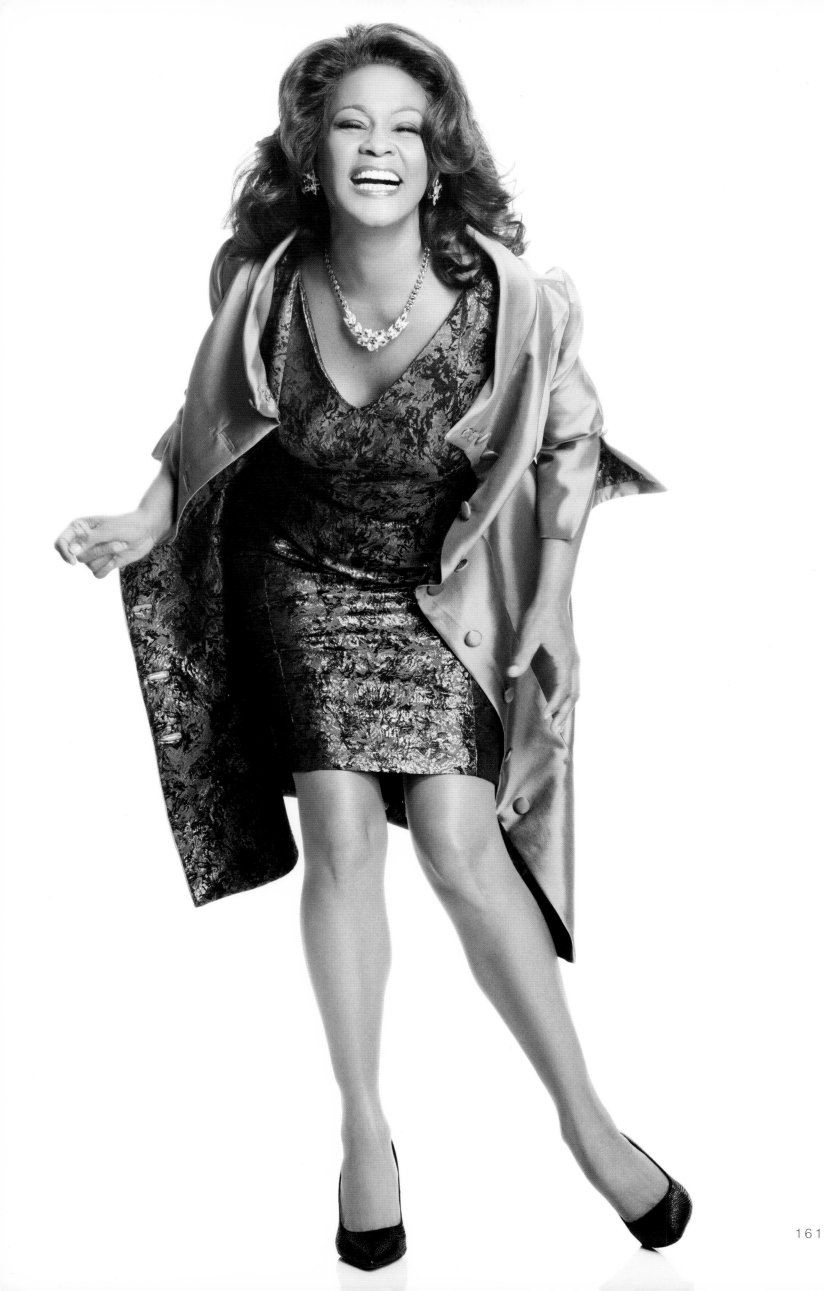

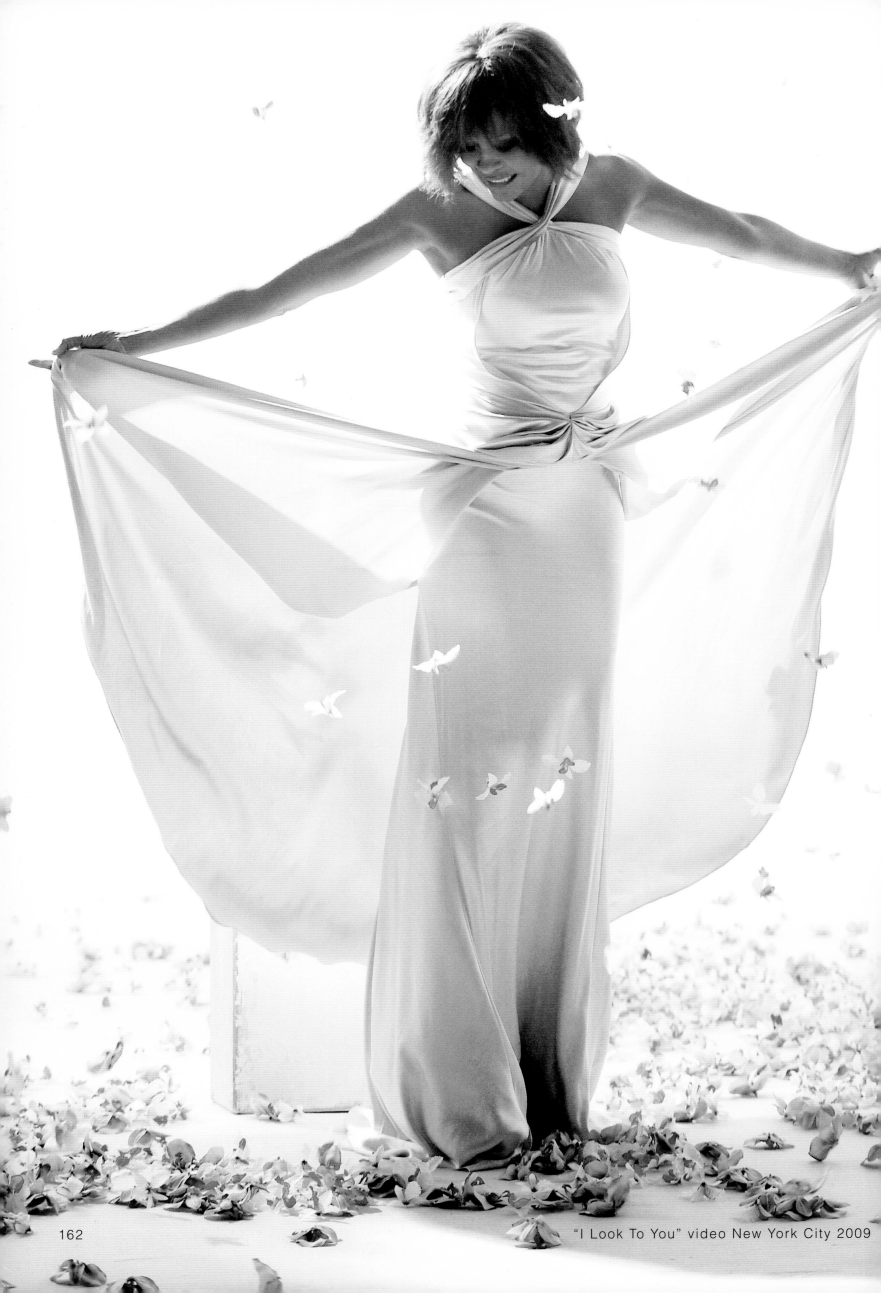

"I Look To You" video New York City 2009

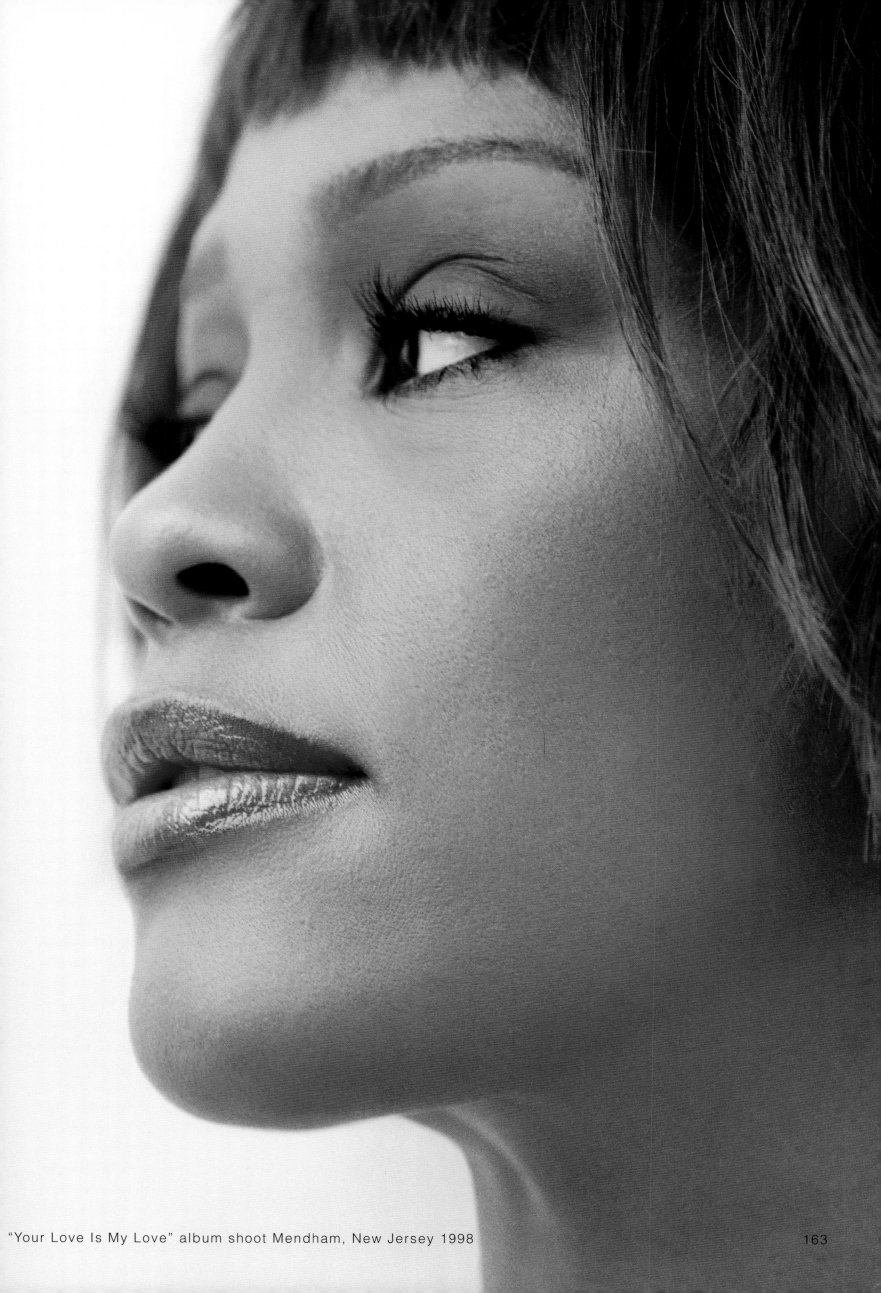

"Your Love Is My Love" album shoot Mendham, New Jersey 1998

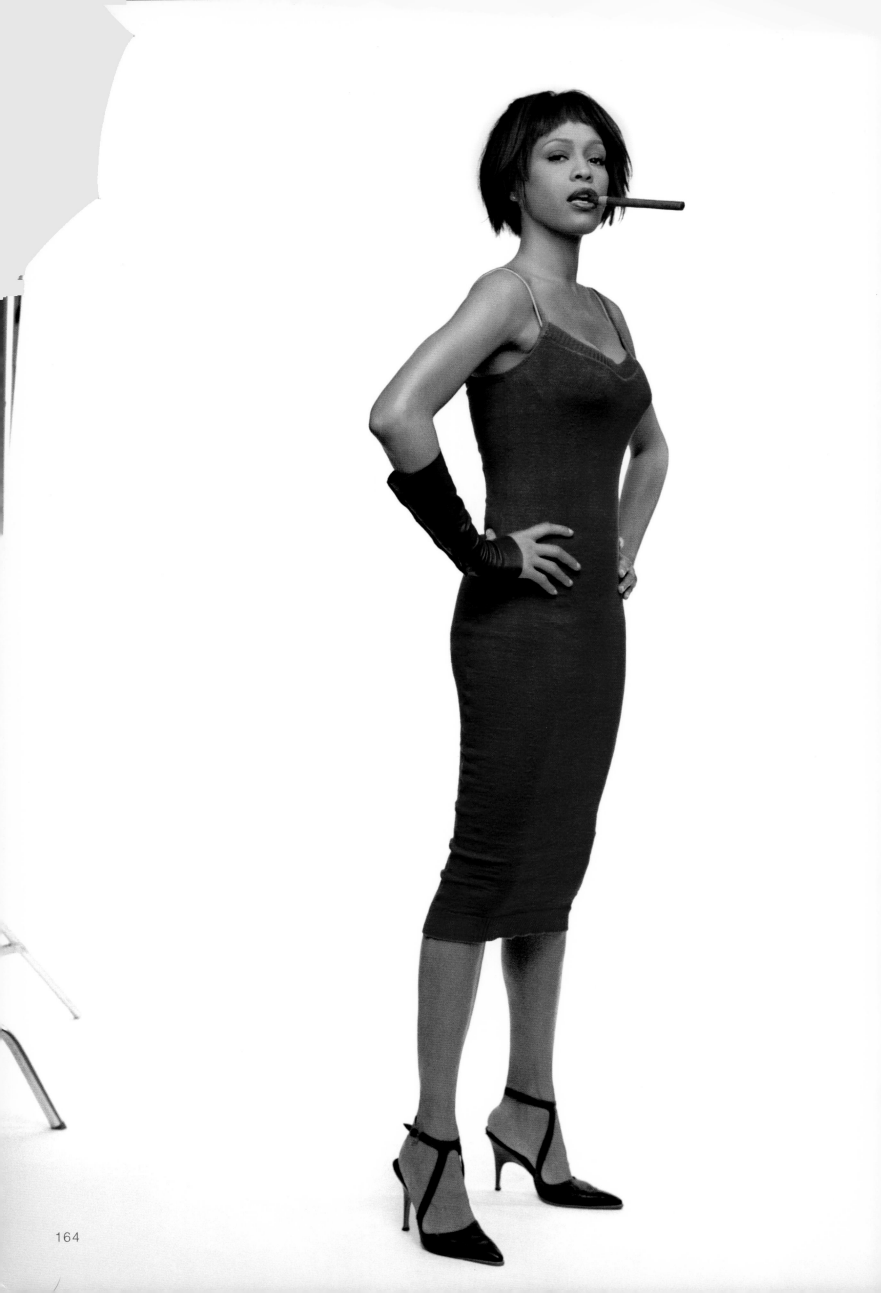

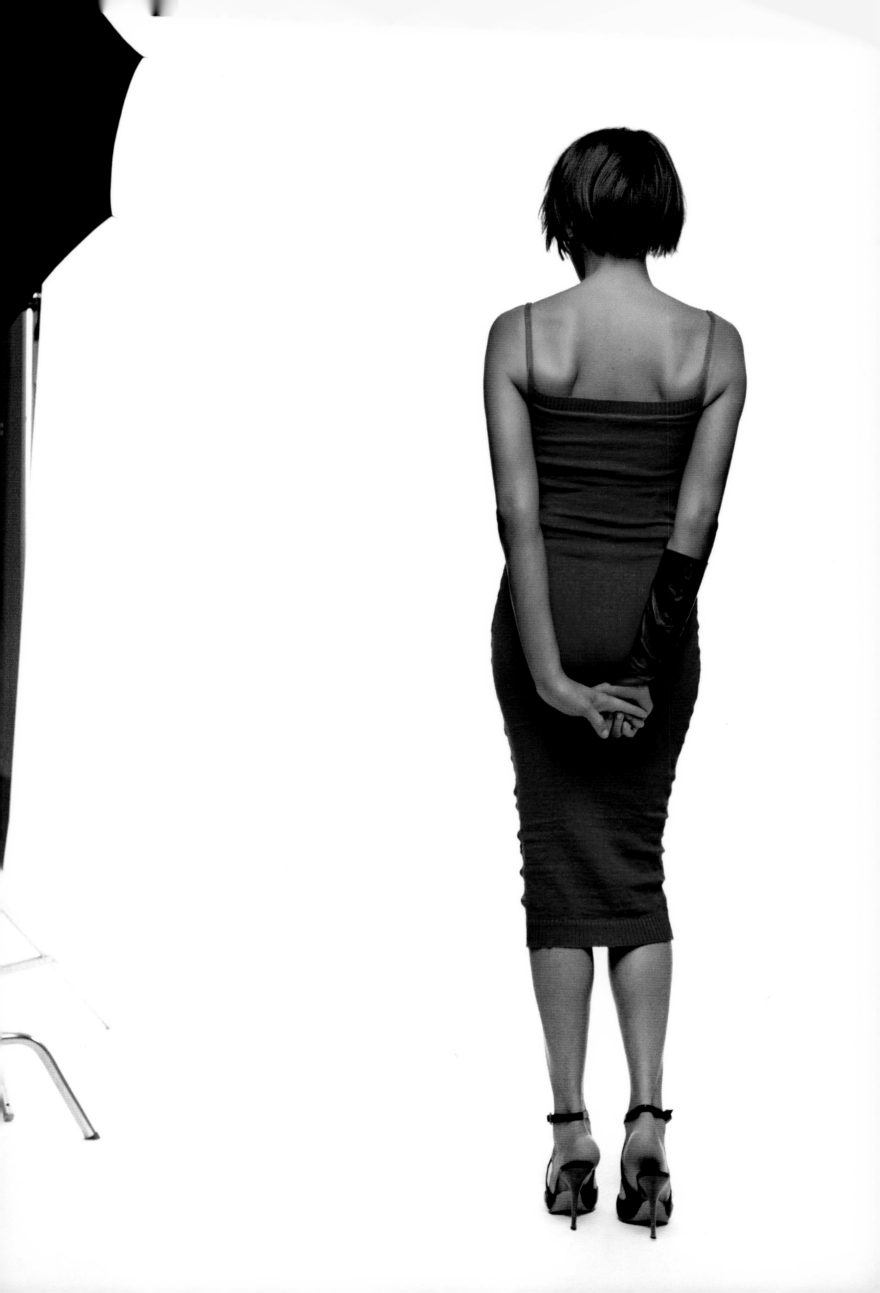

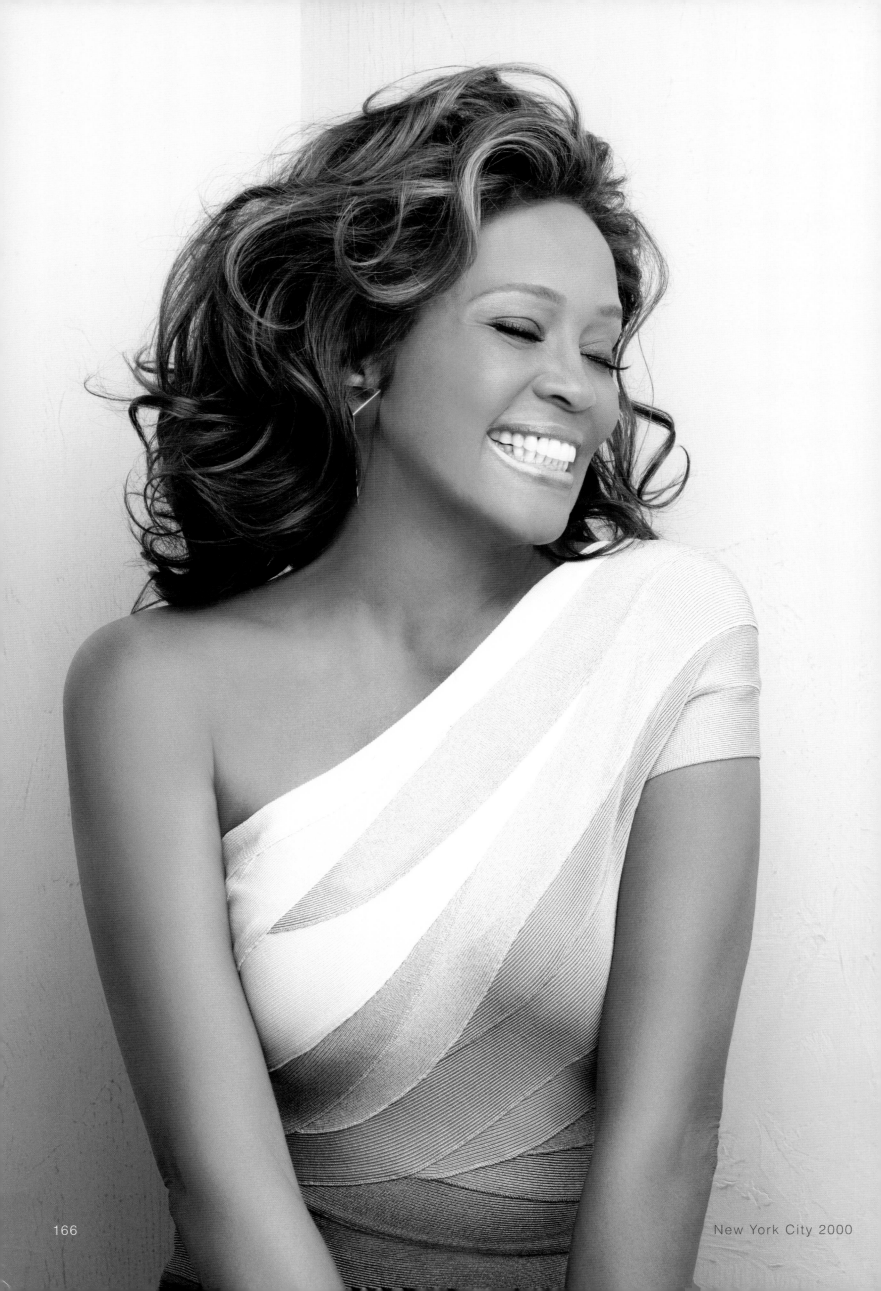

166

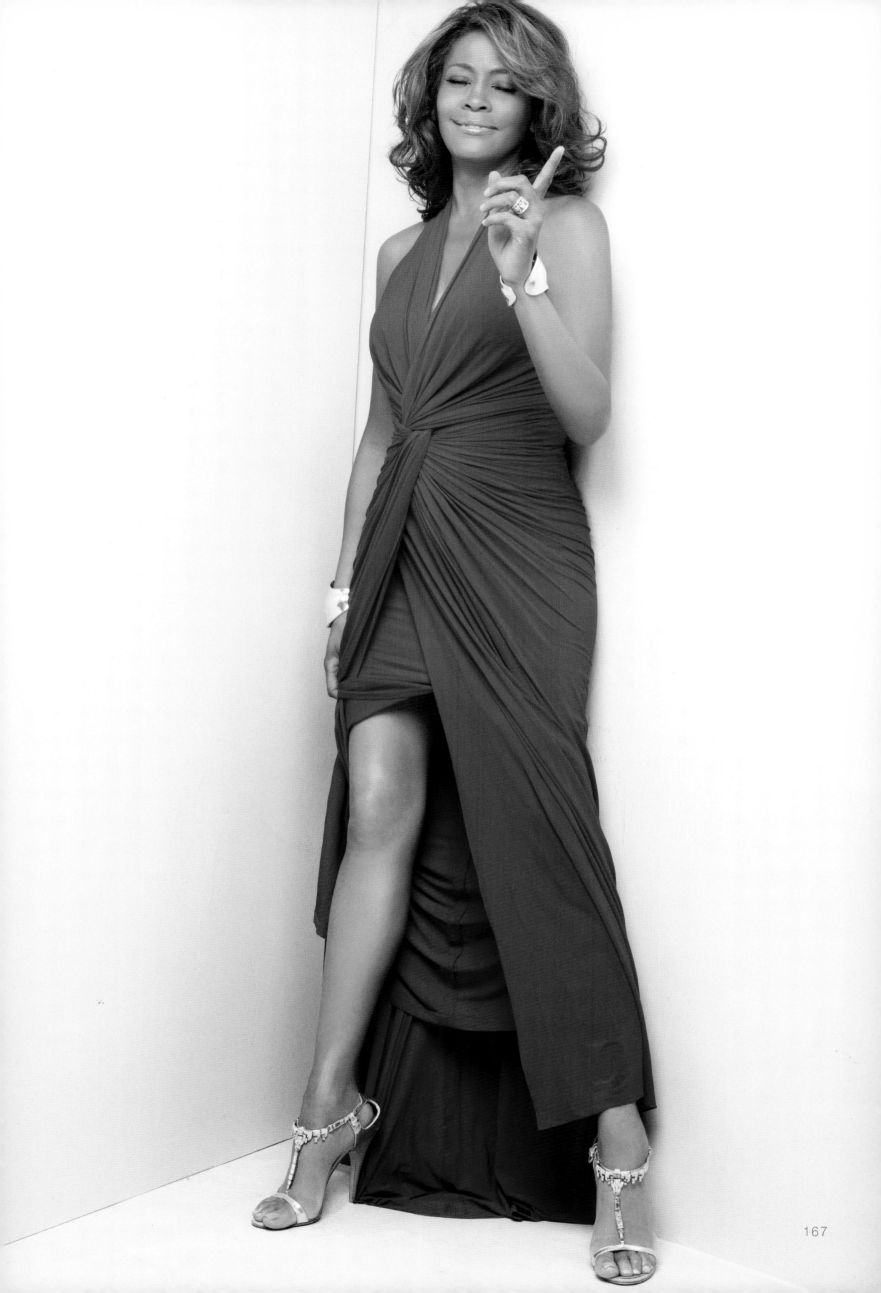

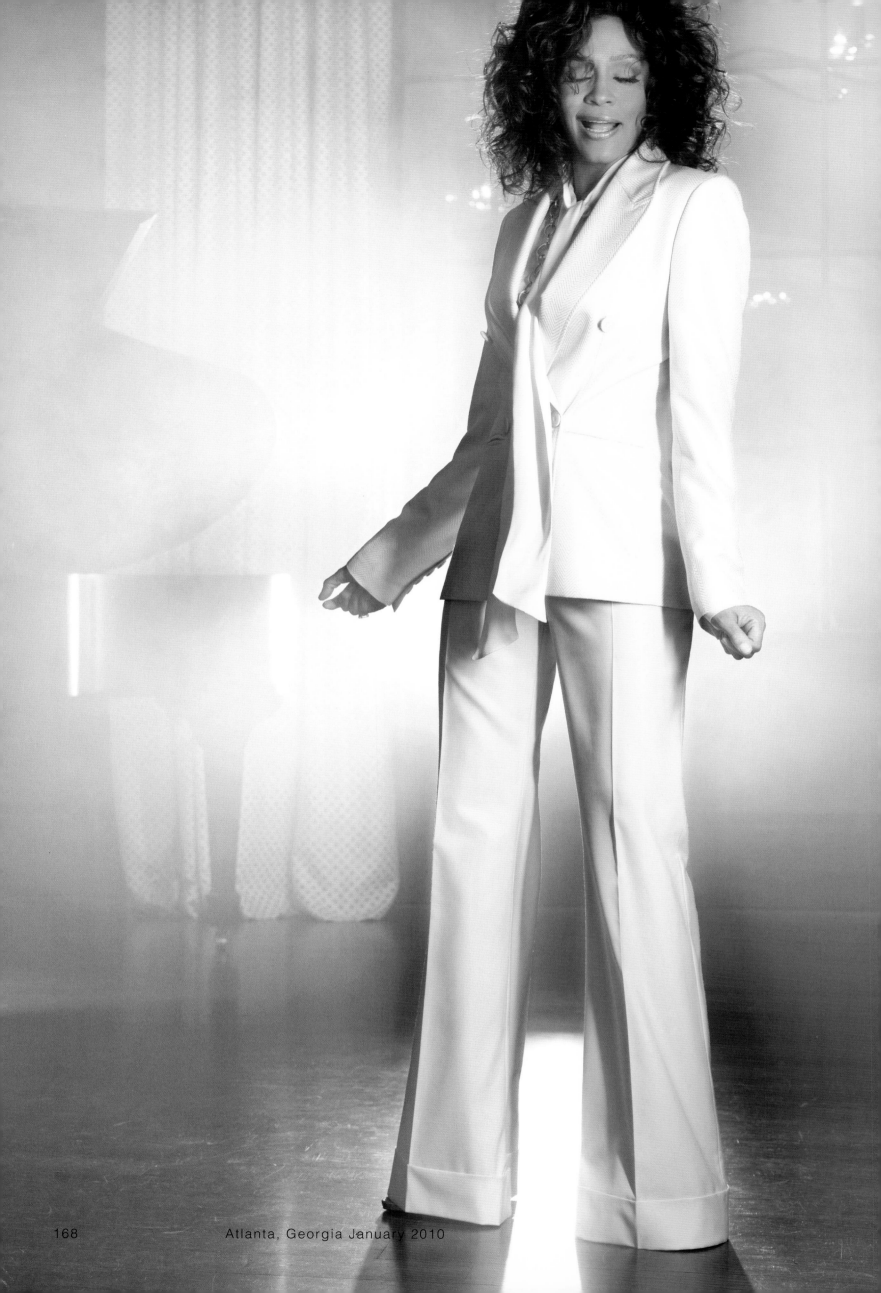

Atlanta, Georgia January 2010

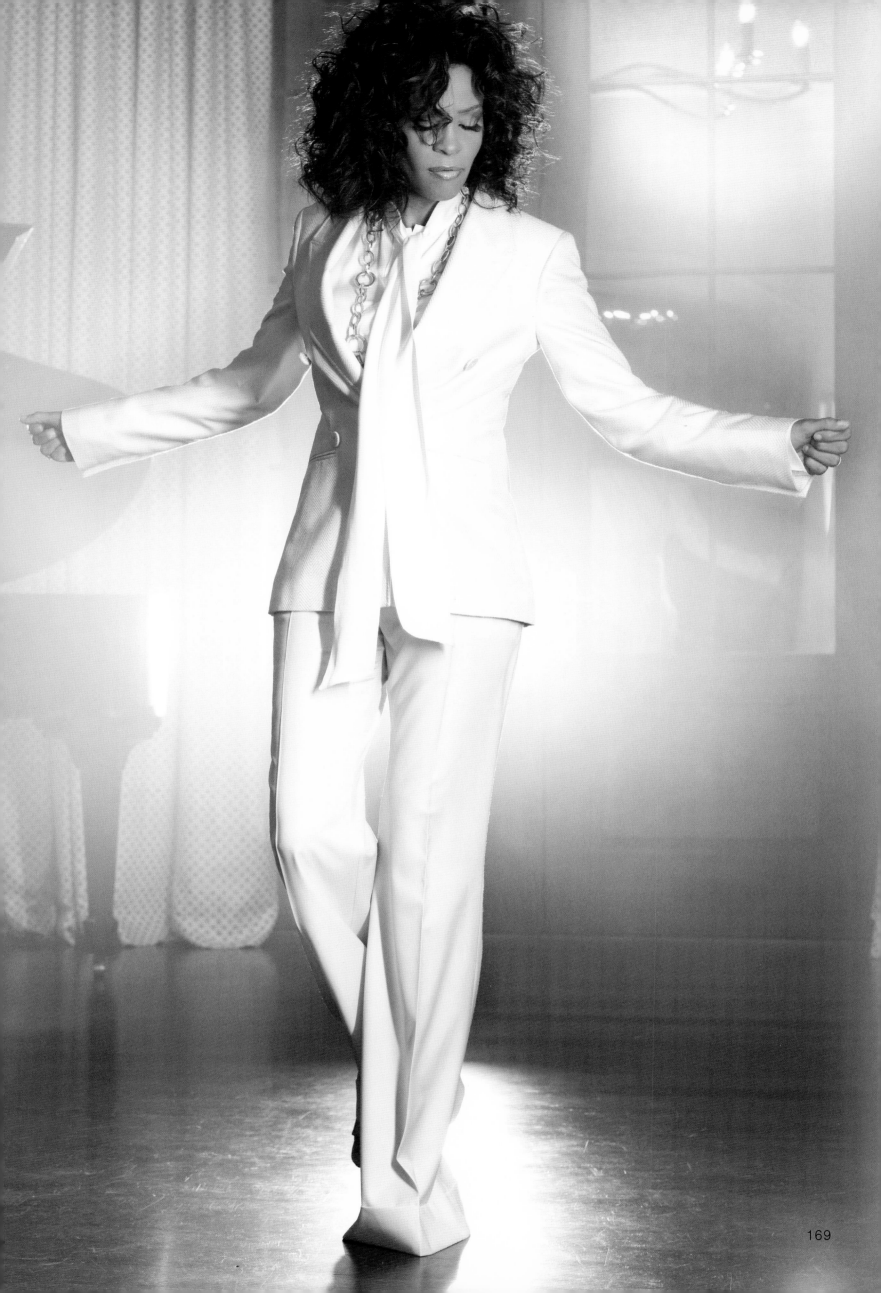

170

Atlanta, Georgia January 2010

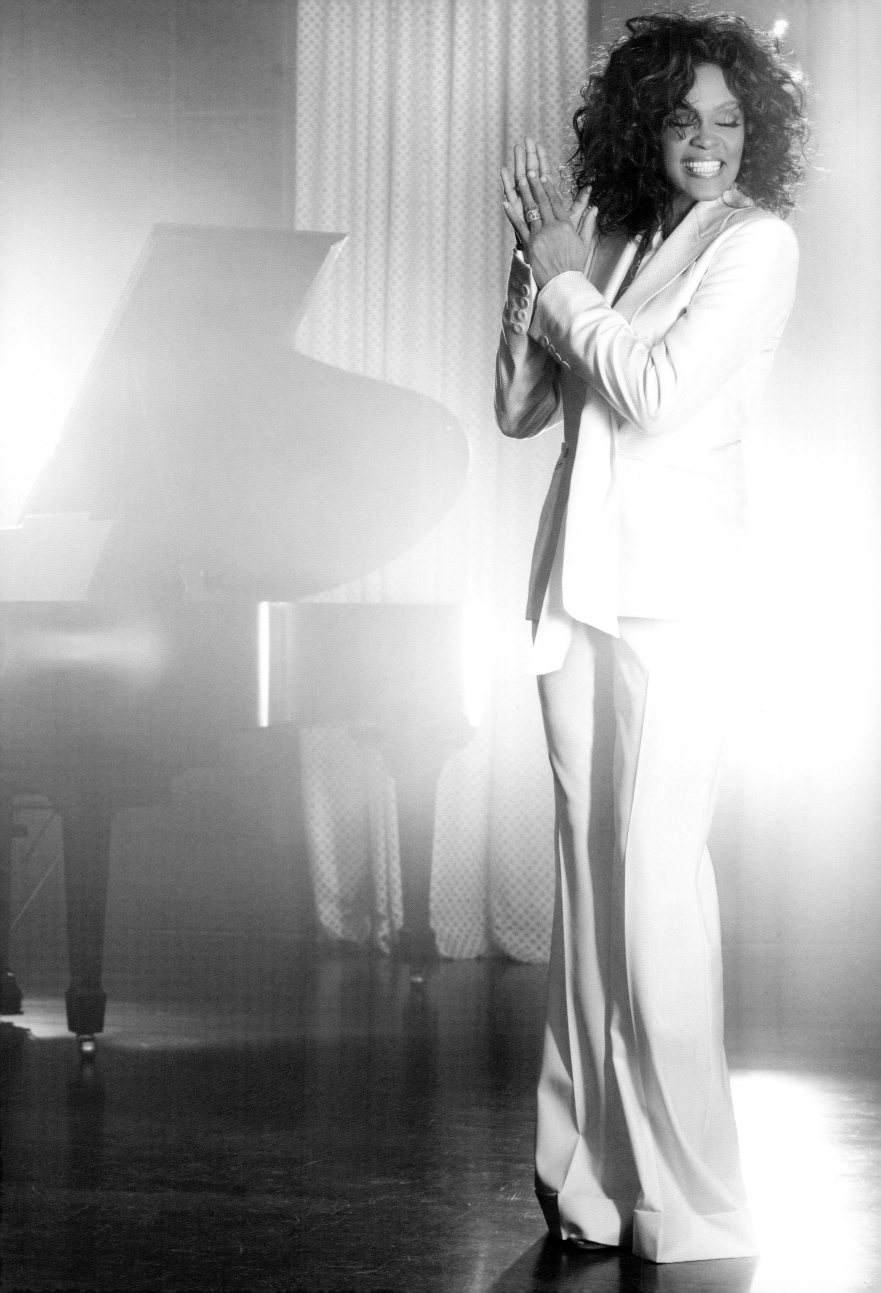

Atlanta, Georgia January 2010

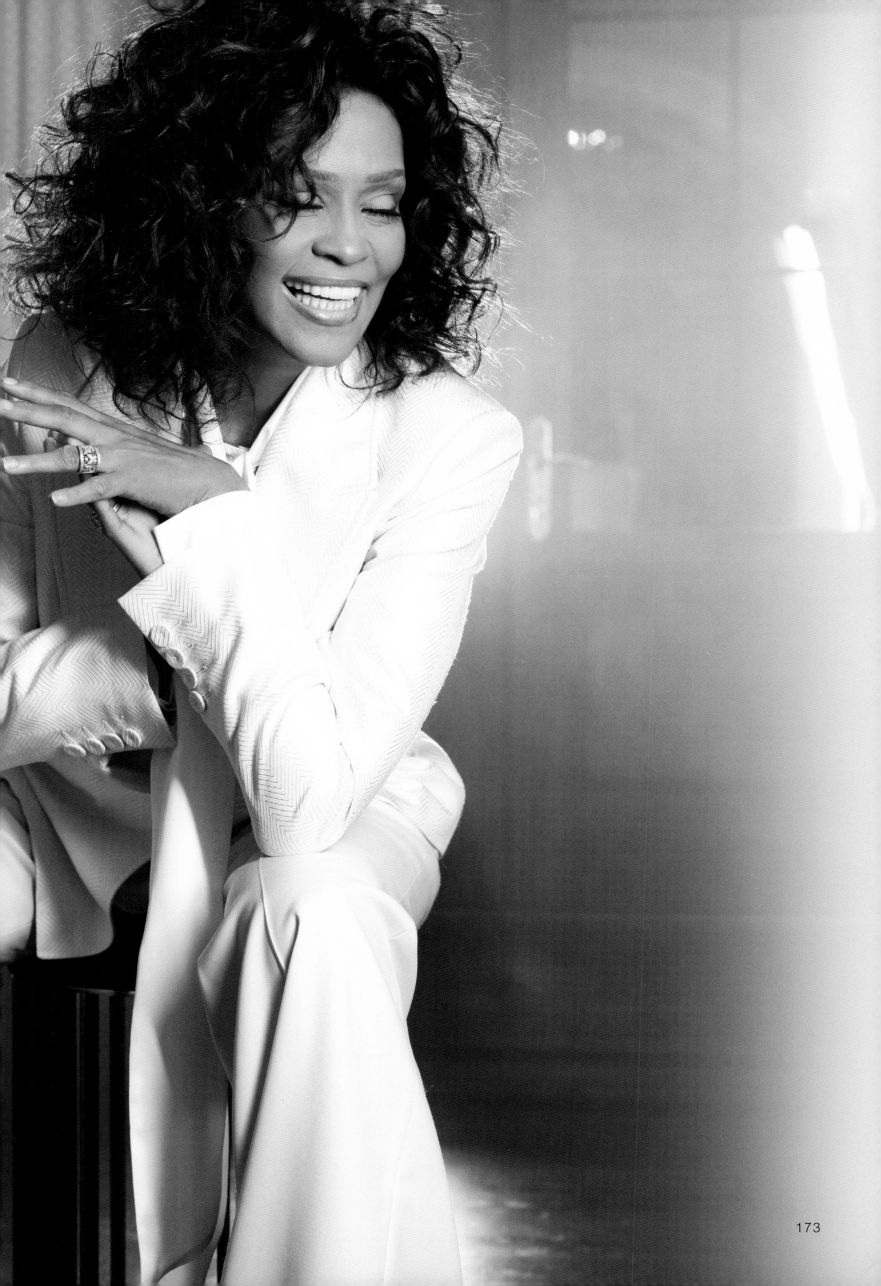

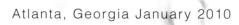

174

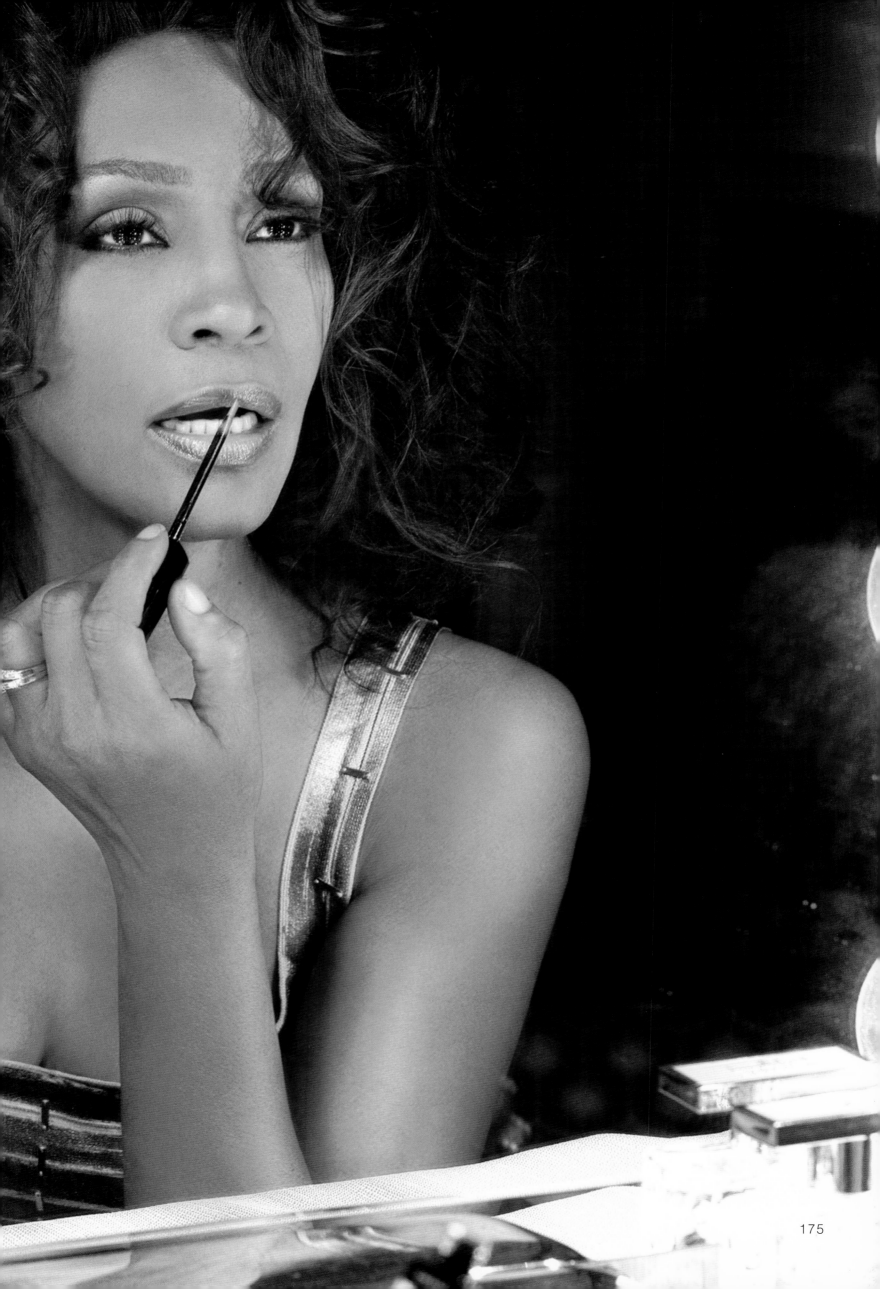

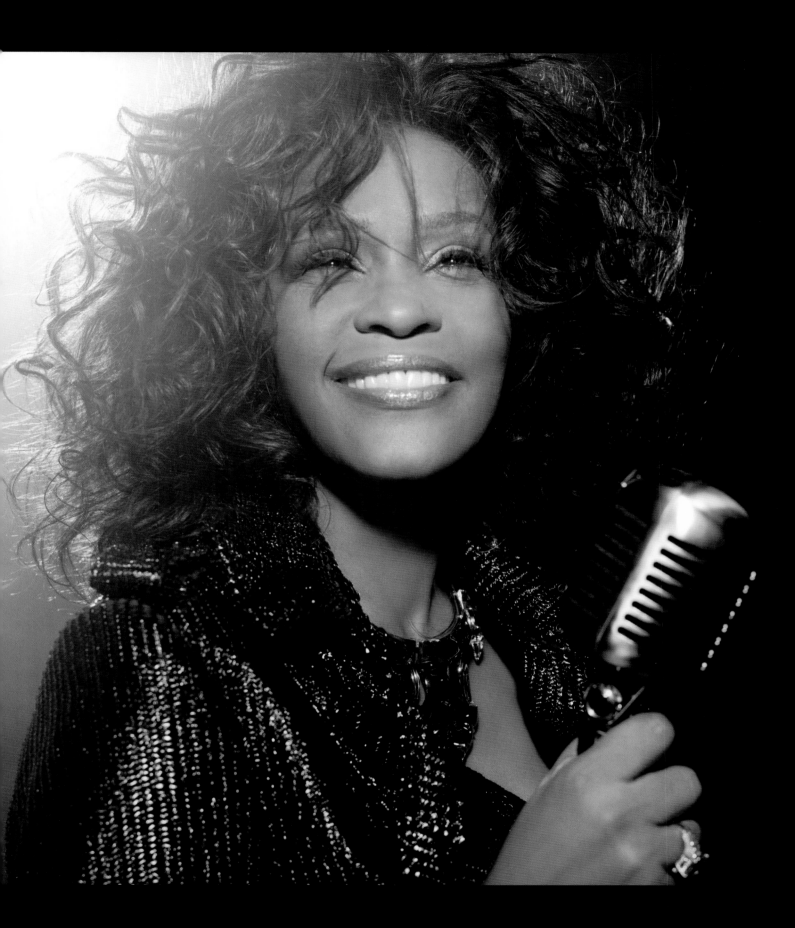

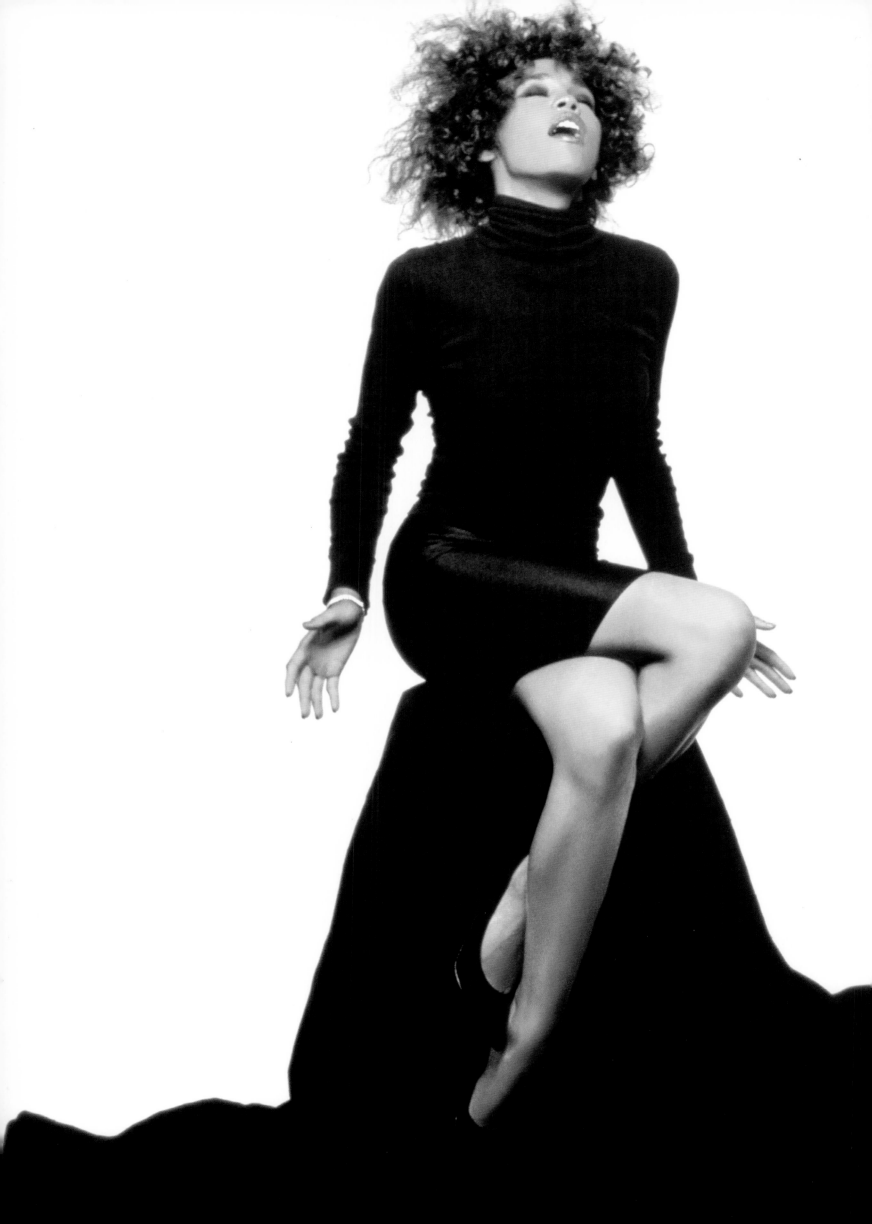

for first tour New York City 1986

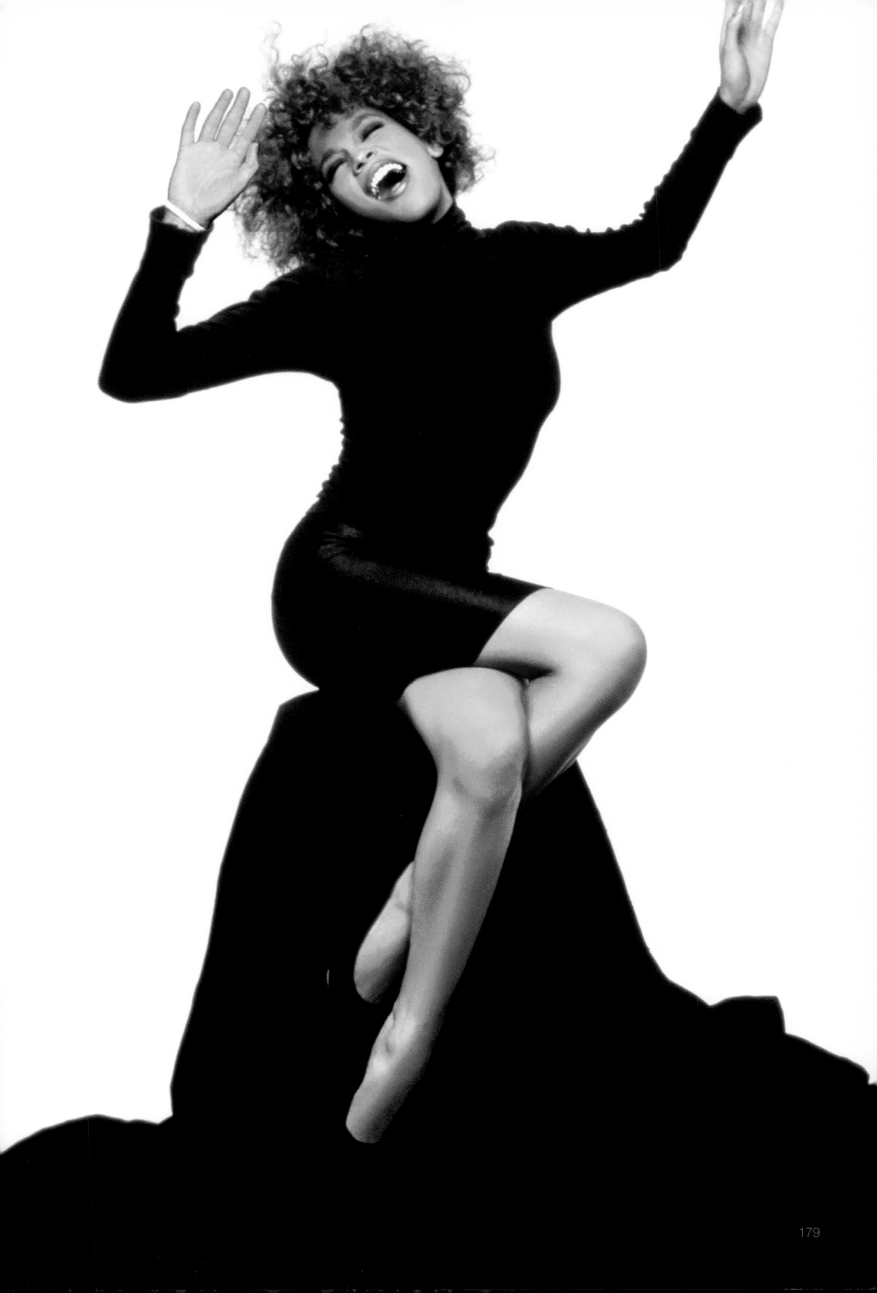

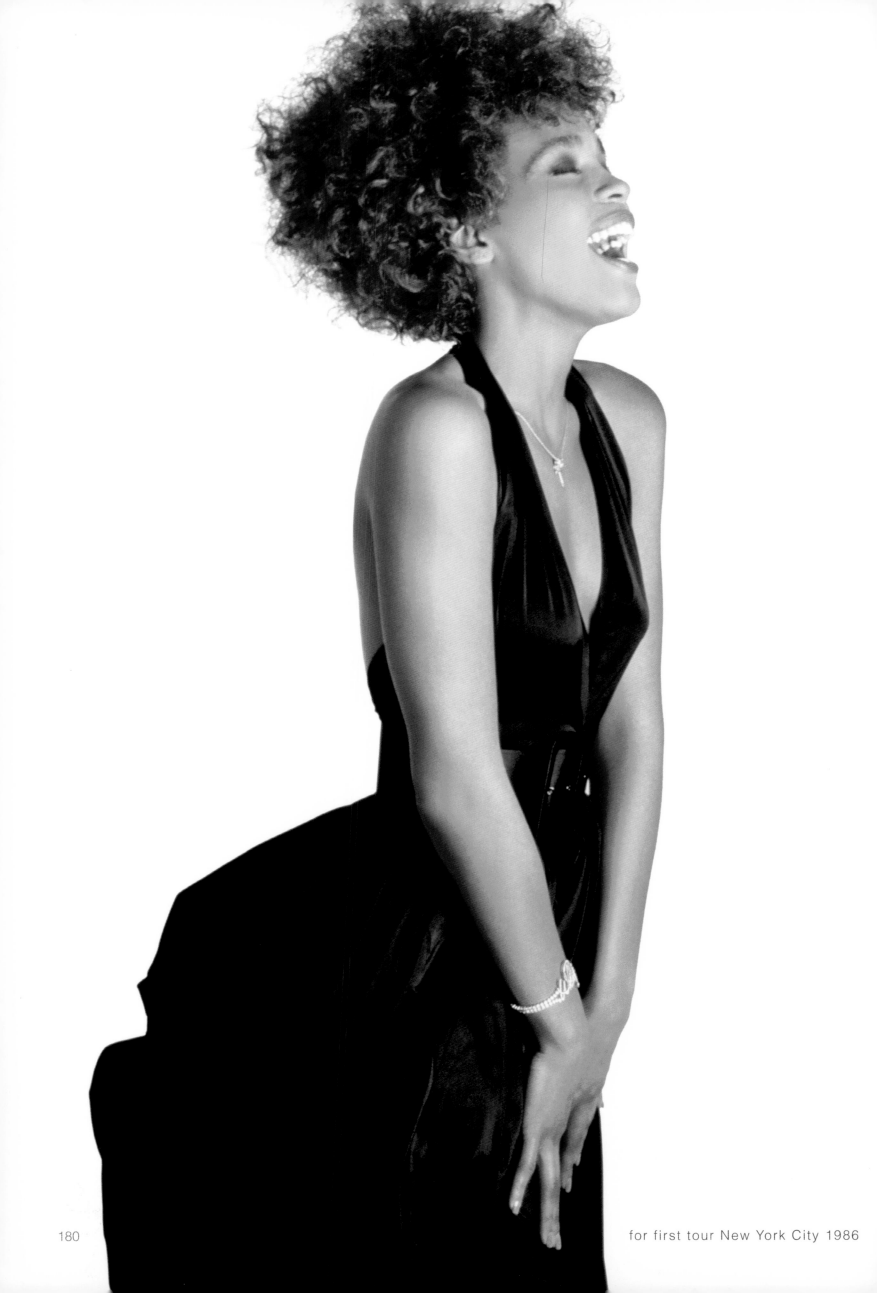

for first tour New York City 1986

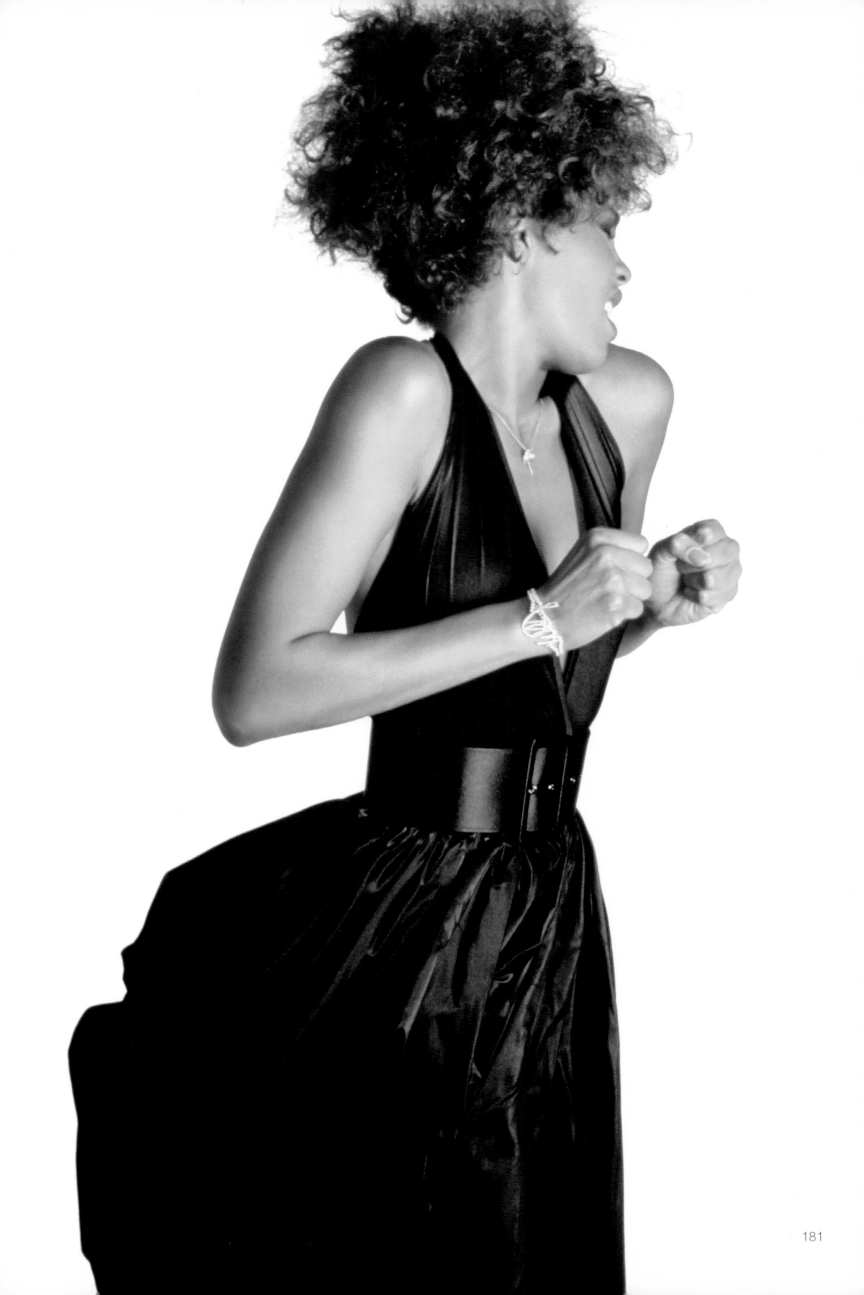

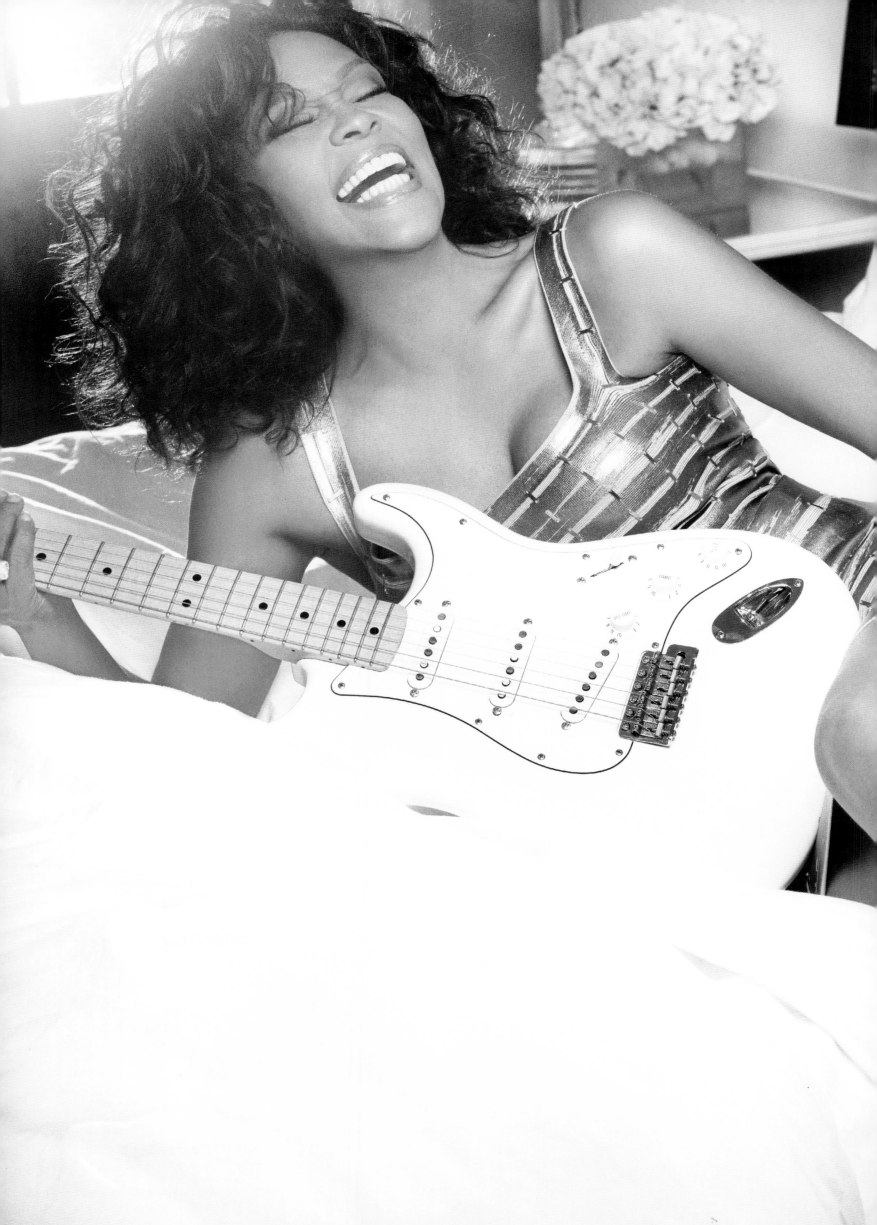

Atlanta, Georgia January 2010

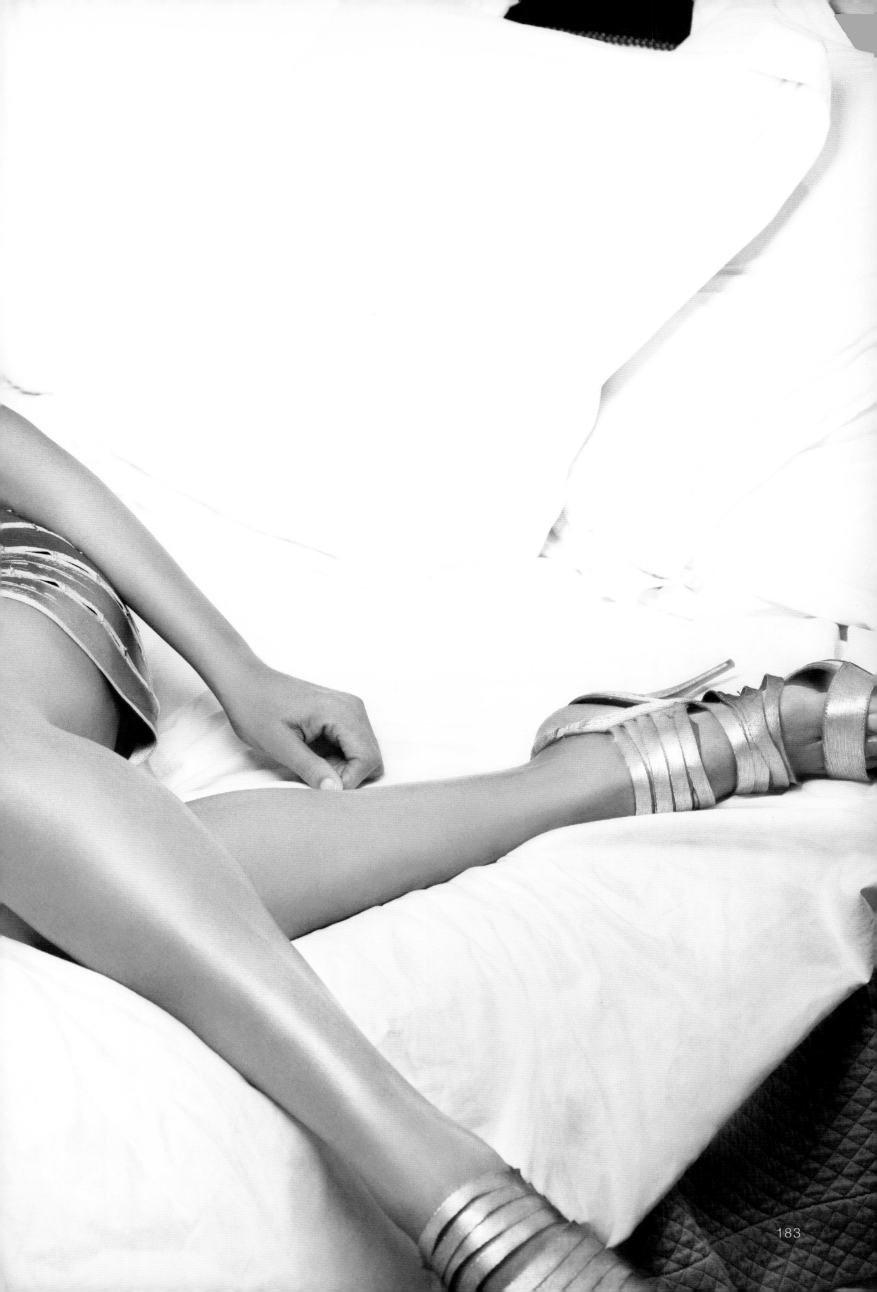

Whitney and Bobbi Kristina Hotel Bel-Air Los Angeles, California 1994

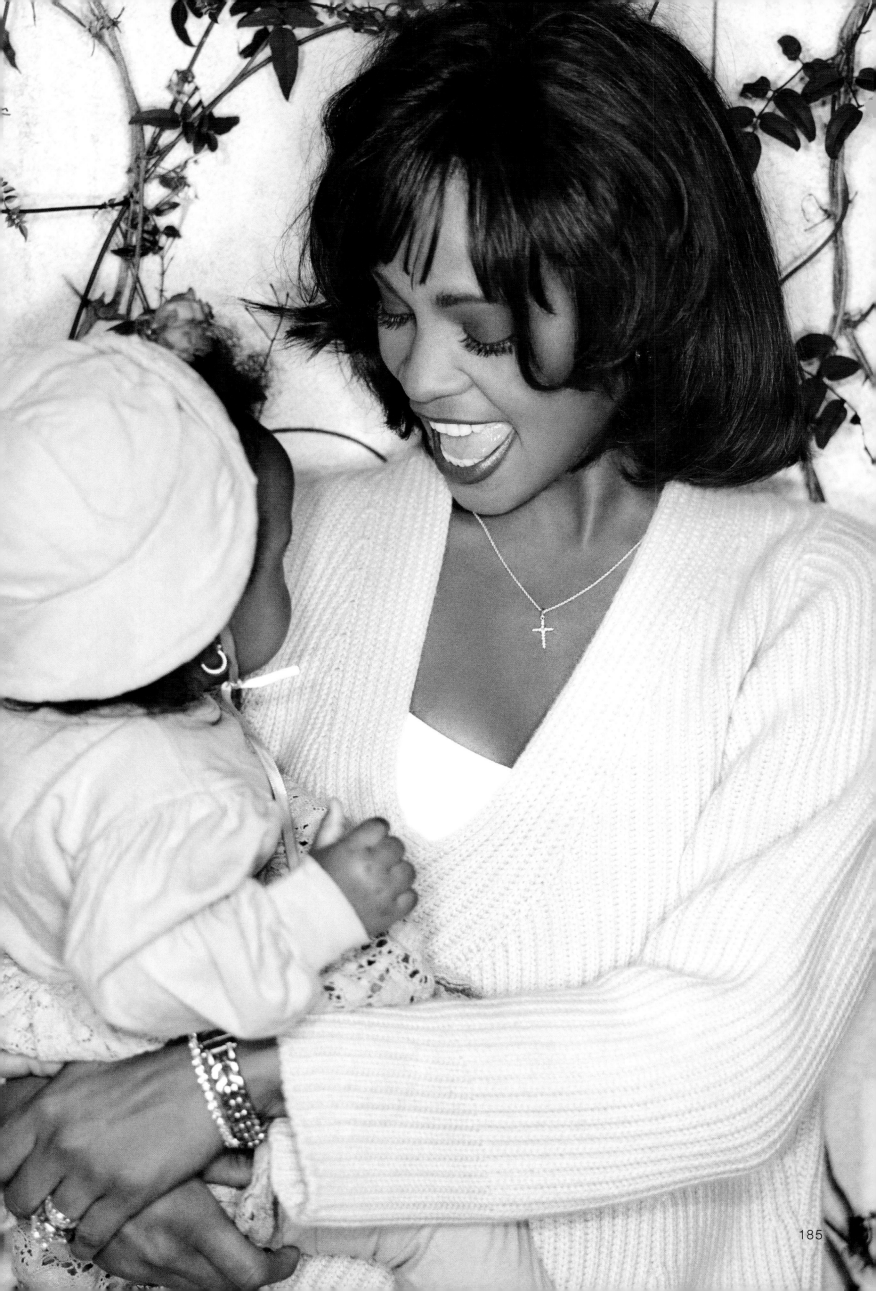

In these photographs you are sharing amazing memories that reflect very special moments in the life of the extraordinary Whitney Houston, "Nippy" to her family and also to me, as her sister-in-law and friend. Without a doubt, the world was blessed by the presence of this matchless woman.

God draws His children together for the right purpose and at the right time, and so it was for the two of us. My special relationship with Whitney, which began some twenty years ago, was an inspired encounter and a truly magical journey. With my arrival in the family through my marriage to Gary Houston, Nippy and I immediately became not just sisters-in-law, but sisters and friends, sharing a working relationship; I was privileged to manage her career and to become her trusted confidante.

It was a great privilege to share that relationship. Over the years, I witnessed firsthand how God brought Whitney safely through the highs and the lows of her existence. She felt certain that He was always there, ensuring that she would fulfill her destiny and reflect His glory. No matter what distractions threatened to take her off course, her faith always helped her to bounce back with an indomitable spirit.

She was immensely gifted. Her talent was enhanced by her brilliant smile and an ever-present shyness, as though she was amazed at the gifts that had been bestowed on her: a sense of presence, innate style and elegance, easy laughter that put people around her instantly at ease—and, above all, that pure, sweet voice with the ability to strike a chord deep down in the hearts of audiences all over the world. That voice also gave wings to the work of musicians and songwriters, for she gave a bit of her very soul to every performance and every nuance of word and emotion.

At the foundation of Whitney's heart and soul were her family and
her deep faith in God. Her final album, "I Look to You," is a testament
to that faith during her time of peril, when she pleaded to be taken
out of the battle.

My levees have broken,
my walls have come tumbling down on me,
the rain is falling, defeat is calling,
I need you to set me free.
Take me away from the battle,
I need you.
Shine on me.

Her plea was heard. The battle is over.

I will always remember this beautiful lady, sister, and friend.
Whitney Houston will remain an icon for us all.

I love you, Whitney. Peace be with you.

Pat Houston

PAT HOUSTON:

I want to start out by thanking God for this beautiful gift that he allowed to
grace our presence in the twentieth century, one of the most incredible voices
and beauties of our time: Whitney Houston.

Thank you, Clive, for your unbelievable love and friendship, leadership and guidance all these
years. You were the reason Whitney stayed in the business as long as she did.
You inspired her and motivated her and always looked beyond the challenges to ensure
that she would give herself a chance. Never have I seen such tenacity in one human
being for another; nothing you said went unheard. She really loved you, Clive.

Thank you, Cissy, for the gift and for sharing your daughter with the world.
I can only imagine all the challenges you had to face throughout her career.
But you still stand like a true champion. I love you.

Thank you, Kristina, for the sacrifices that you made in your young years.
I'm proud of you and your ability to stand for your mother, and I really believe
that she truly was a good mother. She was also a mother who had to share her life
with the world. Thank you for the love.

Gary, Michael, and Donna, thank you for your caring and supporting.
Aunt Bae and family, there are no words to describe the love and dedication
that you showed to Whitney.

To her nieces and nephews and to her godson Nick, thank you for the honor and
respect that you have shown throughout the years.

Ray and Mary, I thank you for your loyalty and love for Whitney.
Your love was unconditional, and she appreciated you. Your level of commitment
and dedication was unprecedented.

Thank you, Nicole David, for being Whitney's agent and sidekick. You are definitely
a part of this family past and present. Thank you for always believing in Whitney.

A special thank-you to Lynne Volkman, for her tireless dedication and commitment
to this project. You are undoubtedly the most efficient person I know.

To Ulysses Carter—always—what would I do without you? You are my right hand.

Thank you, Jonathan Ehrlich, Kenny Meiselas, and Allen Grubman. My hat is off
to you for all the hard work that you have delivered.

Gelfand, thank you.

Ryan, you're a true champion.

Randee, thank you for your embracing this project with the love and admiration
that Whitney so loved about you!

Thank you, Jackie and Mel, for your teamwork.

And last but certainly not least, a special thank-you to all the Whitney Fans Worldwide!

LYNNE VOLKMAN:

Randee St. Nicholas—my idol—thank you for taking on this project of love.
Ryan Supple—for helping put together this incredible book.
Jackie Murphy—for your superior design!
Patricia Houston and The Whitney Houston Estate—for letting us do this project.
Donna Houston—for going to storage for me countless times lol.
Jill Fritzo—Detective Extraordinaire.
Ken Levy—my go-to guy for the early years.
Steven Ciccone—for having the hugest collection of Whitney mags and books that
I could source when I ran into a problem. And for support and friendship
(and meals!) throughout the project.
Terri Cronin—Steven's mom, who never threw out any of his Whitney memorabilia.

A huge thank-you to all the photographers who so willingly gave us their photos
for this book. It means so much to all of us that you gave such incredible and iconic shots of
Whitney. I wanted so much to work on this as a personal tribute
to a woman I worked with for 23 years and sadly is gone too soon....

To all the Whitney fans all over the world. We all did this for you!

RANDEE ST. NICHOLAS:

Thank you to all of the talented photographers who have donated these
poignant images from their archives. Individually and collectively, you have artfully
taken us on a magical journey through Whitney's years of self-expression and growth.

A special thank-you to Ryan Supple, Jackie Murphy, Lynne Volkman, Donna Houston and
Dylann Tharp for their tireless efforts in helping to bring to life this "Tribute to an Icon."

Thank you to Clive Davis and Pat Houston for sharing with us the intimacy
of their special relationships with Whitney, so eloquently expressed.

Thank you to Judith Curr and Atria Books for giving creative freedom to everyone
involved with this project. It has been a wonderful collaboration
of many talented minds.

Thank you to Alan Forney, Jim Thiel, Malaika Adero, Jeanne Lee and
Peter Borland for going above and beyond and gracefully bending the rules
in honor of the creative process.

Thank you to Anna Bolek and Wet Noodles for preserving the artistry of every photograph.

Thank you to Robyn Crawford for her heart and unwavering integrity.

...and a very special thank you to Whitney for her beauty both inside and out,
her extraordinary talent, and most of all for always being herself...
She will forever be an inspiration for us all.

**PRODUCTION THANKS, IN NO PARTICULAR ORDER,
FOR THEIR EFFORTS ON THIS PROJECT:**

Randee St. Nicholas, Ryan Supple, Lynne Volkman, Dylann Tharp, Alan Forney,
George St. Onge, Toni Wyatt, Frank Anastasia, Anna Bolek, Taylor Rowley, Jackie Murphy, Rich
Scane Goodheart, Pat Houston, Donna Houston, The Houston Family and Estate,
Ulysses Carter, Jonathan Ehrlich, Mel Berger, Nicole David, WME, Jill Fritzo, Clive Davis, Tom
Corson, Mariela Bradford, Dan Zucker, Heidi Herman, Damon Ellis, Erwin Gorostiza,
Che Williams, Sandra Luk, Sam Lecca, Aaron Borns, RCA Records, R. Kelly, Neil Portnow, Barb
Dehgan, NARAS, Julie Heath and Warner Bros. Pictures, Kristie Alarcon and
TriStar Columbia Pictures, Debra Martin Chase, Josh Stewart, Susie Shen, Kim Dellara,
Patrick Toolan, Ruk Richards, Diane Prete, Getty Images, Richard's Photo Lab...And to the
best publishing team on the planet: Judith Curr, Malaika Adero, Peter Borland, Jim Thiel,
Jeanne Lee, Min Choi, Todd Hunter, Lourdes Lopez and everyone at
Atria/Simon and Schuster,

And a huge final thank-you to all the contributing photographers, as well as their
reps and employees, whose generous contributions and time have realized this
special Tribute to an Icon

PRODUCTION CREDITS:

President of the Whitney Houston Estate: Pat Houston

Curator/Contributing Photographer: Randee St. Nicholas

Executive Producer: Ryan S. Supple

Supervising Producer/Photographer Liaison: Lynne Volkman

Associate Producer: Dylann Tharp

Book and Cover Design: Jackie Murphy for JMD Inc.

Design Associate: Rich Scane Goodheart

Retouching: Anna Bolek for Wet Noodles Inc

Film Scanning: Richard's Photo Lab

Color Separations by Alan Forney for Color Incorporated
1600 Flower Street Glendale, CA 91201 818-240-1350
Production@Colorincorporated.com

PHOTOGRAPHY DIRECTORY

FRANK MICELOTTA
70, 74-75, 162

SHERYL NIELDS
118-119, 120-121

NEAL PRESTON
26-27, 32-33, 34-35, 48-49, 50-51, 52-53,
54-55, 56-57, 150-151, 152-153

STEVE PREZANT
66-67

EBET ROBERTS
10-11

WARWICK SAINT
87, 88-89, 92, 94-95

NORMAN SEEFF
68-69

RANDEE ST. NICHOLAS
14-15, 22-23, 28-29, 30-31, 43, 58-59, 60-61, 82-83, 86, 106-107,
108-109, 112-113, 114-115, 122-123, 156-157, 158-159, 160-161*,
168-169, 170-171, 172-173, 174-175, 176-177, 182-183, 185

MICHAEL ZAGARIS
46-47

FIROOZ ZAHEDI
17, 71, 96-97

ATRIA BOOKS
A Division of Simon & Schuster, Inc.
1230 Avenue of the Americas
New York, NY 10020

First Atria Books hardcover edition November 2012

ATRIA BOOKS and colophon are trademarks of Simon & Schuster, Inc.

For information about special discounts for bulk purchases,
please contact Simon & Schuster Special Sales at 1-866-506-1949
or business@simonandschuster.com.

The Simon & Schuster Speakers Bureau can bring authors to your live event.
For more information or to book an event contact the Simon & Schuster
Speakers Bureau at 1-866-248-3049
or visit our website at www.simonspeakers.com.

Designed by Jackie Murphy

Manufactured in China

10 9 8 7 6 5 4 3 2 1

The Library of Congress Cataloging-in-Publication Data is available.

ISBN 978-1-4767-1124-9
ISBN 978-1-4767-1126-3 (ebook)